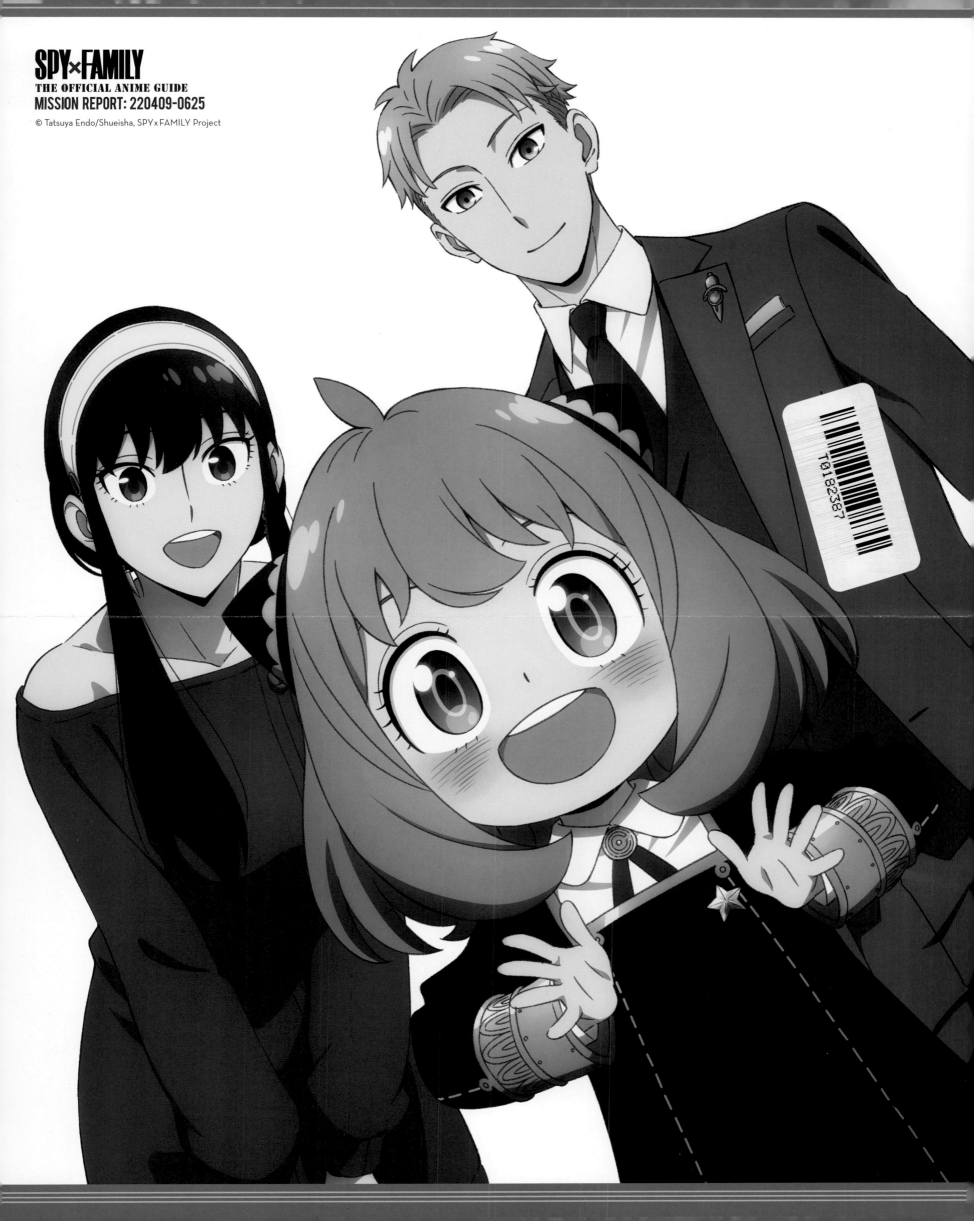

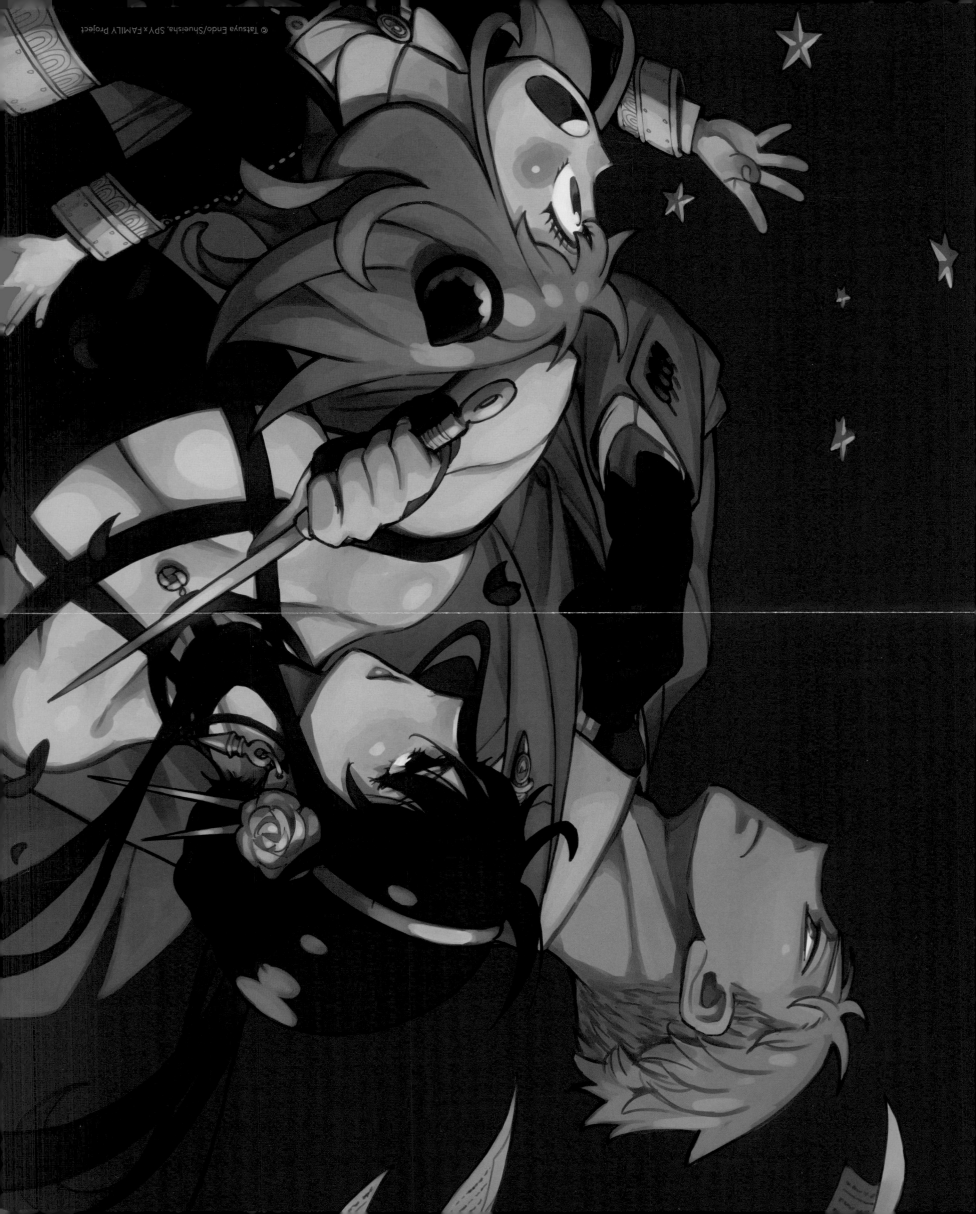

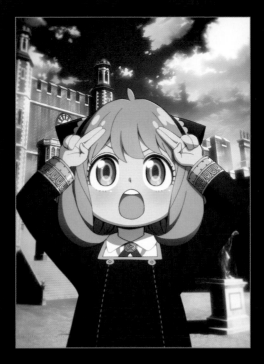

# SPY×FAMILY

## THE OFFICIAL ANIME GUIDE
## MISSION REPORT: 220409-0625

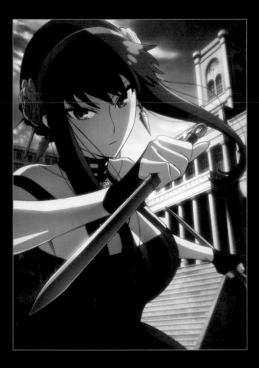

VIZ MEDIA

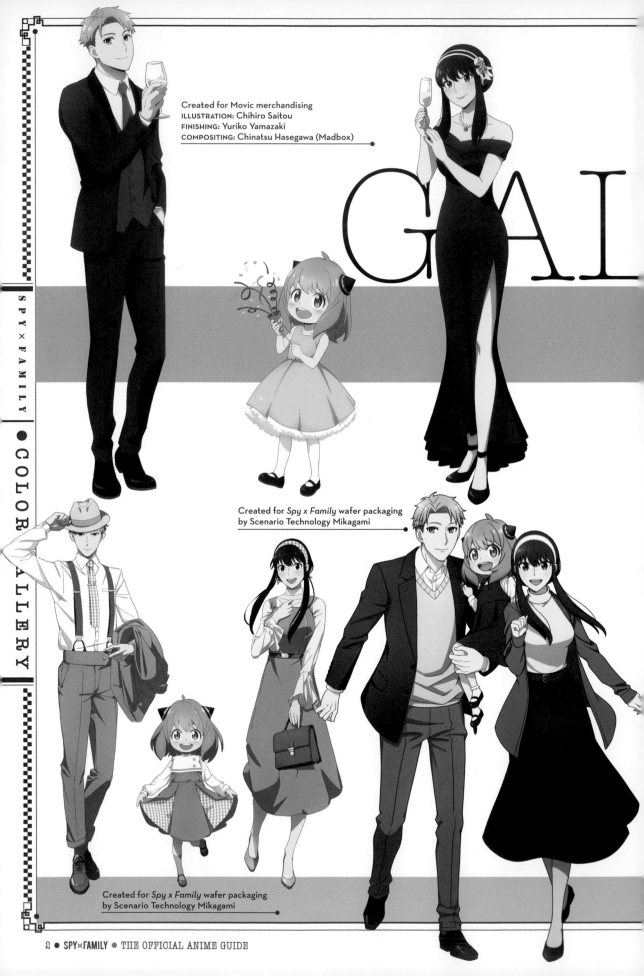

Created for Movic merchandising
ILLUSTRATION: Chihiro Saitou
FINISHING: Yuriko Yamazaki
COMPOSITING: Chinatsu Hasegawa (Madbox)

Created for *Spy x Family* wafer packaging
by Scenario Technology Mikagami

Created for *Spy x Family* wafer packaging
by Scenario Technology Mikagami

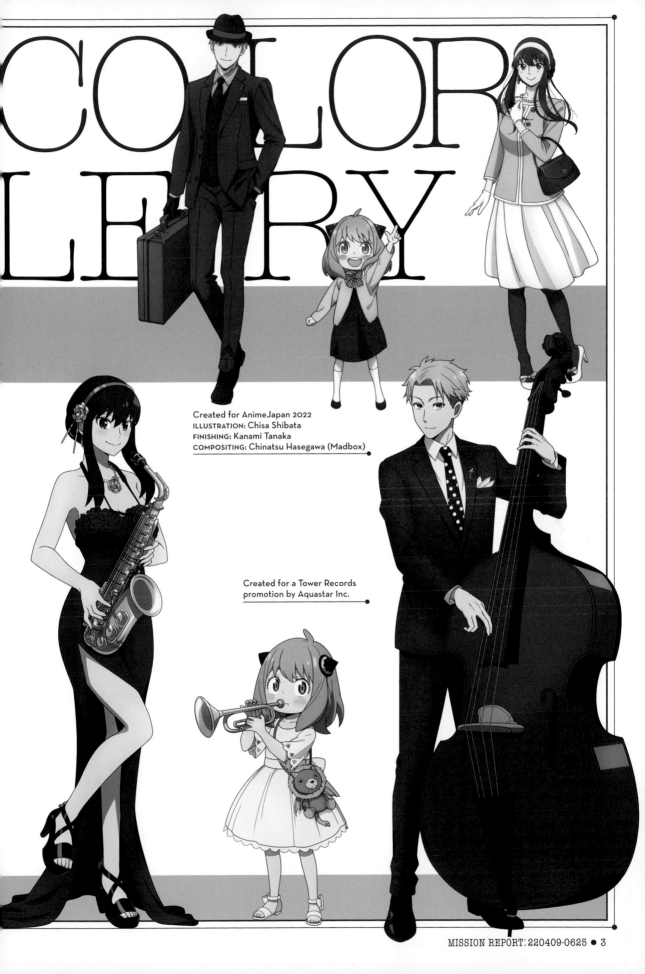

# COLOR GALLERY

Created for AnimeJapan 2022
ILLUSTRATION: Chisa Shibata
FINISHING: Kanami Tanaka
COMPOSITING: Chinatsu Hasegawa (Madbox)

Created for a Tower Records
promotion by Aquastar Inc.

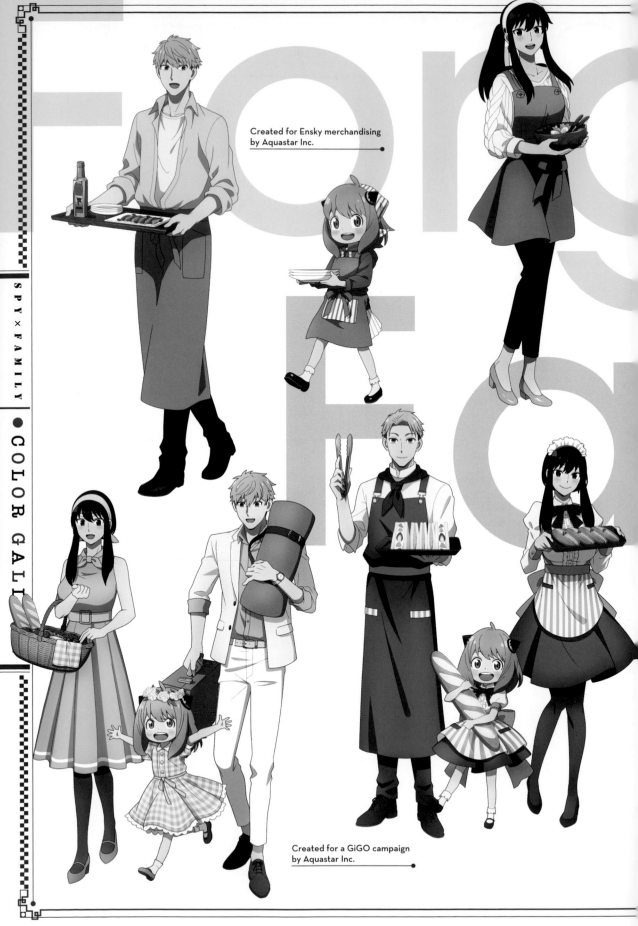

Created for Ensky merchandising
by Aquastar Inc.

Created for a GiGO campaign
by Aquastar Inc.

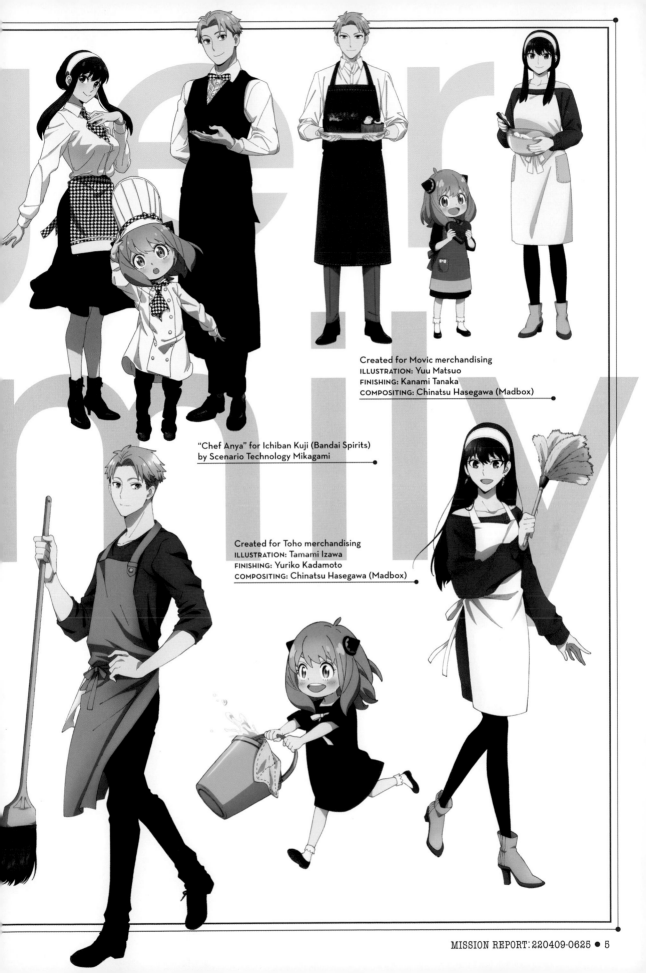

Created for Movic merchandising
ILLUSTRATION: Yuu Matsuo
FINISHING: Kanami Tanaka
COMPOSITING: Chinatsu Hasegawa (Madbox)

"Chef Anya" for Ichiban Kuji (Bandai Spirits)
by Scenario Technology Mikagami

Created for Toho merchandising
ILLUSTRATION: Tamami Izawa
FINISHING: Yuriko Kadamoto
COMPOSITING: Chinatsu Hasegawa (Madbox)

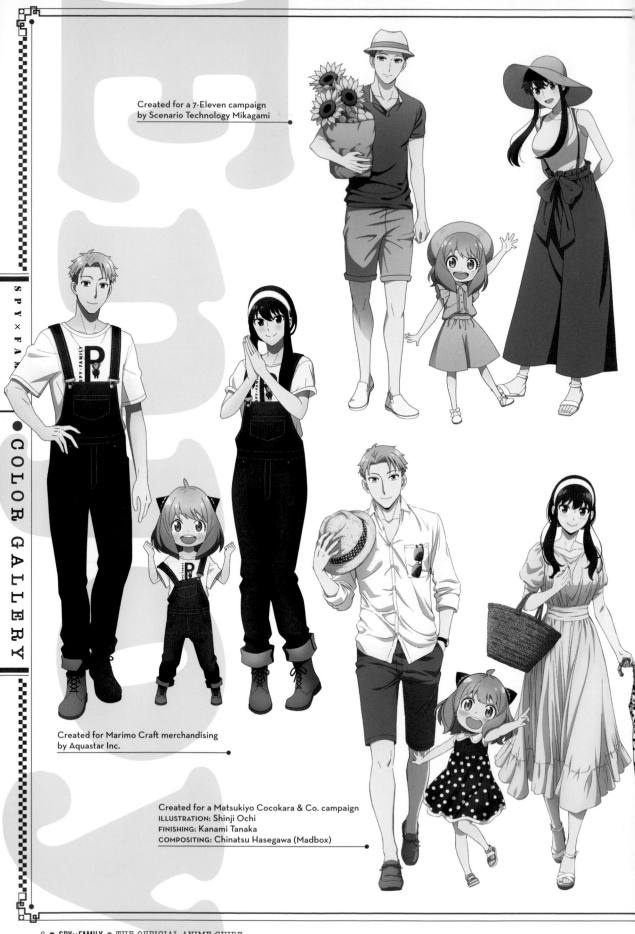

COLOR GALLERY

Created for a 7-Eleven campaign
by Scenario Technology Mikagami

Created for Marimo Craft merchandising
by Aquastar Inc.

Created for a Matsukiyo Cocokara & Co. campaign
ILLUSTRATION: Shinji Ochi
FINISHING: Kanami Tanaka
COMPOSITING: Chinatsu Hasegawa (Madbox)

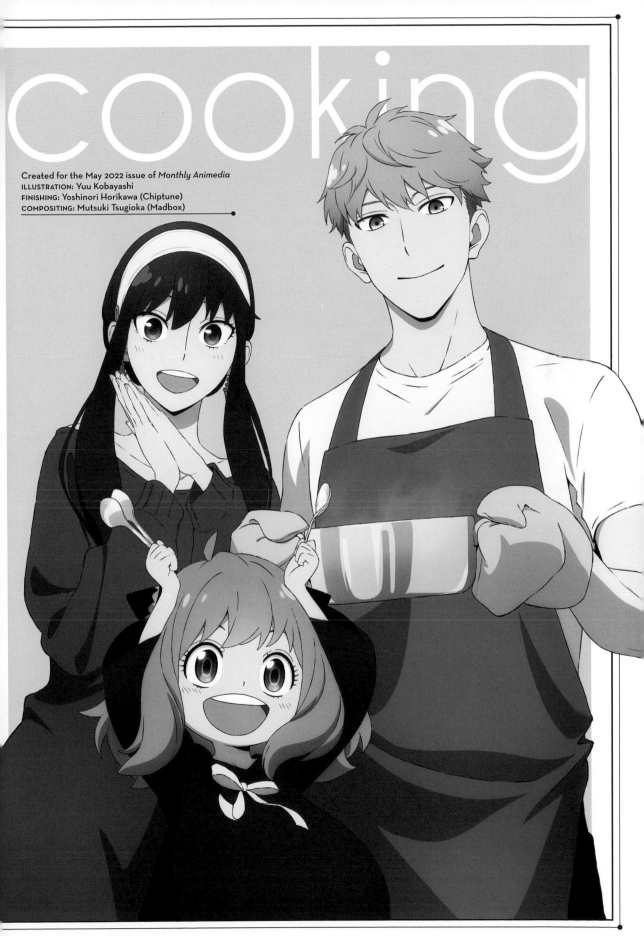

# cooking

Created for the May 2022 issue of *Monthly Animedia*
ILLUSTRATION: Yuu Kobayashi
FINISHING: Yoshinori Horikawa (Chiptune)
COMPOSITING: Mutsuki Tsugioka (Madbox)

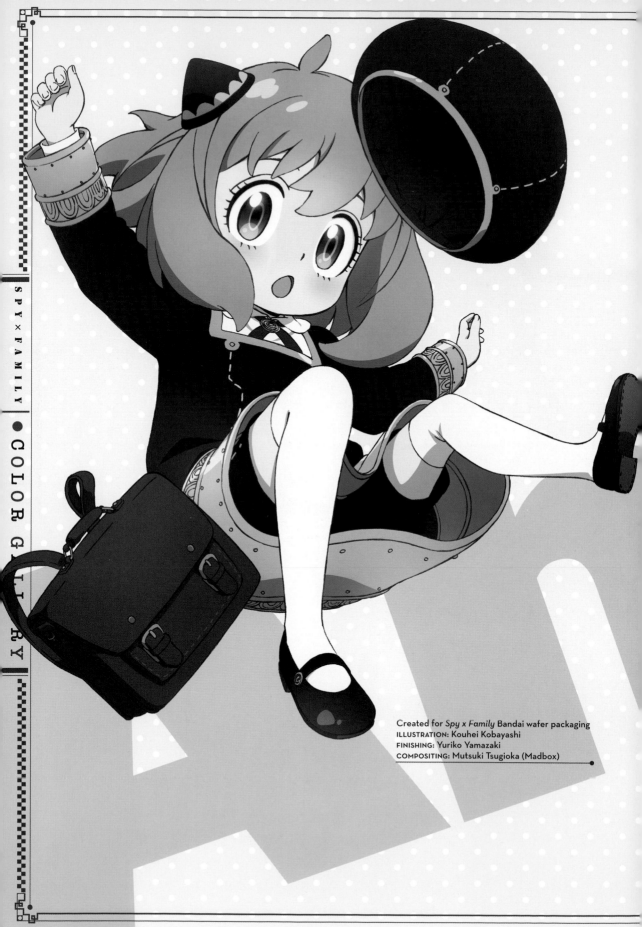

Created for *Spy x Family* Bandai wafer packaging
ILLUSTRATION: Kouhei Kobayashi
FINISHING: Yuriko Yamazaki
COMPOSITING: Mutsuki Tsugioka (Madbox)

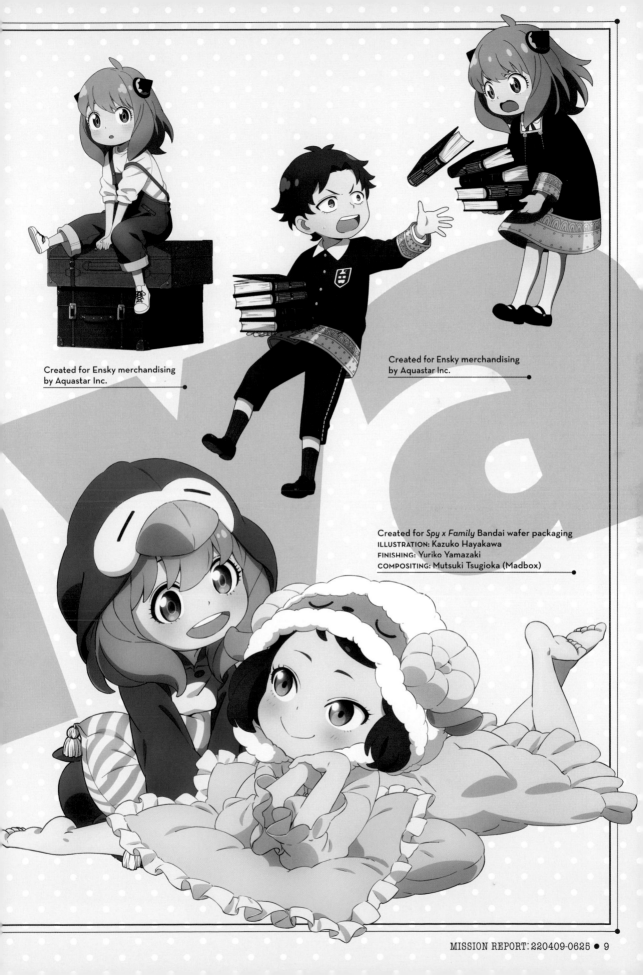

Created for Ensky merchandising
by Aquastar Inc.

Created for Ensky merchandising
by Aquastar Inc.

Created for *Spy x Family* Bandai wafer packaging
ILLUSTRATION: Kazuko Hayakawa
FINISHING: Yuriko Yamazaki
COMPOSITING: Mutsuki Tsugioka (Madbox)

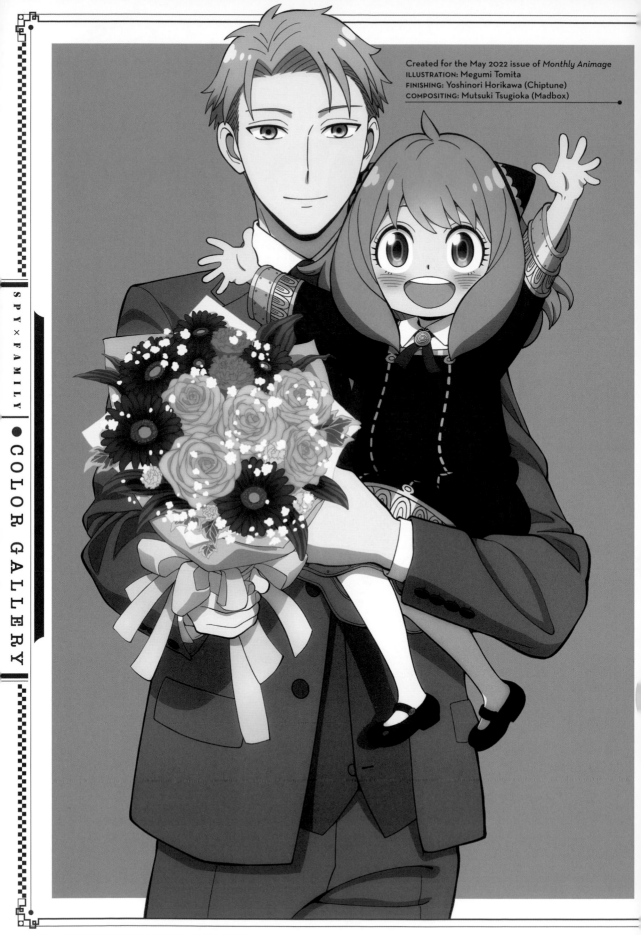

Created for the May 2022 issue of *Monthly Animage*
ILLUSTRATION: Megumi Tomita
FINISHING: Yoshinori Horikawa (Chiptune)
COMPOSITING: Mutsuki Tsugioka (Madbox)

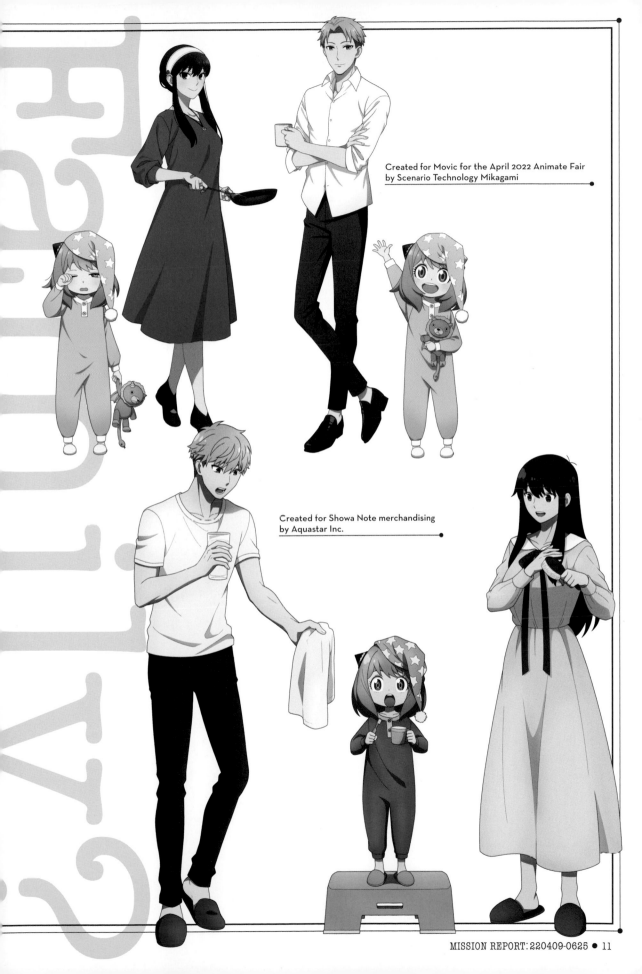

Created for Movic for the April 2022 Animate Fair by Scenario Technology Mikagami

Created for Showa Note merchandising by Aquastar Inc.

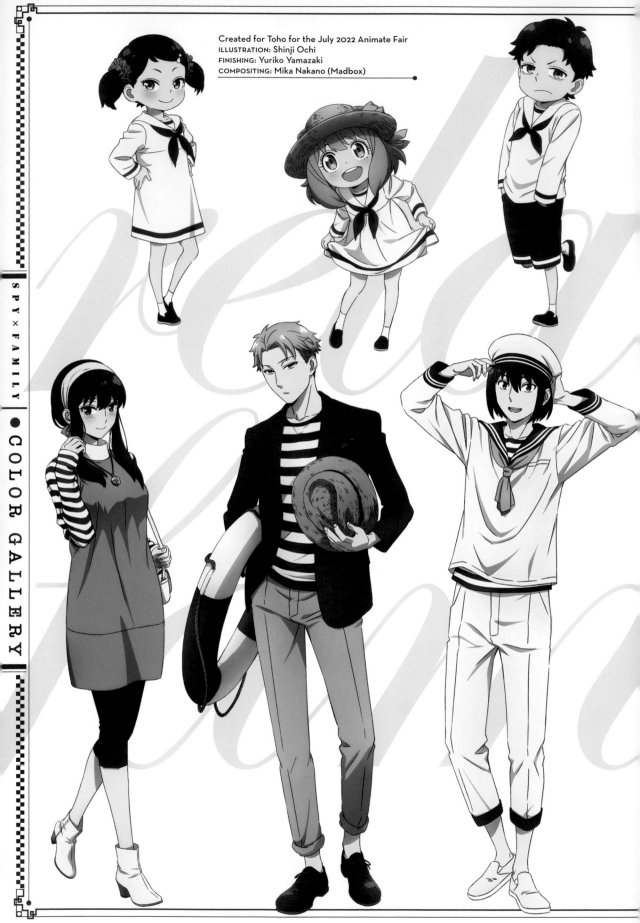

Created for Toho for the July 2022 Animate Fair
ILLUSTRATION: Shinji Ochi
FINISHING: Yuriko Yamazaki
COMPOSITING: Mika Nakano (Madbox)

COLOR GALLERY

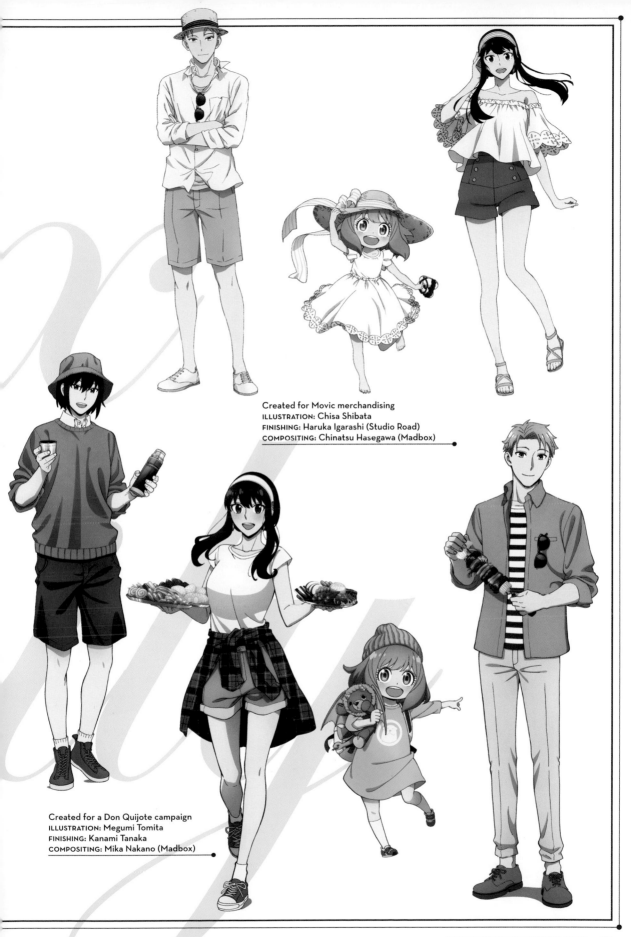

Created for Movic merchandising
ILLUSTRATION: Chisa Shibata
FINISHING: Haruka Igarashi (Studio Road)
COMPOSITING: Chinatsu Hasegawa (Madbox)

Created for a Don Quijote campaign
ILLUSTRATION: Megumi Tomita
FINISHING: Kanami Tanaka
COMPOSITING: Mika Nakano (Madbox)

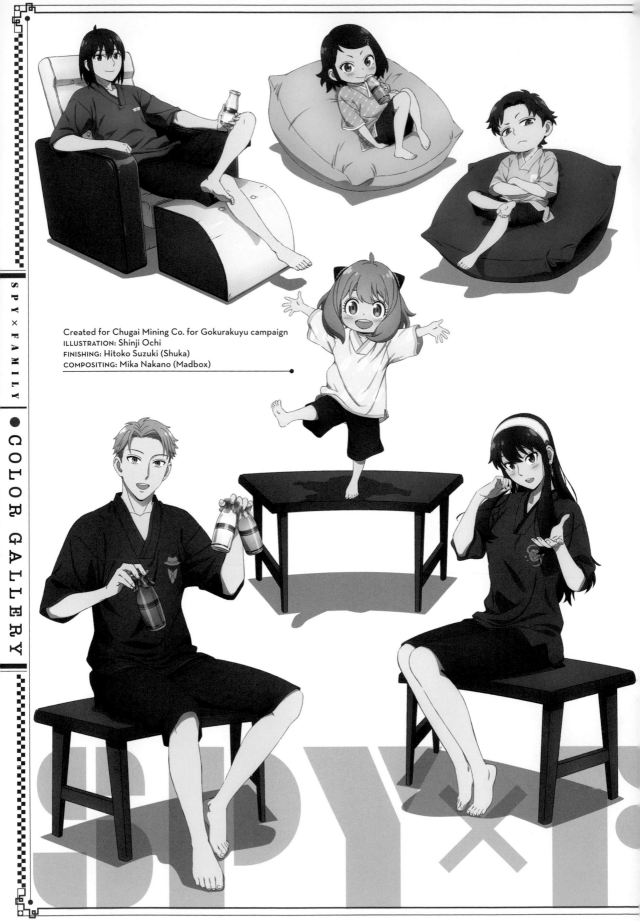

Created for Chugai Mining Co. for Gokurakuyu campaign
ILLUSTRATION: Shinji Ochi
FINISHING: Hitoko Suzuki (Shuka)
COMPOSITING: Mika Nakano (Madbox)

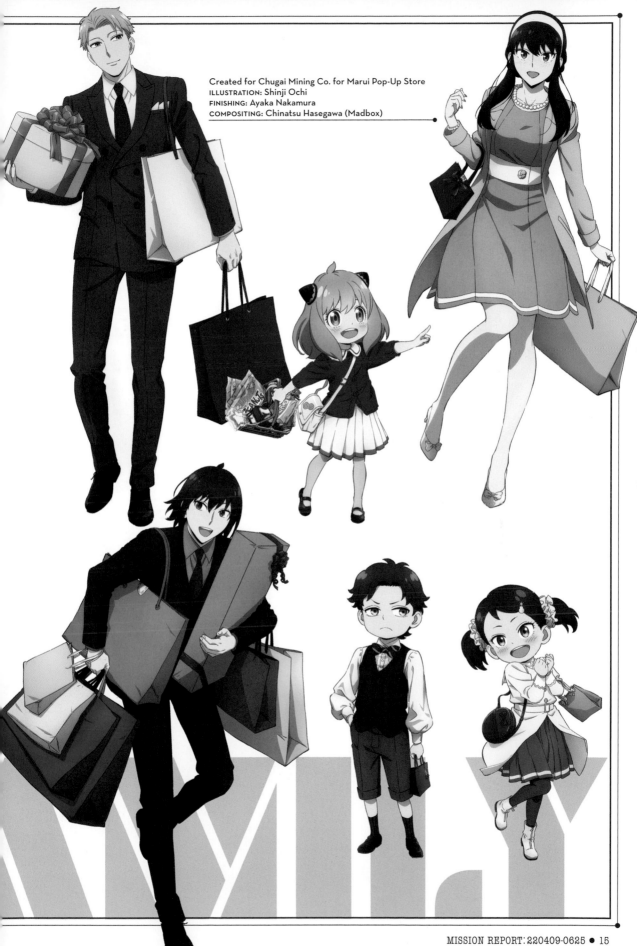

Created for Chugai Mining Co. for Marui Pop-Up Store
ILLUSTRATION: Shinji Ochi
FINISHING: Ayaka Nakamura
COMPOSITING: Chinatsu Hasegawa (Madbox)

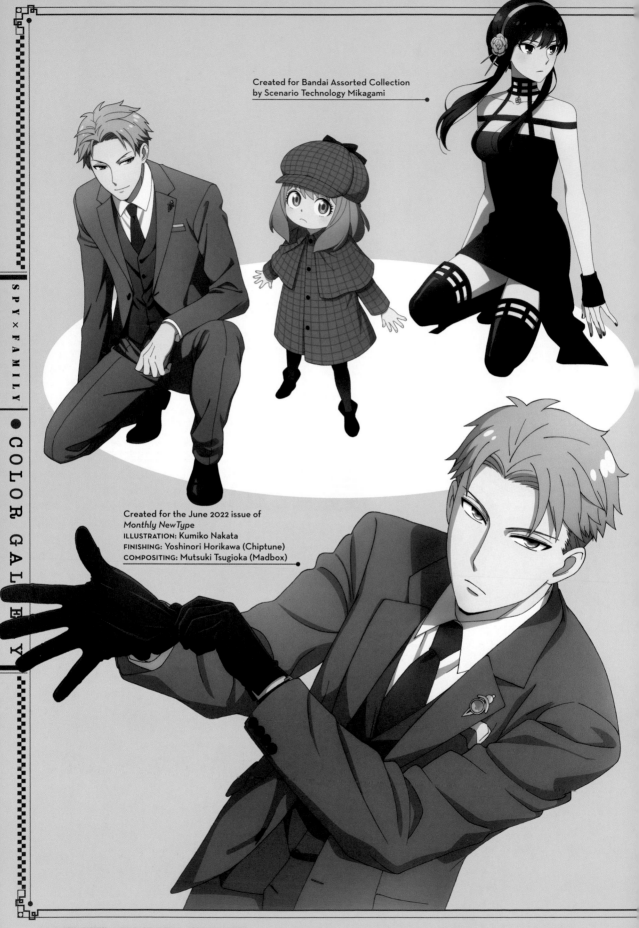

Created for Bandai Assorted Collection by Scenario Technology Mikagami

Created for the June 2022 issue of
*Monthly NewType*
ILLUSTRATION: Kumiko Nakata
FINISHING: Yoshinori Horikawa (Chiptune)
COMPOSITING: Mutsuki Tsugioka (Madbox)

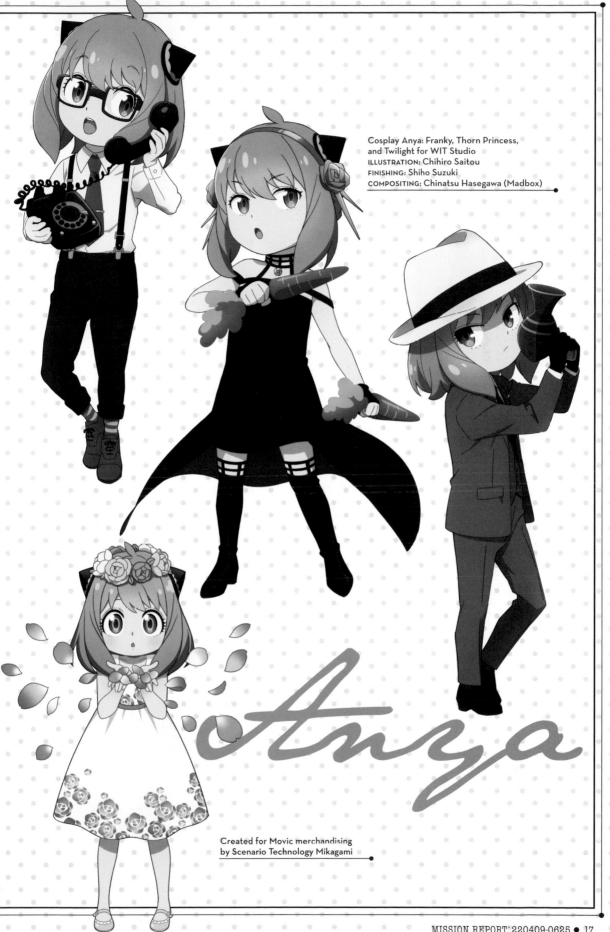

Cosplay Anya: Franky, Thorn Princess,
and Twilight for WIT Studio
ILLUSTRATION: Chihiro Saitou
FINISHING: Shiho Suzuki
COMPOSITING: Chinatsu Hasegawa (Madbox)

*Anya*

Created for Movic merchandising
by Scenario Technology Mikagami

Yor

Loid

Anya

(Left images) Created for Ensky merchandising by Aquastar Inc.

Created for the *Official Starting Guide to the "Spy x Family" TV Anime*
ILLUSTRATION: Aiko Minowa
FINISHING: Yuriko Yamazaki
COMPOSITING: Akane Fushihara (Madbox)

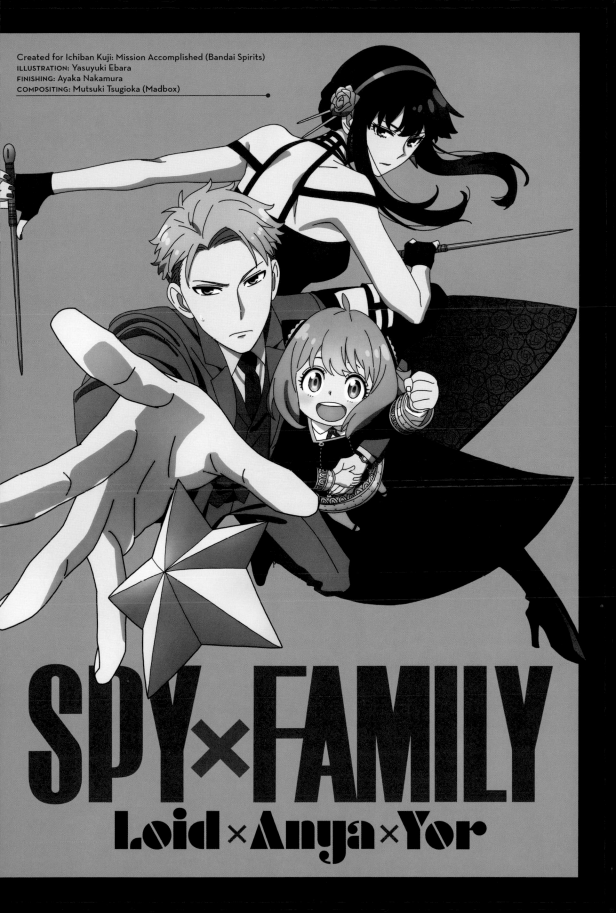

Created for Ichiban Kuji: Mission Accomplished (Bandai Spirits)
ILLUSTRATION: Yasuyuki Ebara
FINISHING: Ayaka Nakamura
COMPOSITING: Mutsuki Tsugioka (Madbox)

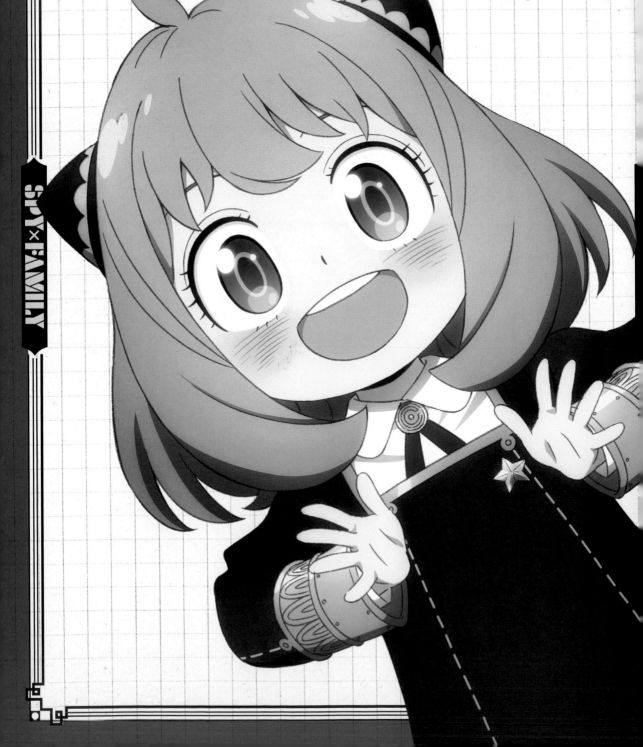

# SPY×FAMILY

**THE OFFICIAL ANIME GUIDE**

**MISSION REPORT: 220409-0625**

Original Story by
Tatsuya Endo

SPY×FAMILY

# OPERATION STRIX IS UNDERWAY! EARN STELLA FOR WORLD PEACE!

## INTRODUCTION

Westalis secret agent Twilight (a.k.a. Loid Forger) faces his toughest mission yet. With Anya and Yor posing as his daughter and wife, he schemes to infiltrate a group of Eden Academy elites by raising Anya to be an honors student. Easier said than done...

# CONTENTS

## *SPY x FAMILY* ANIMATED SERIES MAIN CAST & STAFF

### MAIN CAST

| | |
|---|---|
| Loid Forger | **Takuya Eguchi** |
| Anya Forger | **Atsumi Tanezaki** |
| Yor Forger | **Saori Hayami** |
| Franky Franklin | **Hiroyuki Yoshino** |
| Sylvia Sherwood | **Yuhko Kaida** |
| Henri Henderson | **Kazuhiro Yamaji** |
| Yuri Briar | **Kensho Ono** |
| Damian Desmond | **Natsumi Fujiwara** |
| Becky Blackbell | **Emiri Kato** |
| Emile Elman | **Hana Sato** |
| Ewen Egeberg | **Haruka Okamura** |
| Bill Watkins | **Hiroki Yasumoto** |
| Camilla | **Umeka Shoji** |
| Millie | **Manaka Iwami** |
| Sharon | **Mirei Kumagai** |
| Dominic | **Shohei Kajikawa** |
| WISE Chief | **Akio Ootsuka** |
| Shopkeeper | **Junichi Suwabe** |
| Narration | **Kenichirou Matsuda** |

### MAIN STAFF

| | |
|---|---|
| Original Manga | **Tatsuya Endo**<br>*(Serialized on Shueisha's Shonen Jump+)* |
| Director | **Kazuhiro Furuhashi** |
| Character Designer | **Kazuaki Shimada** |
| General Animation Directors | **Kyoji Asano**<br>**Kazuaki Shimada** |
| Assistant Directors | **Takashi Katagiri**<br>**Kenji Takahashi**<br>**Takahiro Harada** |
| Color Design | **Satoshi Hashimoto** |
| Art Design | **Yuho Taniuchi**<br>**Satomi Sugimoto**<br>**Kazushige Kanehira** |
| Art Direction | **Kazuo Nagai**<br>**Hisayo Usui** |
| 3DCG Direction | **Kana Imagaki** |
| Cinematographer | **Akane Fushihara** |
| Assistant Cinematographer | **Yuuya Sakuma** |
| Editor | **Akari Saitou** |
| Music Production | **(K)NoW_NAME** |
| Sound Director | **Shoji Hata** |
| Sound Effects | **Noriko Izumo** |
| Production | **WIT Studio & CloverWorks** |

# SPY×FAMILY

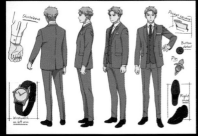

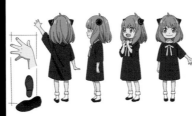

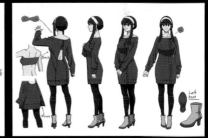

## FILE I

# CHARACTER REPORT

The first part of season 1 begins with the formation of the fake Forger family and introduces many colorful characters. In this section, we'll provide analysis, backstory, and design sketches for each.

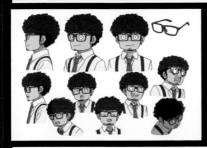

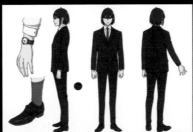

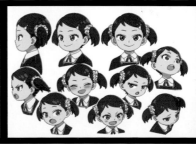

## CHARACTER REPORT

VOICED BY TAKUYA EGUCHI ·····································

# LOID FORGER

DATA ● HEIGHT: 187 CM (6'2") ● OCCUPATION: PSYCHIATRIST ● ALIAS: TWILIGHT

## A SPY POSING AS A DAD FOR THE SAKE OF WORLD PEACE

This secret agent from Westalis has infiltrated the neighboring nation of Ostania to keep a cold war from turning hot. His mission is to get close to a politician who is plotting to escalate the war. To do so, he has taken on the guise of an upstanding Ostanian citizen named Loid Forger and must create a fake family.

"MAINTAINING A WORLD WITH NO WAR... THAT IS MY DUTY."

## FACE OF AN AGENT

### The Legendary Secret Agent "Twilight"

The man known by the code name "Twilight" discarded his real name and past to join the Westalis spy agency WISE. Due to his exceptional talents, Twilight is now well-known by friends and enemies alike.

REPUTATION

### A Man with a Hundred Faces

Infiltration, intelligence gathering, combat... Twilight excels at them all, but his greatest talent is disguise. Not only can he transform his face with special masks and make-up, but he can perfectly replicate the speech, movements, and mannerisms of his targets.

SKILLS

## ◉ LOID FORGER MOMENTS

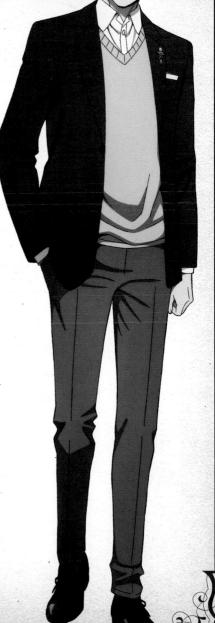

### FACE OF A FATHER

#### A Kindly Father Who Values Education

Loid's mission includes forming a cover family and getting the child accepted into the honors program at the prestigious Eden Academy. As a result, he comes off as a "tiger dad" who is pushing his daughter Anya to excel at school for her future's sake.

**AT HOME**

#### Battling Anya's Unpredictable Nature

Twilight has faced death numerous times, but he's in unfamiliar territory when it comes to raising a child. To such a rational thinker, Anya's wild behavior makes no sense and poses serious challenges to this mission.

**STRUGGLES**

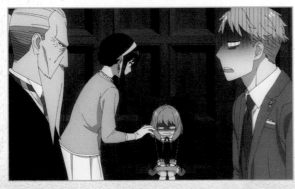

## "A THREAT TO OUR FAMILY IS A THREAT TO THE WORLD!"

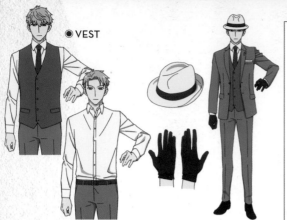

● VEST

● DRESS SHIRT

● WITH HAT AND GLOVES

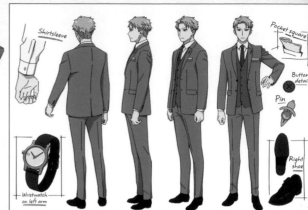

Shirtsleeve

Pocket square

Button detail

Pin

Wristwatch on left arm

Right shoe

● NORMAL CLOTHES (SUIT)

● COAT

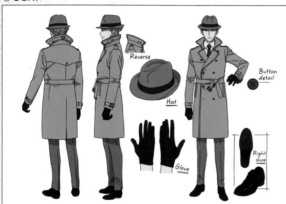

Reverse

Hat

Button detail

Glove

Right shoe

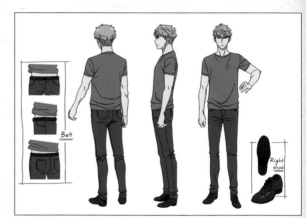

Belt

Right shoe

● LOUNGEWEAR

● PARTY WEAR (WOUNDED)

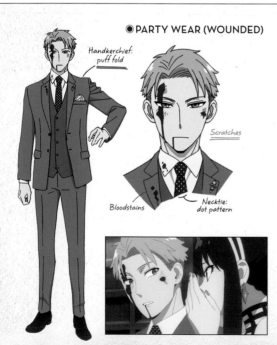

Handkerchief: puff fold

Scratches

Bloodstains

Necktie: dot pattern

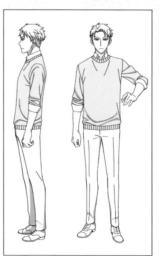

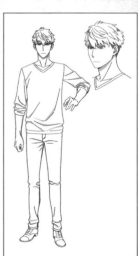

● CASUAL WEAR

● CASUAL WEAR

● FORMAL WEAR

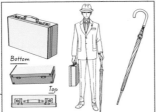

Bottom

Top

● FORMAL WEAR

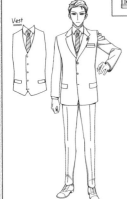

Vest

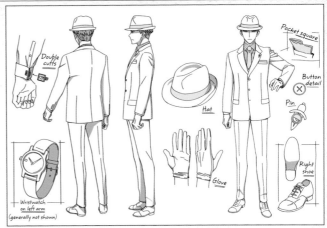

Double cuffs

Pocket square

Button detail

Pin

Hat

Glove

Wristwatch on left arm (generally not shown)

Right shoe

● FORMAL WEAR

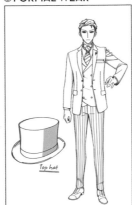

Top hat

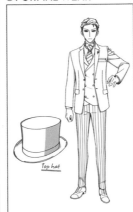

● LOIDMAN

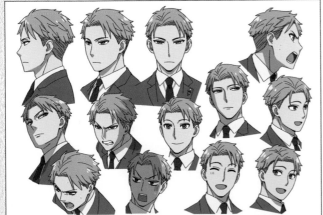

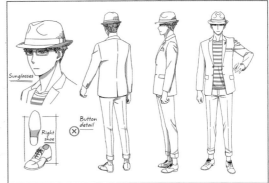

Bag

Comparison

Wristwatch on left arm

Pin

Clip holder

● INFILTRATION WEAR

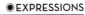

● EXPRESSIONS

Sunglasses

Right shoe

Button detail

● CASUAL WEAR

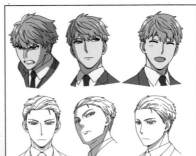

● EXPRESSIONS (HAIR FORWARD)

● EXPRESSIONS (HAIR BACK)

# SPY×FAMILY
### CHARACTER REPORT
### LOID FORGER

VOICED BY ATSUMI TANEZAKI ┄┄┄┄┄┄┄┄┄┄┄┄┄┄▶

# ANYA FORGER

**DATA** ● HEIGHT: 99.5 CM (3'3") ● TEST SUBJECT NUMBER: 007 ● FAVORITE FOOD: PEANUTS

## A THRILL-SEEKING TELEPATH BRIMMING WITH CURIOSITY

Anya was born from an experiment conducted by a mysterious organization and is capable of reading minds. Loid discovers her in an orphanage and adopts her. The thrill-loving Anya is endlessly excited to have a spy for a father and an assassin for a mother.

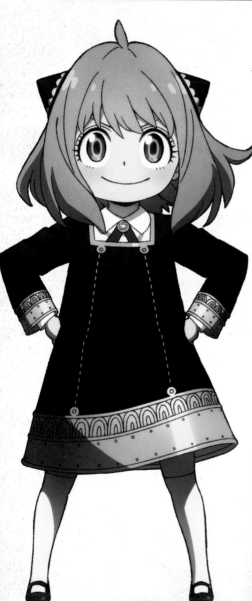

*"ANYA'S POWERS ACTUALLY HELPED SOMEONE?"*

## FACE OF A TELEPATH

### Reading the Minds of Man and Beast

Anya can hear the thoughts of others as clearly as if they were being spoken aloud. She can listen to multiple thoughts at once, but using her ability too much seems to cause her adverse physical and mental effects.

**ABILITY**

### From a Laboratory to Orphanages

During her early childhood, Anya lived an unhappy life as a test subject. At some point she escaped from the facility. She ended up bouncing from orphanage to orphanage until Loid found her. She keeps her telepathy a secret for fear that people would be driven away if they found out.

**ORIGINS**

## ANYA FORGER MOMENTS

# FACE OF A DAUGHTER

### Enjoying a Life of Excitement

Anya's boring life took a sharp one-eighty the moment she met Loid. Now that she lives with a Westalis spy and an Ostanian assassin, Anya's heart races with the knowledge that her family life would explode if her parents learned each other's secrets.

 **AT HOME**

### Striving for Imperial Scholarliness

Anya attends the prestigious Eden Academy to help Loid with Operation Strix. She hopes to either earn the eight stella stars necessary to become an Imperial Scholar or befriend Damian, the son of Loid's target. Neither path is easy.

 **STRUGGLES**

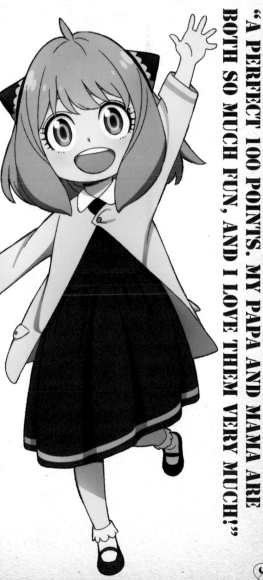

"A PERFECT 100 POINTS. MY PAPA AND MAMA ARE BOTH SO MUCH FUN, AND I LOVE THEM VERY MUCH!"

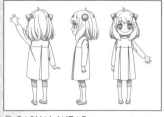

● CASUAL WEAR

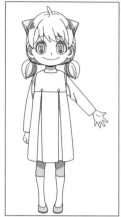

◉ CASUAL WEAR
(HAIR STYLED)

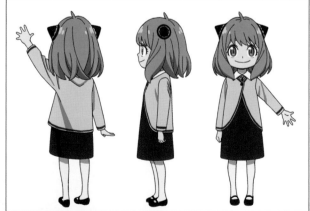

● CASUAL WEAR

● CASUAL WEAR

● CASUAL WEAR

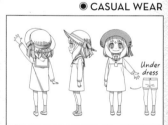

● CASUAL WEAR

Under dress

◉ FORMAL WEAR

◉ FORMAL WEAR

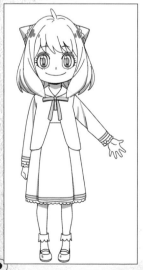

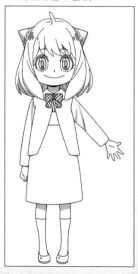

● CASUAL WEAR

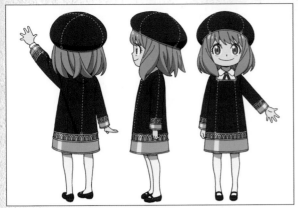

● SCHOOL UNIFORM (WITH HAT)

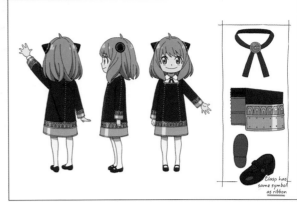

● SCHOOL UNIFORM

Clasp has same symbol as ribbon

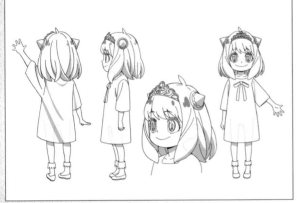

● PRINCESS ANYA

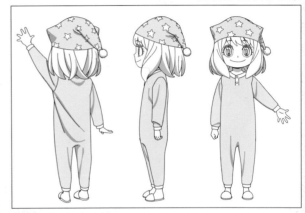

● SLEEPWEAR

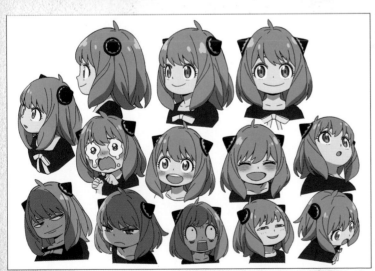

● EXPRESSIONS

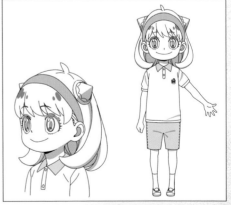

● GYM CLOTHES

VOICED BY SAORI HAYAMI

# YOR FORGER

DATA ● MAIDEN NAME: BRIAR ● OCCUPATION: CITY HALL WORKER ● CODE NAME: THORN PRINCESS

## A TALENTED ASSASSIN PURGING OSTANIA'S ENEMIES

Yor has trained in the art of assassination from a young age. She can usually be found working at city hall, but when she's called to action, she moves to eliminate those who would harm Ostania. She agrees to a fake marriage with Loid because her brother is worried about her being alone.

"MAY I HAVE THE HONOR OF TAKING YOUR LIFE?"

## FACE OF AN ASSASSIN

### An Assassin of Extraordinary Talent

Yor kills under the code name "Thorn Princess." Her employer provides support, but Yor eliminates her targets on her own. She has such incredible combat skills that she can wipe out a large entourage of guards without breaking a sweat.

ABILITY

### Taking Lives for Her Brother's Sake

After losing her parents at a young age, Yor began working as an assassin to support her younger brother, Yuri. The bond between the two siblings is so strong that Yuri can't help but resent Loid.

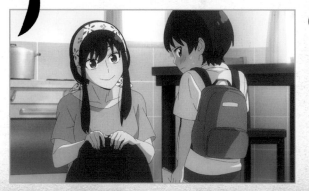

MOTIVATION

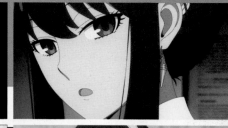

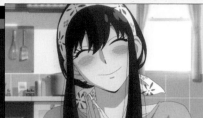

## ◎ YOR FORGER MOMENTS

## FACE OF A MOTHER

### A Ferocious Guardian to Anya

Yor enjoys being in a fake family with Loid and Anya. Incidents like the time she drove off a group of street punks pursuing Anya suggest that her feelings of motherly affection are growing stronger by the day.

**AT HOME**

### Good at Cleaning and Not Much Else

Yor's cooking skills are disastrous, and some of her answers at the Eden Academy entrance interview made her seem like a ditz. Despite these setbacks, she's working hard to become a good "normal" wife and mother.

**HOUSEWORK**

"I AM THAT GIRL'S MOTHER!"

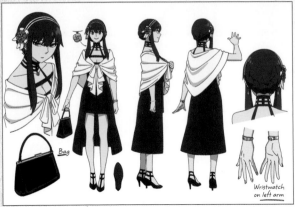

Bag

Wristwatch on left arm

● PARTY DRESS

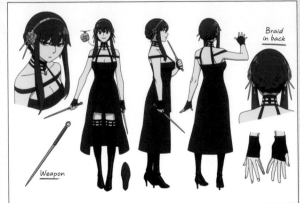

Braid in back

Weapon

● THORN PRINCESS DRESS

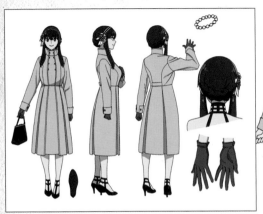

● COAT (PARTY)

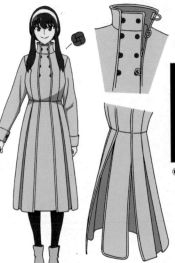

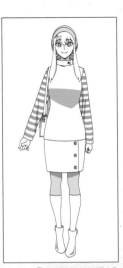

● COAT

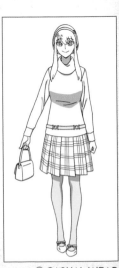

● LOUNGEWEAR

● CASUAL WEAR

● CASUAL WEAR

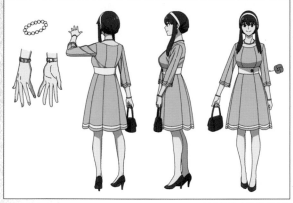

◉ FORMAL WEAR

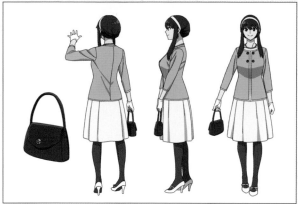

◉ FORMAL WEAR

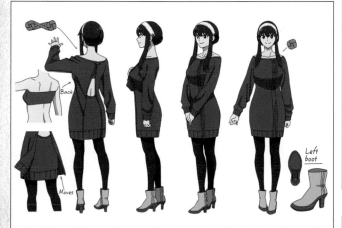

◉ LOUNGEWEAR

Back

Moves

Left boot

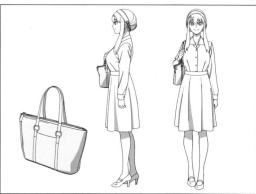

◉ WORK CLOTHES

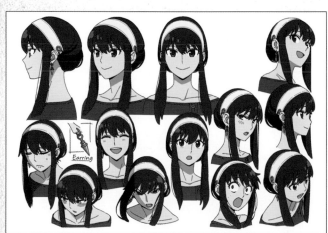

Earring

◉ EXPRESSIONS

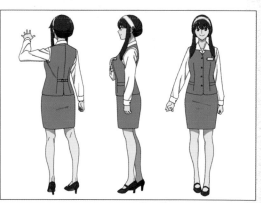

◉ CITY HALL UNIFORM

# SPY×FAMILY
## CHARACTER REPORT
## YOR FORGER

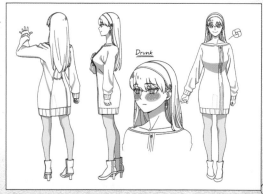

Drunk

◉ LOUNGEWEAR (HAIR DOWN)

VOICED BY HIROYUKI YOSHINO ·············▶

# FRANKY FRANKLIN

## THE INTELLIGENCE ASSET HELPING TWILIGHT

Franky is an Ostanian informant with access to a wide intelligence network. He supports Twilight with his various inventions and even gets drafted into fighting at his side occasionally, although he considers his own combat skills to be "literal trash." Franky is upbeat, open, and highly social, but for some reason he has no luck with women.

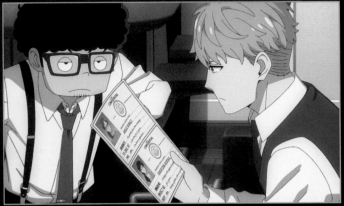

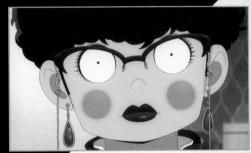

Franky helps Twilight find a woman for the mother role. He borrows a list of unmarried women from city hall to find women in "bad circumstances" who'd be inclined to cooperate.

## FACE OF AN ASSET

### A Source of Intel Twilight Can Trust

Franky's numerous personal connections make for a network that spans Ostania. Whether it's test answers or lists of unmarried women, Franky can get access to highly secure information.

 ABILITY

### A Friend to the Forger Family

Franky is a regular at the Forgers' home. He even comes running over to attend the party to celebrate Anya's acceptance into Eden Academy. Anya calls him "Scruffy Head."

 AMITY

"WA HA HA HA! THIS IS ALL THANKS TO ME STEALING THE ANSWER SHEET."

● **REFERENCE GALLERY** **FRANKY FRANKLIN**

● NORMAL CLOTHES

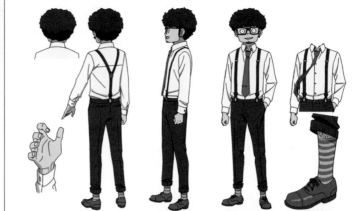

● INFILTRATION WEAR

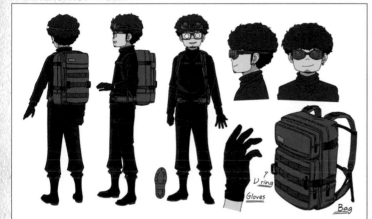

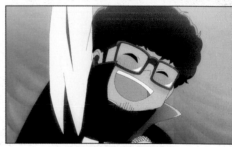

● EXPRESSIONS

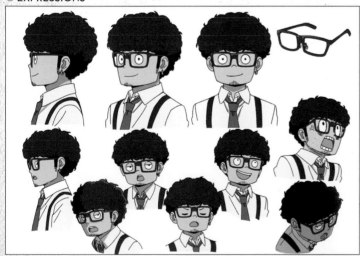

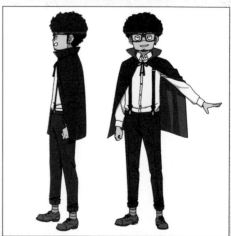

● COUNT SCRUFFY HEAD

# SPY×FAMILY
**CHARACTER REPORT**
**FRANKY FRANKLIN**

VOICED BY YUHKO KAIDA ·············▶

# SYLVIA SHERWOOD

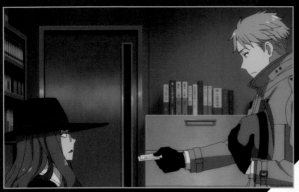

Upon receiving an invoice from Twilight, even the usually unflappable Sylvia is shocked. She seems to grudgingly admire him for daring to submit it.

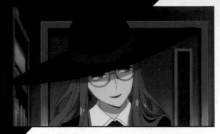

## TWILIGHT'S HANDLER AT WISE

Twilight's direct superior, Sylvia, is on-site in Ostania to give agents of WISE their orders. She despises war and is devoted to Operation Strix's goal of maintaining the peace. She relies on Twilight and assigns him rigorous missions.

● NORMAL CLOTHES

● REFERENCE GALLERY

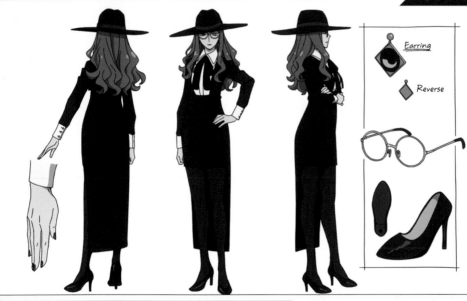

Earring

Reverse

"GOOD DAY…OR PERHAPS GOOD EVENING, AGENT TWILIGHT."

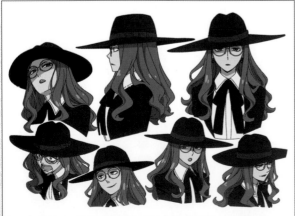

● EXPRESSIONS

VOICED BY KAZUHIRO YAMAJI ·········►

# HENRY HENDERSON

Mr. Henderson begins each elegant day with a morning run. As a teacher at a prestigious school, he knows that all discipline begins with self-discipline.

## AN EDEN EDUCATOR PURSUING ELEGANCE

As housemaster of Cecile Hall, Henry Henderson oversees Anya's class. He values elegance, believing it to be the root of history and tradition. He hates injustice and treats his students equally. He directs the Eden Academy observers during orientation.

● NORMAL CLOTHES

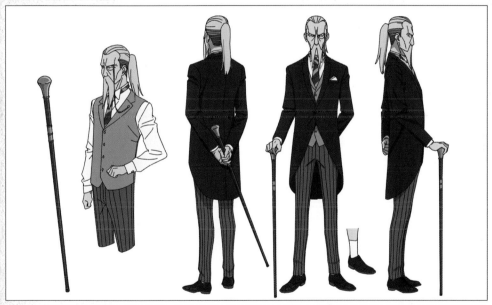

"OHO... IT APPEARS THAT NOT ALL HOPE HAS BEEN LOST. SO ELEGANT?"

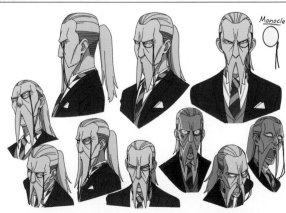

Monocle

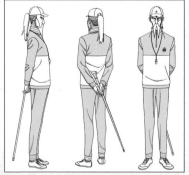

● GYM CLOTHES

● EXPRESSIONS

VOICED BY NATSUMI FUJIWARA

# DAMIAN DESMOND

A tearful apology from Anya awakens new feelings within Damian. But he still makes it a point to verbally berate her whenever they meet.

## PROUD SECOND SON OF DONOVAN DESMOND

Damian is the second son of Ostania's National Unity Party chairman, Donovan Desmond. He's arrogant and overbearing, but he's also a hard worker who cares about fairness—a value that may be rooted in a desire to be acknowledged by his father. At times, he also shows a childish side.

● SCHOOL UNIFORM

● REFERENCE GALLERY

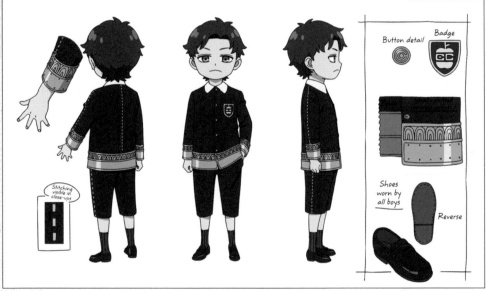

Button detail

Badge

Stitching visible in close-ups

Shoes worn by all boys

Reverse

"I WILL NEVER FORGIVE YOU! MY PRIDE WILL NOT ALLOW IT!"

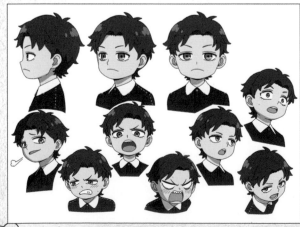

● EXPRESSIONS

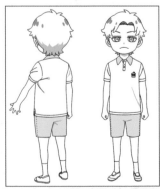

● GYM CLOTHES

VOICED BY EMIRI KATO

# BECKY BLACKBELL

When Anya is depressed about being the class pariah, the presence of an ally cheers her up. Anya is the first friend Becky's ever had, and vice versa.

## ANYA'S EVER-SUPPORTIVE FRIEND

Becky, the daughter of the CEO of a major military contractor, is a classmate of Anya's. She initially seeks to take care of Anya out of pity, but after orientation Becky grows to really like her. Becky can be sharp-tongued and precocious but would do anything for a friend.

◉ SCHOOL UNIFORM

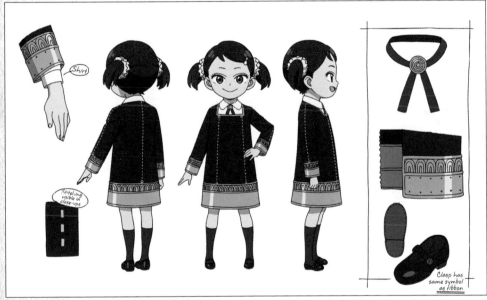

Shirt

Stitching visible in close-ups

Clasp has same symbol as ribbon

"I'M THE ONLY ONE WHO KNOWS HOW GOOD YOU ARE, ANYA."

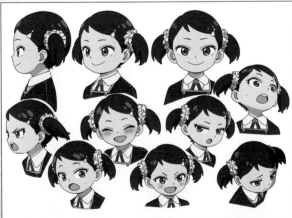

◉ EXPRESSIONS

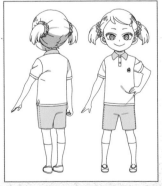

◉ GYM CLOTHES

VOICED BY HANA SATO

# EMILE ELMAN

Emile is one of Damian's closest friends and accompanies him everywhere. When Damian is gunning for the MVP award for dodgeball, Emile throws himself in front of Bill's power throw to protect his "Lord Damian."

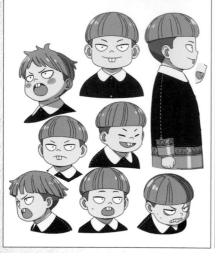

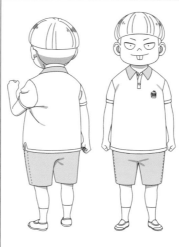

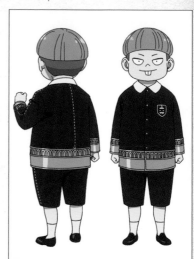

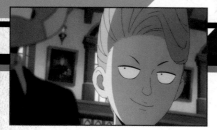

VOICED BY HARUKA OKAMURA

# EWEN EGEBERG

Ewen never leaves Damian's side. To help Damian in dodgeball, he researches the opposition and joins him in his training regimen.

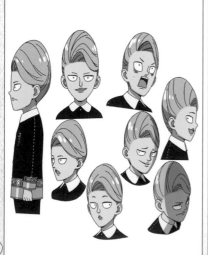

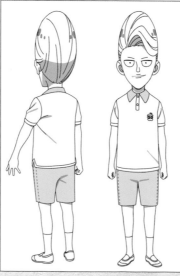

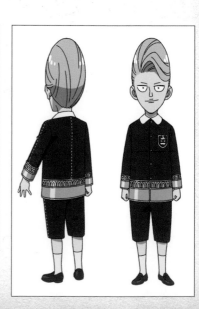

VOICED BY JIN URAYAMA ·············►

# MURDOCH SWAN

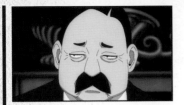

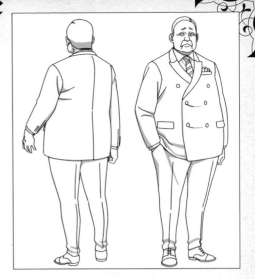

Murdoch Swan is Cline Hall's housemaster and heads up Eden's Economics Department. The son of the former headmaster, he is arrogant and selfish. His resentment of happy families leads him to ask insensitive questions during Anya's admissions interview.

VOICED BY HIROSHI YANAKA ·······►

# WALTER EVANS

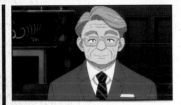

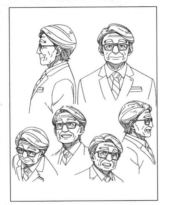

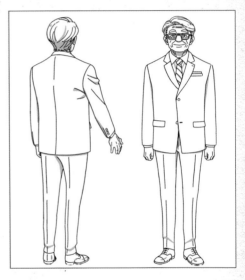

The Language Department head and housemaster of Malcom Hall, Walter Evans is a trusted and beloved Eden Academy educator. He is the secondary interviewer during Anya's admissions interview.

VOICED BY HIROKI YASUMOTO ······►

# BILL WATKINS

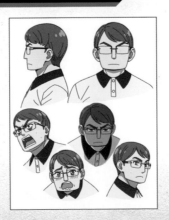

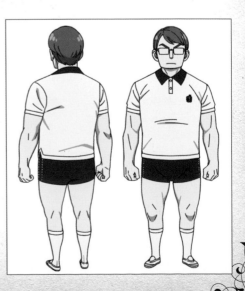

Bill is a student in a different class but the same grade as Anya. His father is a major in Ostania's National Army. He's earned the nickname "Bazooka Bill" by consistently dominating dodgeball tournaments since nursery school.

VOICED BY KENSHO ONO

# YURI BRIAR

## YOR'S LITTLE BROTHER, AN AGENT FOR OSTANIA'S SECRET POLICE

While he maintains a cover identity as a diplomat in Ostania's Ministry of Foreign Affairs, Yuri actually serves the State Security Service—Ostania's feared secret police. He dotes over Yor, his only living relative, and remains devoted to his brutal job for her sake.

While typically gentle, Yuri is a different man at work. Driven by a desire to protect the country in which his sister lives, he doesn't shy away from dirty tasks like interrogation and torture.

## FACE OF AN SSS AGENT

### A Promising Young Man Recruited at Age 20

Yuri's primary responsibilities include hunting spies who are working against Ostania and monitoring the public to prevent revolts. His boss adores him, and his colleagues admit he has talent.

**ABILITY**

### An Unshakable Obsession with His Sister

The Briar children have supported each other since they were young. Having essentially been raised by Yor, Yuri is always thinking about his sister.

**FAMILY**

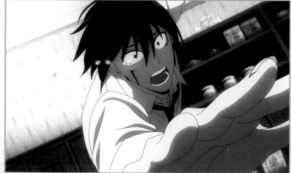

"I CAN FEEL THE RIBS THAT MY SISTER BROKE BEFORE TINGLING... I'M REMEMBERING HER LOVING EMBRACE, AND NOW MY WHOLE BODY IS TINGLING!"

## REFERENCE GALLERY | YURI BRIAR

● NORMAL CLOTHES

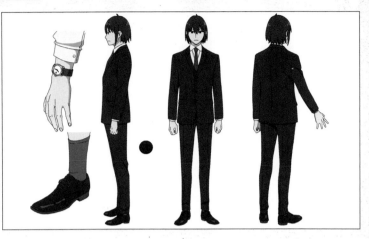

● SSS UNIFORM

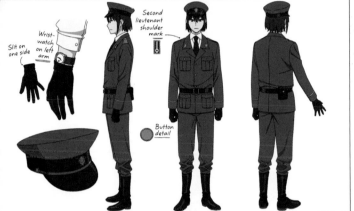

Slit on one side

Wrist-watch on left arm

Second lieutenant shoulder mark

Button detail

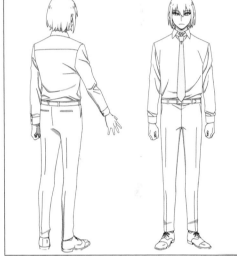

● DRESS SHIRT

● EXPRESSIONS

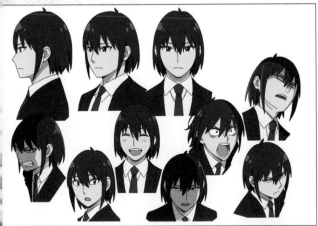

# SPY×FAMILY
### CHARACTER REPORT
### YURI BRIAR

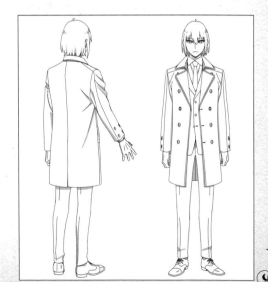

● COAT

VOICED BY UMEKA SHOJI

# CAMILLA

Camilla is one of Yor's coworkers at Berlint City Hall. Intensely competitive by nature, Camilla becomes jealous when Yor speaks to her boyfriend, Dominic, and has been known to mock her viciously.

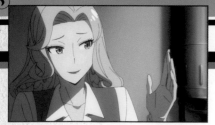

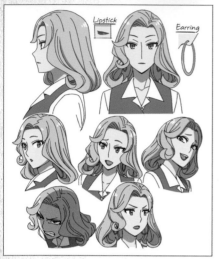

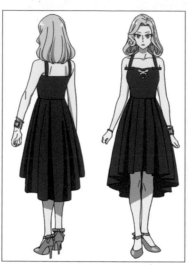

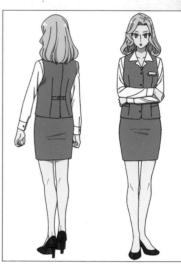

● EXPRESSIONS

● PARTY WEAR

● CITY HALL UNIFORM

VOICED BY SHOHEI KAJIKAWA

# DOMINIC

Dominic is Camilla's boyfriend and a fellow employee at Berlint City Hall. He has a friendly relationship with both Briar siblings and often informs Yuri about developments in Yor's life.

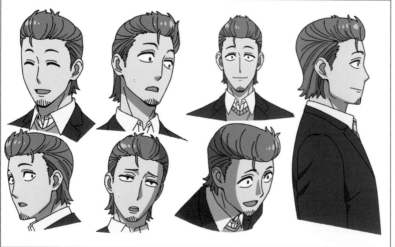

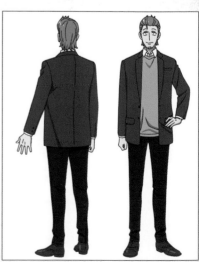

● EXPRESSIONS

● CASUAL WEAR

# MILLIE

Millie is another of Yor's coworkers at Berlint City Hall. She presents herself as bubbly and cheerful but blithely says cruel things at times. She is very attentive to fashion and knows a lot about makeup.

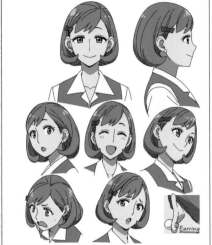

● EXPRESSIONS

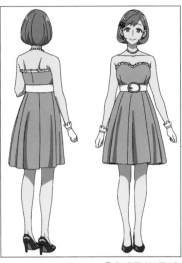

● PARTY WEAR

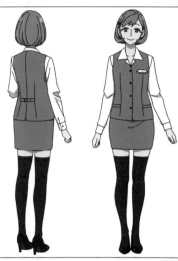

● CITY HALL UNIFORM

---

# SHARON

Sharon also works with Yor at Berlint City Hall, where she can often be found swapping idle gossip with Camilla and Millie. She has children, the oldest of whom is a student at Eden Academy.

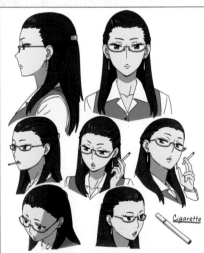

● EXPRESSIONS

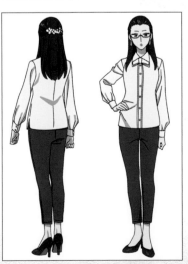

● PARTY WEAR

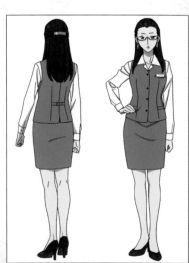

● CITY HALL UNIFORM

VOICED BY YASUYUKI KASE

# SSS LIEUTENANT

Yuri's State Security Service superior officer who engages in such cruelties as putting out cigarettes on suspects. Despite his cold demeanor, he looks after his young subordinate.

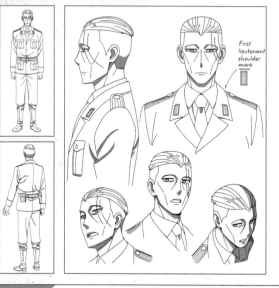

First lieutenant shoulder mark

VOICED BY EMIKO TAKEUCHI

# TAILOR SHOP OWNER

The owner of a tailo shop frequented by th Forgers. Her busines handles Eden Academ uniforms, and she hear a lot of the school's gossi

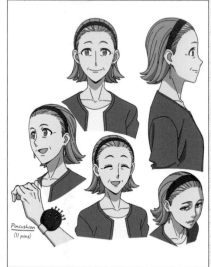

Pincushion (11 pins)

---

VOICED BY EMIKO TAKEUCHI

# BONDMAN

Bondman is the protagonist of Anya's favorite TV cartoon, *Spy Wars*. He is always engaging in grand heroics like rescuing his country's princess.

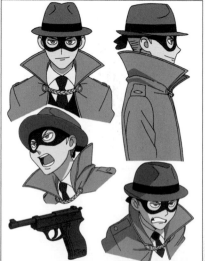

VOICED BY TAISUKE NAKANO

# DONOVAN DESMOND

Donovan is Damian's father and the head of Os tania's National Unity Party. He is the focus of Operation Strix as a potential threat to the peace between Ostania and Westalis.

DONOVAN DESMOND

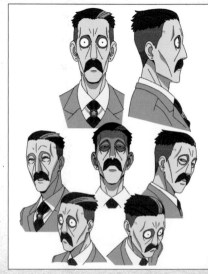

# SPY×FAMILY

→ THE OFFICIAL ANIME GUIDE ←
## MISSION REPORT: 220409-0625

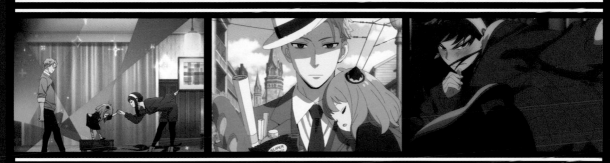

## FILE II
# STORY REPORT

In this section we look back on the 12 episodes that make up the first part of season 1, highlighting the characters and moments that bring each mission to life.

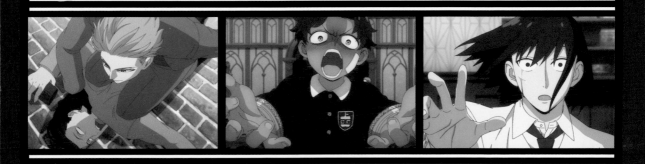

# ► MISSION: 1
# OPERATION STRIX

SPY × FAMILY
THE OFFICIAL ANIME GUIDE
TOP SECRET
STORY REPORT
MISSION REPORT: 220408-0625

• SCREENPLAY: TOMOMI KAWAGUCHI • STORYBOARDS/DIRECTOR: KAZUHIRO FURUHASHI • GENERAL ANIMATION DIRECTOR:
KAZUAKI SHIMADA • ANIMATION DIRECTORS: KYOJI ASANO & YUU MATSUO • ASSISTANT ANIMATION DIRECTOR: TAMAMI IZAWA

## "YOU EXPECT ME TO PRODUCE A CHILD WITHIN SEVEN DAYS?!"
—LOID

## A New Challenge for Westalis's Superspy Twilight

To complete his newest mission, Operation Strix, Twilight will need to assume the identity of psychiatrist Loid Forger, create a family, and get a child into the prestigious Eden Academy. He succeeds in adopting Anya to fill the daughter role—but is unaware that she's a telepath!

Twilight has infiltrated Ostania. Here we see him disguising himself as Edgar to steal secret documents.

Step one of Twilight's mission is acquiring a child that he can enroll at a prestigious private school—and he only has seven days to do it! The absurd timeline makes even the stone-faced Twilight lose his cool.

## HIGHLIGHT

### ● A Truce at the Center of an Information War

Until recently, the neighboring nations of Ostania and Westalis were at war with each other. At present, they are enjoying a truce and diplomatic relations, but the embers of war still smolder, and hostilities could resume at any time. Their conflicts now play out beneath the surface in a vigorous war of intelligence and counterintelligence.

Loid's mind reading "daughter," Anya, is in love with the drama and excitement of spying.

## "WHAT ARE YOU DOING?"
—LOID

## "HIDING." —ANYA

Anya reacts to the fear of an enemy attack that she reads in Loid's mind. To him, her behavior makes no sense.

Loid serves WISE, the Westalis intelligence agency, which sends spies to Ostania to prevent a resumption of war.

Anya repeatedly tries to follow Loid on an outing and keeps getting rebuffed. Are his actions just hide-and-seek to her?

## SUPPORTING CAST

### EDGAR
**Voiced by Atsushi Ono**

Edgar wants the war between Westalis and Ostania to resume. He hopes to blackmail a foreign minister using a photo of the minister wearing a toupee, but Twilight steals the picture.

### NGUYEN
**Voiced by Yuji Murai**

Edgar's short-haired, sharp-eyed henchman attacks Twilight at his home. Twilight then impersonates him to rescue Anya.

Anya's kidnapper Edgar is heartless enough to kill his own men in pursuit of his goals.

### Loid Reacts to Anya's Abduction

Loid returns home to find that Anya's been taken. Loid's duty is to prioritize his mission, but he ignores it to save her anyway. After being rescued, Anya heeds Loid's wishes and strives to pass Eden Academy's challenging entrance exam.

After posing as Nguyen to rescue Anya, Loid returns to the enemy base to finish off Edgar's gang. The intensity of his desire for world peace is palpable.

## "PAPA IS SUCH A COOL LIAR." —ANYA

On the way home, Loid announces that they're moving. Anya can see through his numerous lies but is delighted that they can keep living together.

## "TO CREATE A WORLD WHERE CHILDREN WON'T HAVE TO CRY... THAT'S WHY I BECAME A SPY."
—LOID

Anya memorized the answers in advance, but anxiety from reading the stress of the other test takers still brings her to tears.

When Loid finds Anya's number on the list of students who passed the test, the typically unemotional spy bursts into a smile and...collapses?!

Now that Anya has passed the test, Loid can finally relax. It's quite rare for him to sleep in the presence of others.

STORY REPORT
# ►MISSION: 2
## SECURE A WIFE

SCREENPLAY: RINO YAMAZAKI • STORYBOARDS: KAZUHIRO FURUHASHI • DIRECTOR: TAKAHIRO HARADA • GENERAL ANIMATION
DIRECTOR: KAZUAKI SHIMADA • ANIMATION DIRECTORS: KAZUAKI SHIMADA & RYUU MIURA

## "I'VE HEARD THAT A TRAITOROUS SCUMBAG IS STAYING HERE..."
—YOR

### A Prospective Wife in the Killer "Thorn Princess"

Loid is shocked to learn that both parents must be present for the Eden Academy admissions interview. When he meets Yor by chance at a tailor shop, he asks her to play the part of the wife. Little does he know that she's an assassin known as "Thorn Princess."

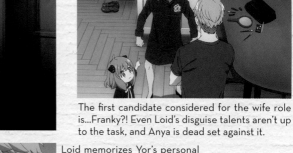

The first candidate considered for the wife role is...Franky?! Even Loid's disguise talents aren't up to the task, and Anya is dead set against it.

The woman who appears to be a ditzy city hall worker is actually an Ostanian assassin, able to march right into a luxury hotel and wipe out her target.

Loid memorizes Yor's personal information and considers her a good prospect, but he is wary of her keen instincts.

## HIGHLIGHT

### ● Anya's Quick Wit Connects Them

Loid and Yor both desire a partner but are extremely wary due to the nature of their jobs. Anya wishes to continue living with her "papa" and uses her telepathy to bring them together. It won't be the last time her quick wits strengthen the bonds of her family.

The threat of returning to the orphanage if she doesn't get into Eden Academy draws out Anya's inner actress.

## "I MUST AVOID THESE SO-CALLED MESSY LOVERS' QUARRELS." —YOR

Having read Yor's mind, Anya knows her fake mother is an assassin, but her desire for excitement overrides her shock at this revelation.

Loid agrees to attend Yor's work party. But at the same time, he's tasked with another urgent mission.

# SUPPORTING CAST

## MEMBERS OF THE SMUGGLING RING

Loid makes quick work of this criminal organization that steals art from Westalis to sell in Ostania. They have menacing faces but oddly adorable hats...

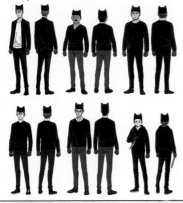

Franky assists Loid in a raid against smugglers. But in their haste, they're discovered by the enemy.

As Loid struggles with his mission, Yor waits for him in the cold, a lonesome trail of snot dripping from her nose.

## A Hasty Proposal That Serves Both Interests

Loid promises to accompany Yor to her party as her boyfriend but is delayed by challenges in his new mission. When he finally arrives, woozy from his wounds, he mistakenly introduces himself as Yor's husband. Afterward, as they repel pursuing enemies, they agree to marry for mutual gain.

Camilla and the others greet Yor at the party, then secretly mock her for arriving alone.

STORY REPORT • MISSION

01 ▼
02 ▼
03 ▼
04 ▼
05 ▼
06 ▼
07 ▼
08 ▼
09 ▼
10 ▼
11 ▼
12 ▼

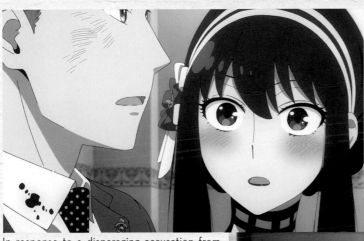

> ## "AND THAT'S SOMETHING TO BE VERY PROUD OF."
> —LOID

In response to a disparaging accusation from Camilla, Loid shows understanding and admiration for how Yor has overcome her past challenges. Yor is deeply moved by his support.

As they flee an enemy attack, Yor abruptly proposes marriage. Pretending to be Loid's wife will benefit her, too.

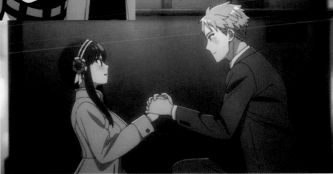

Having lost the diamond ring, Loid slips a grenade pin on Yor's finger. In the distance, smugglers are sent flying by the blast.

> ## "UNTIL MY MISSION..."
> ## "UNTIL MY KILLING..."
> ## "...DO US PART."
> —LOID & YOR

## STORY REPORT
# ►MISSION: 3
## PREPARE FOR THE INTERVIEW

SCREENPLAY: DAISHIROU TANIMURA • STORYBOARDS: KAZUHIRO FURUHASHI • DIRECTOR: TAKASHI KATAGIRI • GENERAL ANIMATION DIRECTOR: KYOJI ASANO • ANIMATION DIRECTORS: DAIKI FUJII & SHINYA YAMADA

## "ONE TIME I HUGGED HIM TOO HARD AND ENDED UP BREAKING TWO OF HIS RIBS. I MUST BE CAREFUL!"
—YOR

### Welcoming Yor with Interview Prep

Yor moves in and completes the Forger family for the admissions interview. Loid is worried about their readiness and decides to take them out as a family to create bonding experiences. But all three are on very different wavelengths...

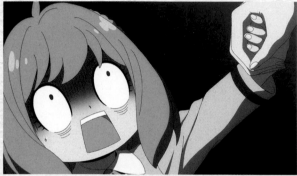

When Anya holds hands with Yor, she ends up fearing for her ribs!

Loid turns his attention to passing the interview. Playing the part of the interviewer, Loid is troubled by his family's responses.

The Forgers attend an opera, as the upper class does. Yor is baffled by it, and Anya falls asleep.

Anya panics when she realizes she's drawn Loid's and Yor's true identities at the museum's kids' corner.

The Forgers visit an art museum, as the upper class does. Yor is moved by a painting of a razor-sharp guillotine.

## "IF PAPA AND MAMA SEE THIS, THEY'LL FIND OUT ABOUT MY POWERS!"
—ANYA

## HIGHLIGHT

● **Anya's Assistance**

Anya is excited about her "mama's" impending arrival. She tries to assist Loid in cleaning up and making cookies but only manages to get in the way. Loid dryly rebuts her boasts about helping out.

Anya trips over a water bucket, making even more of a mess.

In the kitchen, Anya, covered in flour, sneaks samples.

## SUPPORTING CAST

### OLD WOMAN
**Voiced by Yuuko Sasaki**

When a mugger steals her purse (filled with money to buy a gift for her grandchild), the Forgers rush to her aid. She calls her heroes "a lovely family."

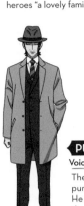

### PURSE SNATCHER
**Voiced by Takaaki Torashima**

The fiend who stole the purse is a skilled criminal. He changes clothes after the crime to throw off pursuers, but he's not skilled enough to elude Loid.

## "S'ALL GOOD, PAPA."
### —ANYA

Having read his mind, Anya tries to cheer Loid up.

Yor enjoys the scenery as they look down on the city from the park. Even Loid feels his anxiety ease a little.

### Family Bonding Over...a Mugging?!

Loid is dispirited about his mission's prospects for success. But while relaxing in a park, the trio witness a mugging. They work together to catch the thief, and Loid feels the first signs of them gelling as a family.

Yor runs straight to the crime scene. The elderly victim smiles kindly at her, appreciative of her concern.

Anya discovers the mugger by reading the minds of the people around her. She points Loid to him by feigning interest in the cake shop behind the purse snatcher.

## "A FILTHY SWINE LIKE YOU DESERVES NOTHING MORE THAN THE FOULEST MEAL." —LOID

A master of disguise like Loid isn't fooled by a change of clothes. He recognizes the culprit's gait and takes him down in spectacular fashion. But for a spy who's supposed to be inconspicuous, he's attracted a lot of attention.

Yor and Loid happily lock eyes at the elderly woman's words. Anya immediately accuses them of flirting.

STORY REPORT

# ►MISSION: 4
## THE PRESTIGIOUS SCHOOL'S INTERVIEW

SCREENPLAY: RINO YAMAZAKI • STORYBOARDS: TATSUYUKI NAGAI • DIRECTOR: KENTO MATSUI • GENERAL ANIMATION DIRECTOR: KAZUAKI SHIMADA • ANIMATION DIRECTORS: YUUYA UETAKE, SAORI YONEZAWA, MASAYA YASUTOME, RYUU MIURA & KAORI MURAI

## "THIS FEELING... THERE'S NO DOUBT ABOUT IT. I'VE EXPERIENCED THIS MANY TIMES BEFORE." —LOID

As a talented secret agent, Loid immediately recognizes he's being watched. His skilled assassin wife realizes it too.

### The Time Has Come. To the Interview!

When the Forgers arrive at the school, Loid senses they're being watched by examiners tasked with covertly grading the applicants and their parents. When the school's farm animals stampede, the Forgers avert the crisis and leave housemaster Henderson in frightened awe of their elegance.

The Eden Academy faculty are highly trained educators who take great pride in their school.

Anya reads the cow's mind and learns it was merely scared. Ignoring Loid's warnings, she kneels beside it and comforts it, creating an even more elegant end to their heroics!

Yor strikes pressure points to fell the lead bull. Fearful of the murderous glint in her eye, Loid, Anya, and the rest of the animals back away.

## "S'OKAY, PLEASE. DON'T BE SCARED." —ANYA

### SUPPORTING CAST

#### SCHOOL FARM ANIMALS

Eden Academy's livestock includes cows, pigs, and ostriches. The school's animal husbandry program seems incredible.

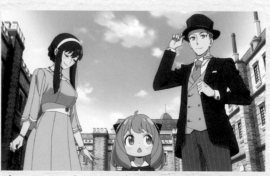

After stopping the stampede, the Forgers change clothes, leaving Henderson staggered at how well prepared they were.

## HIGHLIGHT

### ● Elegance in Action

To a history professor who deeply values tradition and formality, "elegance" is the most important quality one can possess. When Mr. Henderson observes an extraordinary level of elegance, he is profoundly moved.

After a rather inelegant scream, Henderson races to speak to the Forgers.

The dread trio of interviewers. Shielded by nepotism, Swan (in the center) is especially dangerous.

## Loid Loses His Cool at a Malicious Interviewer...

The Forgers face down Henderson and two interviewers. Due to their preparation, all is going well—that is, until a mean-spirited question brings Anya to tears. Despite his efforts to stay calm, Loid can't fully restrain his anger...

Yor's positive attitude and cheerful disposition helped Loid recover from the tragedy of losing his first wife. (Of course, this is all just a fiction created for the interview.)

## "MA...MA..." —ANYA

Swan demands to know if Anya prefers her current mother to her previous one. The question triggers a painful memory in Anya and sends tears streaming down her cheeks.

Even as Loid repeats "Restrain yourself," his fist rises toward Swan...

## "RIGHT NOW, JUST FOR A LITTLE BIT... TO OUR FAMILY'S BRIGHT FUTURE!" —LOID

After hearing Loid's words and reflecting on his own elegance, Henderson punches out Swan for the sake of his own pride.

Back home, Loid is mortified by his behavior at the interview, at least until Anya and Yor are able to cheer him up. The three make an optimistic toast to their future.

STORY REPORT

# MISSION: 5
## WILL THEY PASS OR FAIL?

SCREENPLAY: TOMOMI KAWAGUCHI • SCRIPT ASSISTANCE: AYUMI HISAO • STORYBOARDS: SHINSAKU SASAKI • DIRECTOR: KENJI TAKAHASHI • GENERAL ANIMATION DIRECTOR: KYOJI ASANO • ANIMATION DIRECTORS: TOSHIYUKI NANTOU, TAMAMI IZAWA, TATSUYA MURAKAMI, TATSUAKI OKAMOTO & CHIEKO MIYAGAWA

### Anya Passed! And Now for Her Reward...

When admissions are announced, Anya's number is nowhere to be found. Henderson stops the dejected family to inform them that Anya's at the top of the waiting list. The family celebrates, and Anya requests her reward...

A family in despair. Did their behavior at the interview doom them?!

## "ANYA GOT IN!"
—LOID

Moments after they hear the news, Franky appears to celebrate. Now that's an intel asset!

## "I WANNA PLAY 'SAVE ANYA FROM THE CASTLE'!"
—ANYA

Days later, they hear that a slot has opened for Anya, and Loid fires off the party popper he'd concealed in a pocket.

When Anya says she wants to experience her beloved *Spy Wars*, Loid doesn't know how to react to the unexpected request.

Twilight's talents will be put to the test in Anya's game of make-believe.

### SUPPORTING CAST

#### WISE OFFICER
Voiced by Miho Hino

This WISE official supports Twilight and has such faith in him that she agrees to grant requests others might find ridiculous.

#### WISE OFFICER
Voiced by Kazuya Saji

When this communications officer receives a request from Twilight, he immediately sends new orders to every agent operating in Ostania.

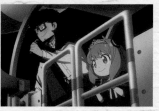

Princess Anya excitedly boards the gondola as a prisoner of Franky's villain character.

As the hero, Loid must wear a mask. Enduring embarrassment is part of the mission!

## Loidman Comes to Princess Anya's Rescue

Loid has mustered all of WISE's resources for a party at a castle. He plays the part of Loidman, tasked with rescuing Princess Anya from the evil Count Scruffy Head. His final challenge: defeating Yorticia to complete his mission.

The final showdown with Count Scruffy Head and his ominously long fingernails awaits! Can Loidman rescue Princess Anya?

At the end, the witch Yorticia stands in Loidman's way. Despite being a witch, she fights with physical attacks, and her incredible skills portend trouble for Loidman.

During the party's grand finale, colorful fireworks illuminate the night sky. Satisfied with her reward, Anya promises to work hard at Eden Academy.

## "ANYONE WHO TRIES TO KIDNAP MISS ANYA WILL NOT GET AWAY ALIVE!" —YOR

In the end, Loidman rescues Princess Anya. Anya is so moved by her papa's heroics that she forgets all about the storyline she made up.

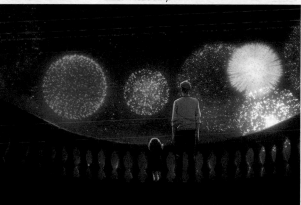

## "SO SPARKLY!" —ANYA

---

## HIGHLIGHT

### ● A Reasonably Priced Castle Rental

Newton Castle, the castle that appeared in *Spy Wars*, is a theme attraction with gondolas and slides to enjoy. You can rent out the whole thing for 35,000 dalc per night!

Experience thrilling spy action with a giant ball pool and guns that fire rubber balls!

Catering and furniture rental are not included.

STORY REPORT

# MISSION: 6

## THE FRIENDSHIP SCHEME

SCREENPLAY: DAISHIROU TANIMURA • STORYBOARDS/DIRECTOR: YOUSUKE YAMAMOTO • GENERAL ANIMATION DIRECTOR: AKIRA TAKADA • ANIMATION DIRECTORS: TOMOE AKUZAWA, YUUSUKE TANAKA, MYUNG HEE KIM, RYUU MIURA, HIROYO IZUMI, KAORI MURAI, KAORI ITO & YUUYA UETAKE

TOP SECRET

After learning from the tailor of the dangers Eden students face, Anya already wants to drop out.

While Anya is getting her uniform with Yor, Loid meets with his WISE handler.

### Perils Abound for Eden Students?!

Anya is beyond excited to get her Eden Academy uniform. Affluent Eden students are often targeted by criminals, however, and Anya is accosted by street punks. Thankfully, Yor fights them off. Anya is impressed by Yor's strength, and Yor gains more confidence in her role as a mother.

## "DO I LOOK CUTE IN MY UNIFORM?"
—ANYA

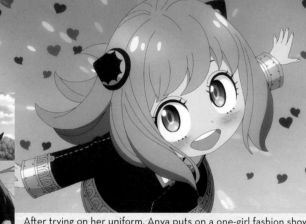

After trying on her uniform, Anya puts on a one-girl fashion show for everyone she sees. In her excitement, she insists on wearing the uniform home.

Yor answers a thug's attack with an adept strike that's powerful enough to smash a pumpkin!

## "I'M GOING TO DO EVERYTHING I CAN FOR HER." —YOR

After protecting Anya, Yor resolves to be the best mother she can for her foster daughter—in her own unique way.

### SUPPORTING CAST

#### TOWN HOOLIGANS

These four young delinquents spot Anya wearing an Eden Academy uniform and move in to abduct her. Yor knocks out the one in sunglasses with her shopping bag, and the other three flee in terror.

Anya is shocked to learn her papa has all but given up on her becoming an honors student.

## School Begins! And with It, the Friendship Scheme

On the day of the Eden Academy initiation, Anya discovers Loid has another plan for her: a so-called friendship scheme in which she is to befriend Damian, the son of Donovan Desmond, as a means of getting close to Loid's target. Anya tries her best but gets angered by Damian's bullying and punches him instead!

# "HEH." —ANYA

Initially, Anya follows Yor's advice to be mature and shrugs off Damian's insults with a smirk. But her peculiar expression only makes him angrier...

Furious at being mocked by Anya, Damian loses his cool and unleashes a flood of crude insults.

Anya packs a heck of a powerful punch! Is this surprising strength the result of her training with Yor?

Anya had hoped to excel but ended up earning a tonitrus bolt on the first day of school. Not a good sign.

As an excuse, Anya claims she got angry at Damian because of how he'd treated Becky. Becky believes her and is moved to tears.

## "SHE DID THAT FOR ME?!" —BECKY

---

## HIGHLIGHT

### ● Stella and Tonitrus Bolts

Stella stars and tonitrus bolts are the Eden version of merits and demerits, awarded to students for their achievements in scholarship and extracurricular activities (or lack thereof). Earning eight stella secures entrance into the Eden Academy Imperial Scholars honors program, which grants special privileges. The only thing eight tonitrus bolts will earn is an immediate expulsion!

The goal of Operation Strix is for Anya to earn eight stella. But for some reason, eight bolts feels more likely.

SCREENPLAY: TOMOMI KAWAGUCHI • STORYBOARDS: KAZUHIRO FURUHASHI • DIRECTOR: KAZUKI HORIGUCHI • GENERAL ANIMATION DIRECTOR: KYOJI ASANO • ANIMATION DIRECTORS: YUU MATSUO & IKUMI OKA • ASSISTANT ANIMATION DIRECTORS: TATSUAKI OKAMOTO & SHOUTAROU IMAI

Loid pushes Anya to apologize as her bus departs. Anya nods solemnly, but Loid's still worried—world peace could rest on her making amends!

## Mission: Apologize to Damian

To get plan B back on track, Anya is determined to apologize to Damian. Despite Becky's constant interference, Anya makes her apology. Damian doesn't react the way she expected, however...

Anya sees Damian as soon as she arrives, but Becky pulls her away.

## "I'M ON YOUR SIDE, ANYA! I'LL PROTECT YOU, NO MATTER WHAT!" —BECKY

Anya is depressed that her classmates are speaking ill of her, but Becky—her lone friend—cheers her up. Maybe school will be fun after all!

Loid hatches seve... humorous schem... to encourage An... to say sorry. Me... sages in trees a... notes stuck to a st... dent's back spur h... to action.

Anya finally manages to apologize. After being reduced to tears by the unspoken insults of Ewen and Emile, she comes off even more contrite than she'd intended.

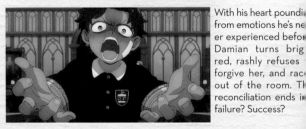

With his heart poundi... from emotions he's ne... er experienced befor... Damian turns brig... red, rashly refuses... forgive her, and rac... out of the room. Th... reconciliation ends i... failure? Success?

## "I JUST WANTED TO BE FRIENDS WITH YOU!"
—ANYA

## HIGHLIGHT

### ● The Variety of Insults Directed at Anya

Emile and Ewen have no shortage of harsh words for Anya. Though they never speak their insults aloud, Anya reads their minds and is brought to tears. The boys misinterpret her crying, but they are strangely affected by it.

Ewen commenting that her "lame hair things look like horns" brings a look of anguish to Anya's face.

Calling Anya a "raccoon-faced commoner" shows an impressive vocabulary for a first grader.

Caught between a mastermind dad and a mom who thinks of everything in terms of murder, Anya's brain is about to explode.

## Loid and Anya Battle Over Studying

Having lost faith in plan B, Loid begins tutoring Anya to improve her scholastic skills. But Anya reacts badly to his uncompromising attitude and flees to her room. But for the sake of her papa and world peace, she continues studying by herself.

Unlike her younger brother, Yor hated studying. Perhaps her brother's ambition and love of learning affected who she's become...

When Loid checks on Anya, he finds her asleep, but it's clear she's been studying. She may hate it, but she wants to get good grades for his sake. Loid's stone face cracks with a smile.

## "I WONDER WHAT IT'D FEEL LIKE TO HAVE A REAL FAMILY." —LOID

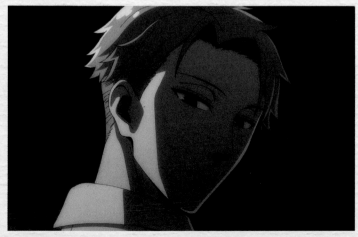

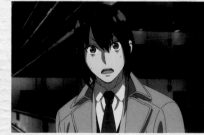

This young man can't hide his shock at learning that Yor got married. Meet Yuri Briar, Yor's younger brother!

Loid seems every bit the father as he tucks his daughter into bed. His expression remains composed, but he seems to be dealing with difficult thoughts about family.

01 ▼
02 ▼
03 ▼
04 ▼
05 ▼
06 ▼
07
08 ▼
09 ▼
10 ▼
11 ▼
12 ▼

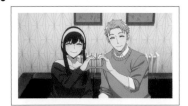

## STORY REPORT

# →MISSION: 8
# THE COUNTER-SECRET POLICE COVER OPERATION

SCREENPLAY: RINO YAMAZAKI • STORYBOARDS/DIRECTOR: YUKIKO IMAI • GENERAL ANIMATION DIRECTOR: KAZUAKI SHIMADA •
• ANIMATION DIRECTORS: MIKI TAKIHARA, YUI USHIO, SATOMI TAMURA & MIHO NAKATA • ASSISTANT ANIMATION DIRECTORS: •
YUUSUKE TANAKA, KAORI MURAI & HIROYO IZUMI

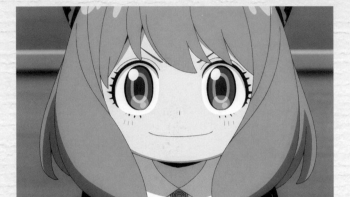

As Operation Strix now rests on Anya's academic performance, things are looking grim. Math is a particularly weak point for her.

A bead of cold sweat slides down Loid's brow as he makes his progress report. He usually shows no emotion, but he can't hide his anxiety this time.

## "I SEE...THAT YOUR ABILITY TO LIE HAS DIMINISHED."
### —SYLVIA

Yuri shows up with a bouquet of bright-red roses, which signal love in the language of flowers. The sheer quantity of them sends a message as well.

Loid and Yor blush at the lovey-dovey items they've left out to give the appearance they're a real couple. Are they at all ready for this?

### The Fake Newlyweds Prepare for Yuri's Visit

Despite making no progress toward earning stella stars, the Forger family has achieved some stability. But that peace is shaken when Yor's brother, Yuri, makes a surprise visit! Loid takes steps to conceal that he and Yor aren't a real couple.

# "THREE-THIRDS!"
## —ANYA

## HIGHLIGHT

● **Yuri's Secret Occupation**

After getting hired at the Ministry of Foreign Affairs, Yuri transferred to the State Security Service. Since this involves getting his hands dirty in the defense of his country, he hasn't told his sister.

Despite keeping secrets from each other, the Briar siblings have a strong relationship, and Yor is proud of her brother.

Yuri is far more cruel than his youthful demeanor suggests. He's highly regarded for doing whatever it takes to extract confessions from suspects.

## SUPPORTING CAST

### JIM HAYWARD
**Voiced by Shinya Takahashi**

Jim works in the finance department at city hall. Suspected of leaking documents, he is arrested by the SSS for espionage and interrogated by Yuri.

### SSS ENSIGN
**Voiced by Takaaki Torashima**

This secret police officer always accompanies the first lieutenant and seems to have earned his trust. He calls Yuri "a softy" and doubts his prowess.

Their first meeting begins with a handshake. Though placid on the surface, they are anything but calm inside.

### Will Yuri's Suspicions Expose the Forgers?!

Yuri and Loid may be all smiles, but neither lower their guard around the other. What appears to be a peaceful dinner is a battlefield of clashing objectives! As the evening continues, Loid realizes who Yuri truly is.

When Yuri asks why Yor never told him she got married, Yor fires off her "perfect excuse."

# "W-WELL...B-BECAUSE I COMPLETELY FORGOT!" —YOR

# "[YOUR HUSBAND] HAS TO BE SOMEONE WHO COULD PROTECT YOU EVEN BETTER THAN ME!" —YURI

After jumping to the conclusion that Yor calls Loid "Loidy," Yuri becomes jealous of their intimacy and downs his wine.

Yuri wholeheartedly loves his sister and strives to protect her. He resents Loid, feeling his presence negates all his years of hard work.

Loid realizes that Yuri works for the secret police. He raises his guard and plots to exploit Yuri for information.

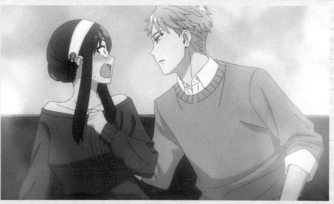

Suspicious of their relationship, Yuri demands that the couple kiss. Loid quickly moves to comply, while Yor blushes bright red.

01 ▼
02 ▼
03 ▼
04 ▼
05 ▼
06 ▼
07 ▼
08 ▼
09 ▼
10 ▼
11 ▼
12 ▼

# ►MISSION: 9

## SHOW OFF HOW IN LOVE YOU ARE

SCREENPLAY: HONOKA KATOU • STORYBOARDS/DIRECTOR: TAKASHI KATAGIRI • GENERAL ANIMATION DIRECTOR: KYOJI ASANO • ANIMATION DIRECTORS: YUMI SHIMOJOU, TAMAMI IZAWA & CHIEKO MIYAGAWA

### A Mission of Ostentatious Love

Yor moves in to kiss Loid as a show of their love. When Yuri rushes to stop them, he ends up getting mistakenly slapped away by a drunken Yor, bringing the chaotic dinner party to an end.

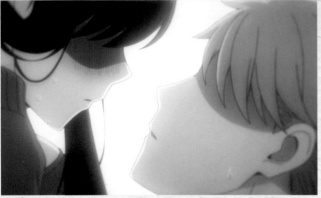

Her inhibitions dampened by alcohol, Yor pushes Loid down and moves her lips close to his... Mission accomplished?

The prospect of anot[her] man's lips touching [his] beloved sister ma[kes] Yuri weep and recal[l his] childhood with Yor.

## "I JUST CAN'T!" —YOR

Yor tries to slap Loid, but Yuri rushes in to stop them and takes a direct hit. It's powerful enough to send a grown man flying!

A drunken Yor an[d] a bleeding Yuri kee[p] each other fro[m] falling, providing [a] glimpse at the dee[p] bond they share.

Loid promises Yu[ri] that he'll try to mak[e] Yor happy as the sib[lings] stare on, eac[h] affected by his word[s.]

## "LET'S DO EVERYTHING WE CAN TO MAKE SURE YOR IS HAPPY." —LOID

### HIGHLIGHT

● **The Ties That Bind the Briars**

Yuri dotes on his older sister and has made her happiness a personal goal. As his only surviving relative, Yor raised him in place of their parents, and Yuri's deep affection for her is what drives him. The bonds they forged in childhood remain strong today.

Yuri proudly shows his perfect school test results to Yor. He's been an exceptional student since he was little.

Yor gives Yuri a peck on the cheek as a reward. That intensifies his love, and he even declares he'll marry her.

## SUPPORTING CAST

### SECOND LIEUTENANT MOP (FRANKY)
**Voiced by Hiroyuki Yoshino**

Second Lieutenant Mop of the secret police is, of course, Franky in disguise. He seems to particularly enjoy the character and really brings his performance to life.

### CHIEF BURNS
**Voiced by Masafumi Kobatake**

Chief Burns is one of Yor's superiors at city hall. He's unpopular with the women on his staff and a frequent target of workplace gossip.

Having read Loid's doubts about Yor, Anya almost speaks up to defend her but complains about her cooking instead.

### Wiping Away His Doubts About Yor

Now that he knows her brother is in the secret police, Loid views Yor with suspicion. Meanwhile, Yor is depressed about her failings as a wife. After bugging and interrogating her, Loid's doubts are eased. Anya smiles to see her fake parents being more open around each other.

Loid hesitates before he sticks a listening device onto Yor's collar. With world peace at stake, Loid won't fully trust anyone.

## "MAMA AND PAPA NEED TO GET ALONG."
—ANYA

Loid poses as a secret police officer and puts Yor in a situation she could easily get out of if she knew Yuri was in the SSS.

That children sometimes say startling things seems to be as true in fake families as in real ones.

Yor stands firm, showing both her innocence and how far she'd go to protect her family. Loid is convinced and abandons his suspicions.

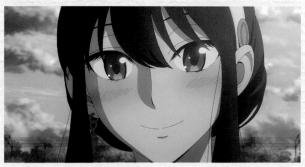

Loid tries to cheer up a downcast Yor. Unaware of what he's done, Yor responds with a pure, guileless smile.

## "I'M TRULY GRATEFUL THAT I MARRIED YOU, LOID." —YOR

STORY REPORT • MISSION

01 ▼
02 ▼
03 ▼
04 ▼
05 ▼
06 ▼
07 ▼
08 ▼
09
10 ▼
11 ▼
12 ▼

## STORY REPORT

# ▶MISSION: 10
# THE GREAT DODGEBALL PLAN

SCREENPLAY: DAISHIROU TANIMURA • STORYBOARDS/DIRECTOR: KENJI TAKAHASHI • GENERAL ANIMATION DIRECTOR: KYOJI ASANO • ANIMATION DIRECTORS: YUMI SHIMOJOU, TAMAMI IZAWA, CHIEKO MIYAGAWA, TATSUYA MURAKAMI & TOSHIYUKI NANTOU

Henderson's morning routine is as refined as you would expect for someone who strives to teach his students elegance.

### Training for a Stellar Opportunity

A rumor spreads that the MVP of an interclass dodgeball match will be awarded a stella. Anya, who strives to become an Imperial Scholar, begins a special dodgeball training regimen in hopes of claiming the star.

## "I'LL SHOW YOU A KILLER MOVE THAT WILL HELP YOU CATCH THAT STAR!" —YOR

Eager to help Loid with his mission, Anya aims for the stella!

## "ANYA WILL CATCH THE STAR!"
## —ANYA

Yor takes it upon herself to train Anya and teach her a "killer move." Will Anya be able to keep up with her tough training regimen?

Damian is also determined to win MVP. With the help of his friends, he fights tirelessly for victory.

Having endured Yor's strict training, the glint of that stella is in Anya's eyes!

---

## HIGHLIGHT

### ● The Individual Training Regimens

With a stella in their sights, Anya and her fellow students begin special dodgeball-focused training routines. Whether they want to boost their core strength or learn flashy new moves, there's a regimen for that!

Anya's rigorous muscle-building routine involves running, pitching, visualization exercises, and even waterfall meditation.

Damian engages in strict training as well, practicing everything from cliff climbing to distraction techniques.

## SUPPORTING CAST

### BILL'S DAD
Voiced by Hiroki Yasumoto

Bill Watkins's father is a major in the National Army, and he has high expectations for his son. He hopes to see Bill become the hero of Eden Academy and one day of Ostania itself.

## Bazooka Bill Stands in Their Way

The dodgeball match has begun. Damian and his friends are eager to show off the fruits of their training, but Bill from the opposing team is a brutally tough competitor. In the end, Anya unleashes the killer shot Yor taught her!

Becky and her classmates are in tears with fear over the power of Bill's throws. Each of his shots can eliminate multiple students!!

### "OH, THAT WASN'T A FLUKE." —BILL

By reading Bill's mind, Anya can elegantly dodge his shots!

With his advanced physical development and a blazing fastball, Bill single-handedly keeps Anya's team in check. He has great confidence in his abilities and acts as if his victory is inevitable.

To avenge Damian and the rest of her fallen teammates, Anya recalls her lessons from Yor. It's time to unleash the killer move she learned at the end of her training: Star Catch Arrow!

When Anya stumbles in the middle of the game, Damian protects her by sacrificing himself to block the ball!

When Anya's shot misfires, Damian and his friends can only watch dumbfounded as their class is quickly eliminated.

### "NOW IS THE TIME TO UNLEASH MY KILLER SHOT!" —ANYA

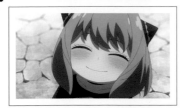

# ►MISSION: 11
## STELLA

**SCREENPLAY: RINO YAMAZAKI • STORYBOARDS/DIRECTOR: TOSHIFUMI AKAI • GENERAL ANIMATION DIRECTOR: AKIRA TAKADA • ANIMATION DIRECTORS: SATOSHI YAMAGUCHI, YUUYA UETAKE, SAORI YONEZAWA & MASAFUMI TAYORI**

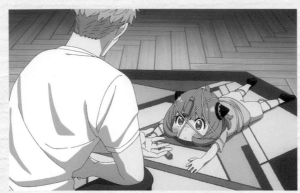

Since Anya's study skills are poor, Loid has her attempt arts, music, and sports, only to watch her fail at each. At least her enthusiasm never wanes.

### Anya's Brave Win for Operation Strix

Losing hope that Anya will earn a stella star for academics or athletics, Loid takes Anya to volunteer at the hospital. There, she saves the life of a drowning boy, earning a stella in a spectacular fashion.

## "NOW UNTIE ME."
### —ANYA

Anya is so bad at volunteering that even the nurses have had enough.

Anya dives into the pool to save a drowning boy. In the nick of time, Loid saves them both.

For saving a life, Anya is awarded her first stella of the year. Her face glows with confidence!

Loid smiles after Anya earns her stella, and it's clearly about more than just his mission's success.

---

## SUPPORTING CAST

### POOL INSTRUCTOR
**Voiced by Marie Ooi**

This instructor is helping Ken with his physical rehab. When she looks away for a moment, Ken falls into the pool, and she doesn't notice until Anya comes racing over.

### KEN
**Voiced by Arisa Kiyoto**

Ken has hurt his leg but is scared to begin his recovery. While his instructor is away, he slips and falls into the pool.

## "IT'S SIMILAR TO HOW I FEEL WHEN I'VE THWARTED A TERRORIST ATTACK. I'M SO PROUD OF HER." —LO

## Anya Wants a Dog for Plan B's Sake

Anya's grown haughty after earning a stella, even insisting that Becky call her "Starlight Anya." When asked what she wants as a reward, she decides it's a dog! For the sake of world peace, of course.

Anya proudly wears her stella and forces Becky to use her new nickname.

### HIGHLIGHT

#### ● The Second-Son Friendship Scheme

Anya has revised her incredible, infallible plan for world peace. Now all she needs is to get a dog as her reward!

Damian will surely invite Anya to his house so their dogs can play together. Surely!

When Loid and Damian's dad talk, war will end and peace will reign. Surely!

## "CALL ME 'STARLIGHT ANYA.'" —ANYA

Damian defends Anya when her classmates accuse her of cheating her way to a stella star. At the same time, it galls him that she beat him to it.

## "THE FACT THAT SHE DIDN'T CHEAT IS WHY I'M SO MAD THAT THIS LITTLE SHRIMP GOT AHEAD OF ME."
—DAMIAN

Becky has received some unusual presents as rewards, including a warplane and a tank. It's nice to be the daughter of a military contractor!

When Anya says she wants a dog, Yor explains that pets are a big responsibility even when world peace isn't on the line.

The dogs Loid and Yor visualize are violent and brawny and not cute at all! Brought nearly to tears, Anya requests a small dog, and the Forgers agree to go to a pet shop as a family the following week. Anya smiles as she imagines the dogs she'll meet there.

# ►MISSION: 12
## PENGUIN PARK

SPY × FAMILY
THE OFFICIAL ANIME GUIDE
TOP SECRET
STORY REPORT
MISSION REPORT: 2204195-8825

SCREENPLAY: DAISHIROU TANIMURA • STORYBOARDS: TOMOYA KITAGAWA & DAIKI HARASHINA • DIRECTOR: TOMOYA KITAGAWA •
GENERAL ANIMATION DIRECTOR: KAZUAKI SHIMADA • ANIMATION DIRECTOR: DAIKI HARASHINA

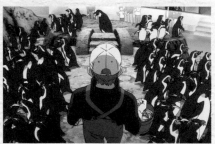

### A Mission of Performative Normalcy

Having learned that his neighbors are gossiping about his frequent absences, Loid decides to take his family to the aquarium. Once there, he must play the part of the perfect husband and father, even as he becomes embroiled in a mission to retrieve information stolen by terrorists.

Yet another new mission awaits Loid on the way to the aquarium.

Loid is exhausted from having to complete additional daily missions on top of Operation Strix. His face shows his lack of vigor.

Loid plays the part of a new employee, stunning everyone with his incredible competence.

## "SO MANY FISHIES!" —ANYA

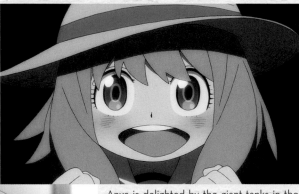

Anya is delighted by the giant tanks in the aquarium. She races through the building without stopping.

Believing Anya has been kidnapped, Yor launches an enemy agent into the ceiling with a powerful kick, inadvertently helping Loid complete his mission.

His new mission complete, Loid staggers back to his family. Once he sees their smiling faces, he rededicates himself to his goal of world peace.

## "MAINTAINING A WORLD WHERE CHILDREN DON'T CRY, A WORLD WITH NO WAR... THAT IS MY DUTY." —LOID

## SUPPORTING CAST

### ROOKIE CARETAKER
Voiced by Takaaki Torashima

A new employee at the aquarium. Loid steals his identity. His success in his role gets him promoted to chief caretaker.

### CHIEF CARETAKER
Voiced by Motoki Sakuma

The aquarium's chief caretaker can tell every penguin apart, although he does make mistakes sometimes.

### PARLES

Terrorists force-fed this penguin a capsule containing instructions on how to make a new type of biological weapon and smuggled him into the country.

### RIVAL AGENT
Voiced by Katsunori Okai

This enemy plans to retrieve the capsule. He's posing as a college professor, but Loid discerns his true identity.

### A New Recruit to Spy Agency P-2

Anya plays at being spies with the new stuffed penguin she receives from Loid. Loid gets upset when she breaks a house rule. Anya bursts into tears and even threatens to quit school! Loid and Yor work hard to turn her mood around.

Anya performs a ritual that involves splitting a peanut to welcome a new spy into her secret agency, P-2.

## "PAPA AND MAMA, I HATE YOU BOTH. ANYA'S GONNA RUN AWAY FROM HOME!"
—ANYA

To calm the bawling Anya, Loid and Yor join her spy game. They even do the voices!

Anya gets yelled at for trying to enter Loid's room. Her parents' rooms are full of dangers!

## "A SPY MUST NOT STAND OUT..."
—LOID

Loid and Yor follow Anya outside, still playing her spy game. It draws more attention than a certain spy would like.

01
02
03
04
05
06
07
08
09
10
11
12

# Forger Family
## PROGRESS
# INTERIM REPORT

WE PRESENT OUR REPORT ON THE OBSERVABLE STATE OF THE FORGER FAMILY AS OF THE END OF THE FIRST PART, ALONG WITH TWILIGHT'S COMMENTS.

## ITEM 1 ◎ POSING AS A FAMILY

### ● INTERNAL FAMILY COHESION ●

It took time for the family to gel, but they've built trust through their interactions.

As skilled an agent as Twilight is, "family" is well outside his area of expertise. Loid is at times bewildered by Yor's strange behavior, Anya's inability to read his signals, and normal familial emotional distancing. This has begun to change as the family spends more time together.

After learning Yuri's true identity, Loid began to suspect Yor, going so far as to question her in disguise.

Yor helps Anya train. Anya trusts in her mother's strength, and it brings Yor joy to be able to help her.

### ● REPUTATION AMONG OTHERS ●

Despite some suspicion from neighbors, the Forgers are generally highly regarded.

The amount of time Loid has spent on other spy missions cut into his family time, leading neighbors to question the strength of the Forgers' relationships. A show of fatherly behavior during a trip to the aquarium helped, but a reduction of his work responsibilities is also needed.

The three Forgers cooperated to catch a purse snatcher and were thanked by the victim. Loid was observed being uncharacteristically bashful.

Yor's younger brother, Yuri, works for the SSS. He does not yet suspect the Forgers' marriage to be fraudulent, but he should continue to be monitored.

### ● OVERCOMING OBSTACLES AS A FAMILY ●

The family has surmounted the Eden Academy admissions interview and a visit from Yuri.

The Forgers have attended various events together, including the Eden Academy admissions interview, a celebratory party at a castle, and a trip to the aquarium. Challenges associated with these events have seemingly built higher levels of trust between them.

During the interview Anya was questioned aggressively and Yor and Loid showed enraged reactions characteristic of an authentic family.

Yor attempts to kiss Loid to demonstrate their marital love to Yuri. The kiss was not completed, but the deception was successful.

"Even the slightest suspicion from those around us can be detrimental. A threat to our family is a threat to the world!"

# ITEM 2 ◎ OPERATION STRIX

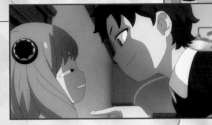

Eden admission and family creation: successful. One stella (and one tonitrus bolt) achieved. Plan B status: uncertain.

Anya has recovered from earning a tonitrus bolt on the first day of school by becoming the first student in her class to earn a stella. She has also made friends and is enjoying her life at Eden. A poor relationship with key figure Damian is a cause for concern, however.

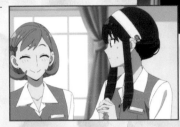

Despite being unable to swim, Anya leapt into a pool to save a drowning child. Even Loid has openly praised her courage.

Anya and Damian quarrel regularly. Outside support may be necessary to salvage their relationship.

 "Plan B hasn't...*completely* fallen apart, but we need to boost plan A's chances of success as much as possible."

# ITEM 3 ◎ INDIVIDUAL MEMBER ISSUES

Anya: Must improve as a student to become an Imperial Scholar.
Yor: Can she effectively act as a mundane wife and mother?

Eden Academy prioritizes normalcy. It is essential that Anya be capable of responsible student behavior. It would also be desirable for Yor's behavior and homemaking skills to rise to a level where they do not attract suspicion.

Yor has at times been mocked by her city hall coworkers, but her relationship with them has changed since she married Loid.

Incentives, such as the castle rental, should be periodically applied to maintain Anya's motivation to study.

 "Our success hinges on Anya's schoolwork and Yor's ability to be a convincing wife. If we don't strive for improvement..."

# ITEM 4 ◎ FUTURE CAUSES FOR CONCERN

Anya's relationships with classmates, Yuri's behavior, the pet issue, etc.

These two made a terrible first impression. We hope to see an improvement in their relationship.

First, it is essential that the relationship with Damian deepen to advance the friendship scheme. A pet could possibly present a solution. Secondly, the entire operation depends on the Forgers being perceived as a good, normal family.

Ascertaining the threat level of Yuri, who views Loid with hostility, remains a pressing issue.

 "Maintaining a world without war is my duty. I am aware that we cannot afford to stand still. That said, a little time off—"

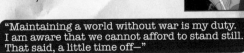 "Earning a single stella is not sufficient cause for optimism. Work yourself to the bone to advance your mission objectives, Twilight!"

Damian's family owns a dog. If the Forgers had a pet, could that serve as a pretext for a home visit?

# OPENING
## ANIMATION GALLERY

STORYBOARD/DIRECTION: MASASHI ISHIHAMA
ANIMATION DIRECTOR: KYOJI ASANO
OPENING THEME: "MIXED NUTS" BY OFFICIAL HIGE DANDISM

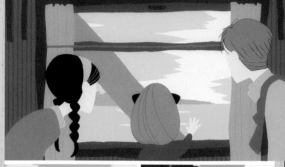

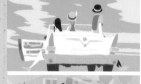

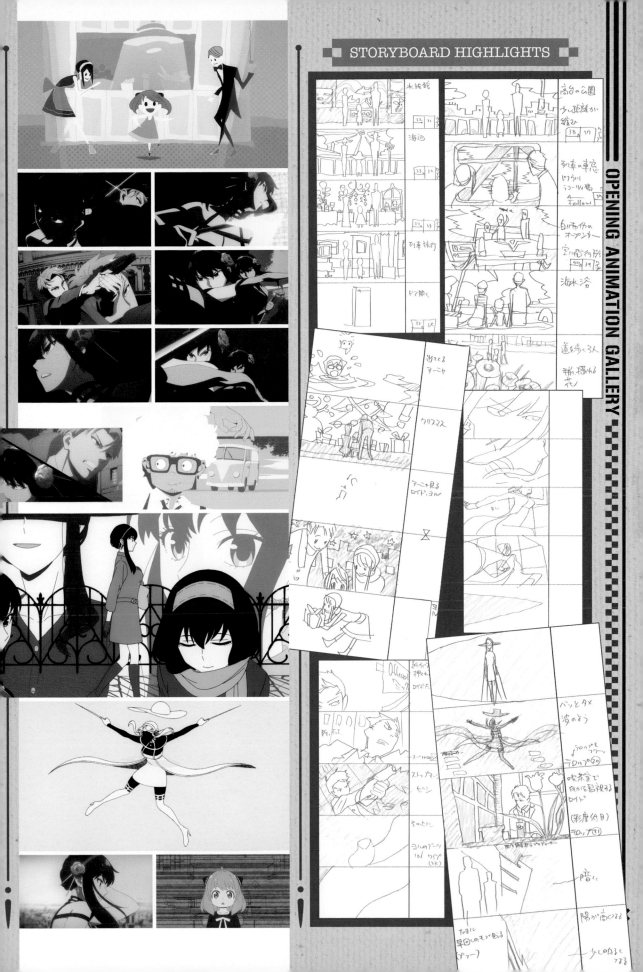

# ENDING
## ANIMATION GALLERY

STORYBOARD/DIRECTION: ATSUSHI NISHIGORI
ANIMATION DIRECTOR: KAZUAKI SHIMADA
ENDING THEME: "KIGEKI" BY GEN HOSHINO

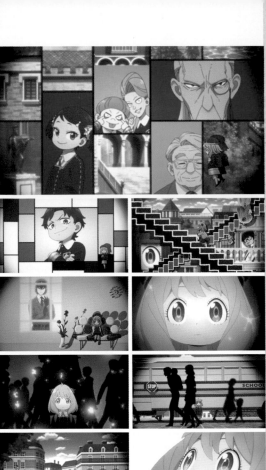

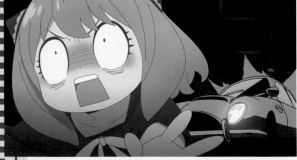

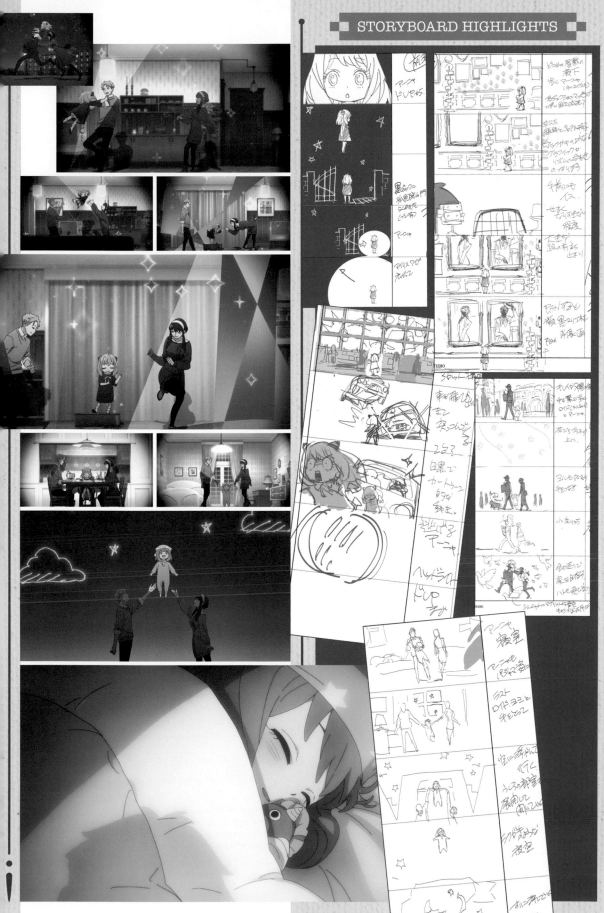

# Theme Song Artist Interviews

## OPENING THEME: "MIXED NUTS"

# OFFICIAL HIGE DANDISM

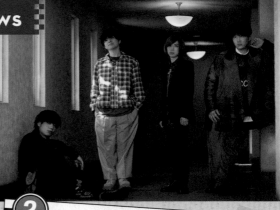

**1 Please tell us about the significance of the song title.**

Anya loves peanuts, and I thought that was cool and restrained for a kid. I started thinking about how there are peanuts in mixed nuts. However, peanuts are the only nut that grows underground, and while they look like nuts that grow on trees, botanically they're classified as a completely different thing.

That's the theme to this work—concealing one's identity while pretending to be part of a fake family. In *Spy x Family* they face challenges the way a real family would, which raises the question, "If you're happy, does it really matter whether the family is real or not?" That's what I was thinking about as I made this song.

**2 What inspired the lyrics and composition of the song?**

Loid, Anya, and Yor each have these incredible abilities and very cool qualities to them. But as a family, there's a sense, either clearly or vaguely, that they're each missing something. I wrote the song thinking it would be cool to try to capture that juxtaposition in the composition.

Even though they function as a family, I don't think they could really live together without hiding their secrets from each other. But I think that's okay. There are all sorts of different families in the world, and I wanted to celebrate that in the song's lyrics.

**3 There are so many words and phrases in the lyrics that are evocative of the show. Do you have a favorite?**

"*I ga motareteyuku*," meaning something like, "My stomach begins to churn." I myself do not have a strong stomach and frequently have stomach problems. This lyric is based on the coffee-loving Loid from the manga putting milk in his coffee to protect his stomach—and the idea of him living his life with all this stress. I felt the lyric really synced up well with the visuals of the rich foods and the musical composition in that segment. I like that part a lot.

**4 What was your reaction when you saw the completed anime opening for the first time**

The mix of coolness and fanciness in the animation left m thinking that the visuals really meshed well with what we the band had wanted to do with the music. I was really hap that the opening animation drew attention to some of the n things we were trying to do with the song.

**5 Do you have any favorite scenes or characters from the anime?**

During the interview in Mission 4, when Anya is asked whether she prefers her current mom (Yor) or her real mom, she starts crying from the cruelty of the question, and Loid and Yor both become enraged. Twilight knows he has to keep his cool, but you get a glimpse of how much they've all begun to value their family. That scene really resonated with me.

**6 What has been the reaction from your fans to the release of "Mixed Nuts"?**

We debuted the song at the final performance of our tour for our last album, *Editorial*. Even then our fans seemed to respond to it strongly, and we could really feel the power lurking in that track. I remember thinking we might have a mainstream hit with that one.

**7 Do you feel you've expanded the band's creative horizons as a result of making that song?**

It reminded me that this is a band that's capable of performing such a difficult co position. We went into it thinking it might not be doable, but everyone perform well beyond what I'd hoped for. That's given me confidence that the next time want to create a really elaborate arrangement, we'll probably be able to pull it off. A of course, I was very happy that the listeners responded so positively to a song w been that passionate about making.

## PROFILE

Official Hige Dandism formed in 2012 and is known by its fans as "Higedan." *Hige* means beard, and the band was named after their ethos that even once they're old enough to have respectable beards, they want to keep producing exciting music for the world.

They released their debut EP *Love and Peace Are Inside You* in April 2015. They made their major label debut with the single "No Doubt," and their major label album debut with *Editorial* in 2021, in support of which they launched their largest-ever arena tour. With roots in a variety of genres but especially African American music, their music continues to draw fans from among all generations.

**8 Do you have a final message for your fans?**

As a fan of the manga, I was thrilled to be able to write this song. I didn't want to let down all of the *Spy x Family* fans, and at first I had a lot of anxiety about that, but it ended up being such a great honor to be part of such an incredible anime. It brings me so much joy to know that there are so many people who are enjoying listening to it, whether it's as fans of the anime or as fans of our band.

BOTH ARTISTS WROTE THEME SONGS THAT MESH BEAUTIFULLY WITH THE SETTING OF *SPY x FAMILY* AND HELP BRING THE SERIES TO LIFE. WE ASKED ABOUT THE DEEPER MEANING OF EACH SONG.

## ENDING THEME: "KIGEKI"

# GEN HOSHINO

**1** Please tell us about the significance of the song title.

One of the main things I like about *Spy x Family* is that it's a comedy. The word *kigeki* means "comedy," but it doesn't just means jokes. It also has a sense of "subverting tragedy into humor, because life is inherently tragic." That sense of *kigeki* is a perfect match to the world and music that I like to express, as well as a perfect match for *Spy x Family*, so I chose it as the title.

**2** What inspired the lyrics and composition of the song?

I based the BPM of the song on the image of Anya walking while holding hands and then composed the song around that. As for the lyrics, my image of family and the image of family presented in *Spy x Family* have a lot of points in common, and that's where I got inspiration for the lyrics.

**3** There are so many words and phrases in the lyrics that are evocative of the show. Do you have a favorite?

I like the lyric "*chi ni masaru mono, kokorotachi no keiyaku wo*," which means that the vows made from one heart to another can be stronger than the bonds of blood.

**4** What was your reaction when you saw the completed anime ending for the first time?

I was moved. I was surprised at how perfectly they'd captured what they were going for, and I was very impressed with the richness of the animation and the level of detail used to capture the essence of *Spy x Family*'s world.

**5** Do you have any favorite scenes or characters from the anime?

I love all the characters, of course, but Mr. Yamaji's performance as Henry Henderson when he says "elegant" is so flawless I couldn't stop laughing. I'll never forget that.

**6** What has been the reaction from your fans to the release of "Kigeki"?

I was very happy that they immediately supported the song's message and groove.

**7** Do you feel you've expanded the band's creative horizons as a result of making that song?

Even now, the comments section of the song's YouTube video has notes written in a great many languages from all over the world. I was really delighted by that. Seeing so many people responding to the song's message makes me see how music can overcome cultural differences.

**8** Do you have a final message for your fans?

Thank you so much for enjoying my song "Kigeki." I truly hope it can remain a part of the background music of the Forger family's story and endure forever.

### PROFILE

Gen Hoshino is a musician, actor, and writer who was born in Saitama Prefecture in 1981. He made his solo debut album in 2010 with *Stupid Songs*. His 2016 single "Koi" became a phenomenon as the theme song for the TV drama *The Full-Time Wife Escapist*, which he also starred in. The song "Strange" from his 2021 single *Strange/Creation* hit number one on Japan's Hot 100 chart from Billboard Japan, and his song, "I Wanna Be Your Ghost (feat. Ghosts)," has also been well received. As an actor, he has appeared in numerous films and TV series, and has won several acting awards, including the Newcomer of the Year award from Japan's 37th Academy Awards.

**A NEW THREAT ENDANGERS PEACE BETWEEN EAST AND WEST!**

# NEXT MISSION

# STOP THE TERRORIST BOMBERS!

Thanks to the efforts of the Forger family, Operation Strix has shown solid progress. But when a new crisis erupts, WISE must step in to preserve world peace. What is this new mission that they've given Loid?

## "I'VE HAD ENOUGH OF WAR." —LOID

## "THAT WAY, DOGGY. WE NEED TO STOP IT!" —ANYA

## "YOU WON'T GET AWAY WITH IT, MR. PERVERTED KIDNAPPER!" —YOR

"LET'S END THIS." —LOID

NEW CHARACTER

## BOND

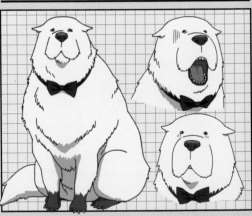

Bond is a large-breed dog being held captive by a terrorist organization. His white fur and gentle eyes are his most prominent characteristics. He was raised in terrible conditions, but for what purpose? And what part does he have to play in the future?

# SPY×FAMILY

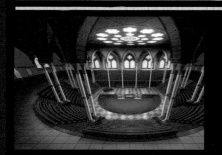

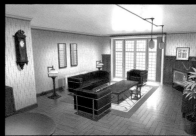

## FILE Ⅲ

# SETTING & PROP REPORT

In this section we highlight the background art and props used in the first part of *Spy x Family*. These illustrate the world and mood in the primary setting of Ostania, as well as the country's unique mix of high culture and cold war oppression.

# ART BOARDS & BACKGROUNDS

This is some of the background artwork that helps establish *Spy x Family*'s setting, depicting everything from main locations in the Forger home and at Eden Academy to episode-specific locales. The architecture and furniture design help establish the series' unique visual style.

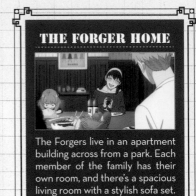

## THE FORGER HOME

The Forgers live in an apartment building across from a park. Each member of the family has their own room, and there's a spacious living room with a stylish sofa set.

**• LIVING ROOM**

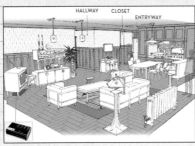

HALLWAY    CLOSET    ENTRYWAY

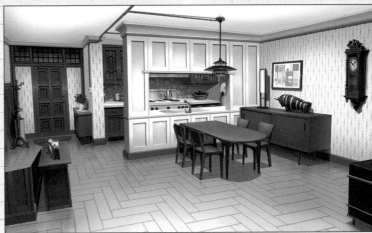

**• KITCHEN**

**• HALLWAY**

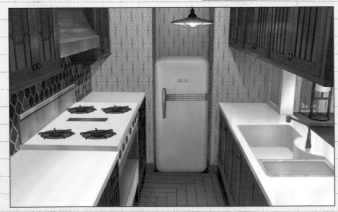

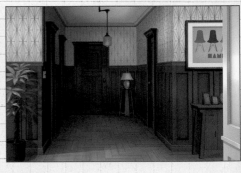

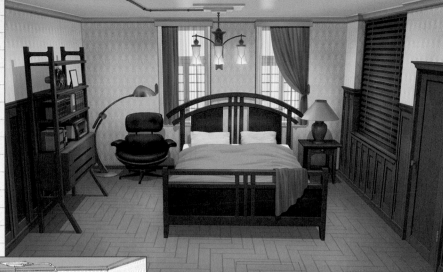

• LOID'S ROOM

• ANYA'S ROOM

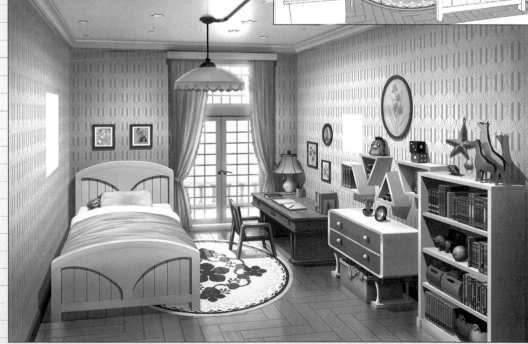

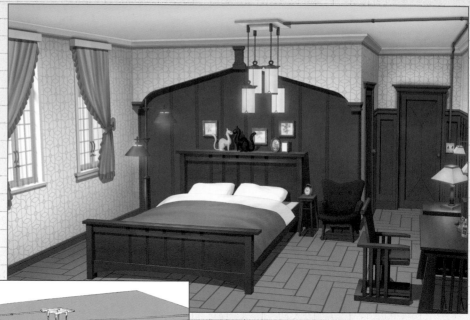

•YOR'S ROOM

•CORNER ROOM

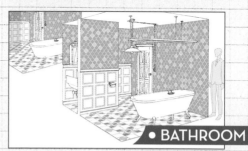

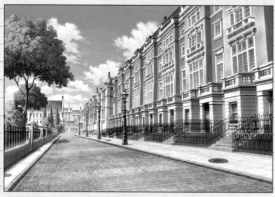

•EXTERIOR VIEW

•BATHROOM

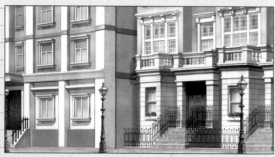

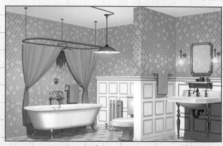

## THE PREVIOUS FORGER HOME

Loid rents his first apartment in Berlint with his future family in mind, but they have to move in a hurry after Anya's mischief alerts Edgar to its location.

**● LIVING ROOM**

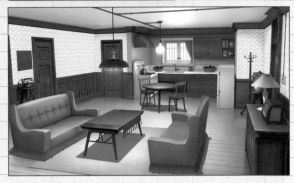

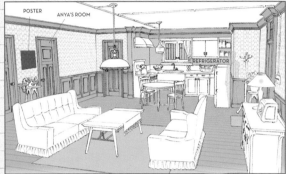

POSTER    ANYA'S ROOM

REFRIGERATOR

**● LOID'S ROOM**

## THE ORPHANAGE

The orphanage where Loid and Anya first meet is fairly large but seems quite shady. When Loid visits, it doesn't look as if it's been cleaned in quite some time.

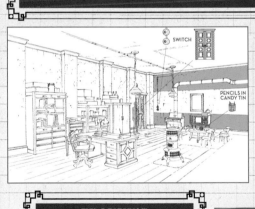

SWITCH

PENCILS IN
CANDY TIN

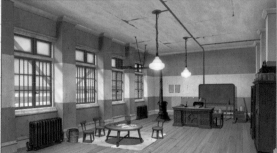

## FRANKY'S TOBACCO STAND

This small kiosk in a corner of Berlint sells tobacco products as well as newspapers and magazines. Its customers include commuters and, seemingly, people seeking information.

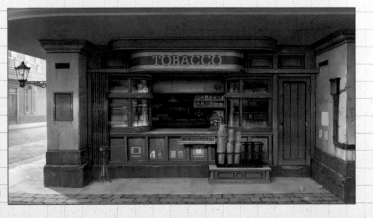

## • SCHOOL GROUNDS NEAR GATES

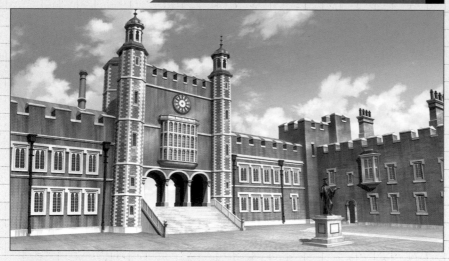

### EDEN ACADEMY

Ostania's most prestigious private school. Its vast grounds contain dorms and classrooms for students of all 13 grades. Its exceptional educators and ample facilities have fostered generations of Ostanian leaders.

## • NEAR THE MESSAGE BOARDS

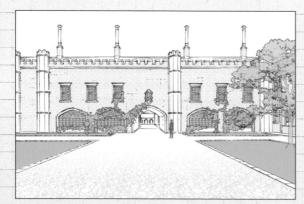

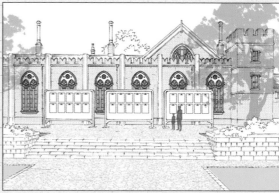

## • INTERVIEW ROOM

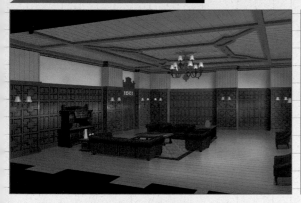
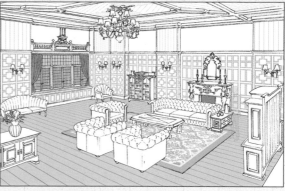

## • ASSEMBLY HALL

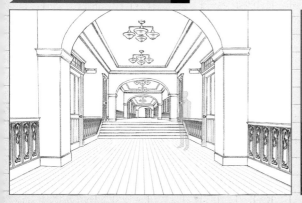
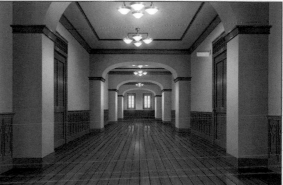

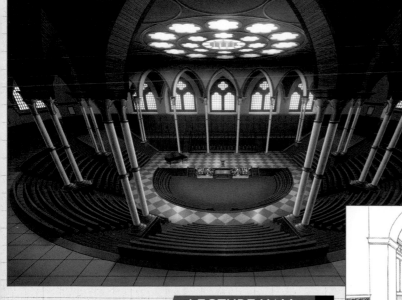

## • LECTURE HALL

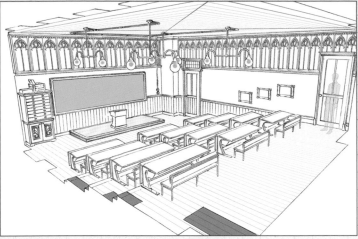

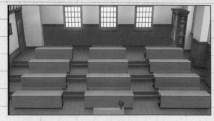

● CLASSROOM 1

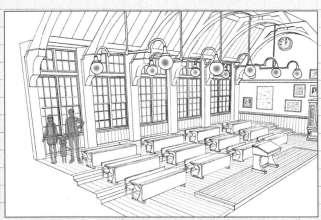

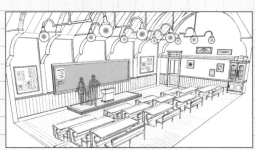

● CLASSROOM 2

● DINING HALL

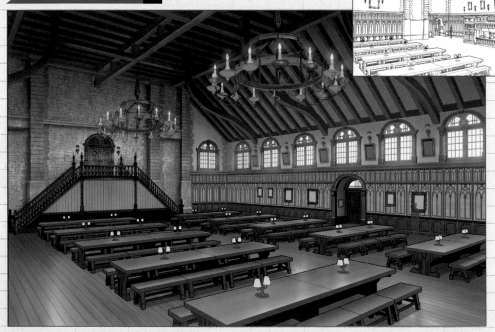

## ● GYMNASIUM

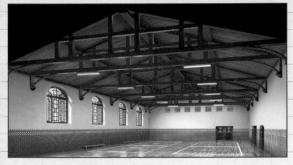

## ● LOUNGE

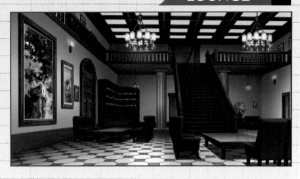

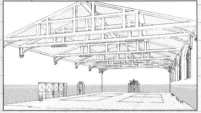

▼ Henderson's Apartment

## ● CECILE HALL

▼ Exterior

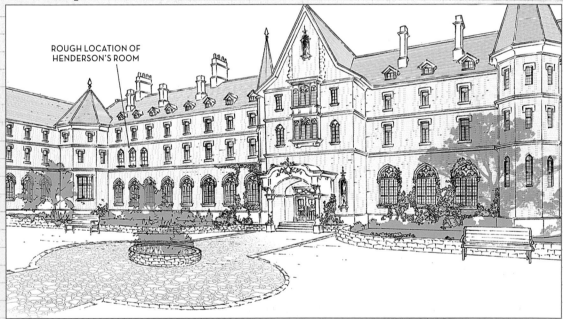

ROUGH LOCATION OF
HENDERSON'S ROOM

▼ Tea Lounge

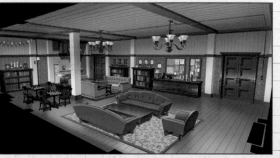

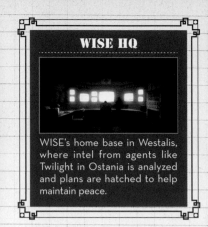
## • MEETING ROOM

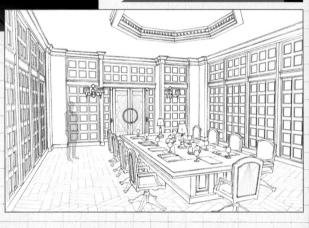

## • DIRECTOR'S ROOM

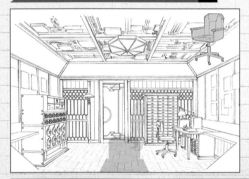

## • MONITORING ROOM

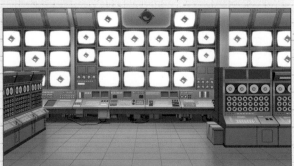

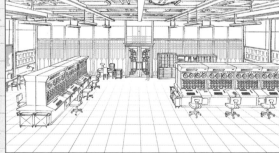

## ● ENTRANCE

### SAFE HOUSE D

The secret base for agents based in Ostania, where Loid met with the Handler in Mission 6. It uses a photo booth as a facial recognition system and an elevator that goes underground.

## ● INTERIOR

### TRAINS & SUBWAYS

Loid rode a surface train into Berlint. A subway carries commuters around the city. A WISE liaison is stationed at a snack stand at one of the stations.

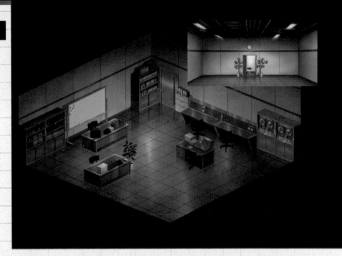

## ● TRAIN TO BERLINT

▼ Train Interior

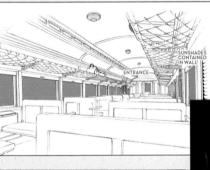

## ● BERLINT CITY SUBWAY

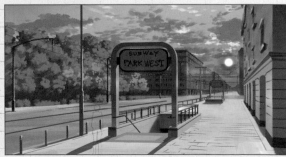

▼ Station

▼ Entrance

## FACTORY DISTRICT

This run-down district on the outskirts of town is where Yor and Loid fight a smuggling ring and agree to a fake marriage in Mission 2. It appears to be deserted at night, and even gunshots and screams draw no attention.

### • PASSAGEWAY

### • PANORAMA

## OLD DEPARTMENT STORE

This large department store appears to be abandoned. It's dark inside due to the boards on its windows, and there's a thick layer of dust on the floor. This secluded location is sometimes used for criminal purposes.

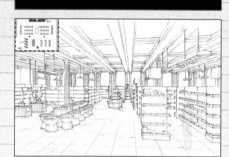

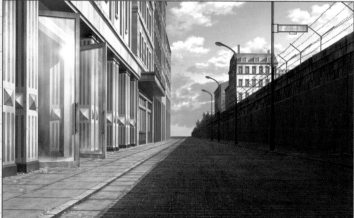

### • FIRST FLOOR

### • FRONT OF STORE

### • SECOND FLOOR

## BERLINT CITY HALL

Yor's workplace, where office workers busily process paperwork. Employees gather in the kitchenette to gripe and trade gossip.

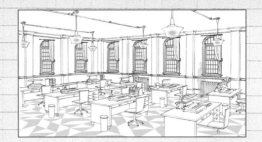

## •KITCHENETTE

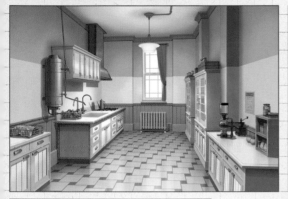

## •OFFICES

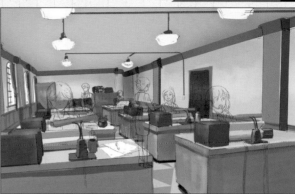

## CAMILLA'S HOUSE

Yor's coworker Camilla lives in a mansion that's far grander and more luxurious than Yor's humble apartment. She hosts parties in its spacious living room.

## •EXTERIOR

## •LIVING ROOM

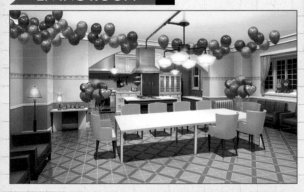

## •ENTRYWAY

## TAILOR SHOP

Yor first encounters Loid at this tailor shop, where she is a regular. There's a sofa opposite the register counter. The shop accepts even the smallest of jobs.

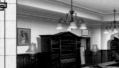

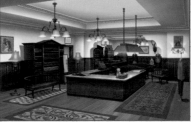

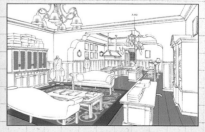

● CESSNA LANDING AREA (BY RIVER OUTSIDE THE CITY)

## NEWSTON CASTLE

This ancient castle in the Münk region was rebuilt as a theme park for the popular cartoon *Spy Wars*. Its attractions let visitors relive favorite moments from the show.

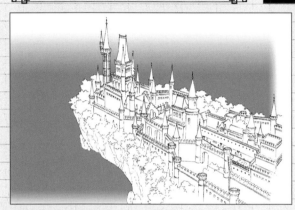

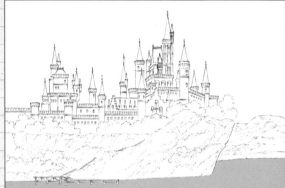

● PANORAMA

● BALLROOM

● COURTYARD

● WAITING ROOM

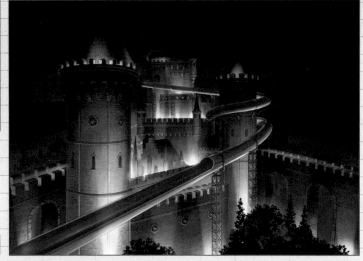

● EXTERNAL SLIDE

● SPIRAL STAIR TOWER

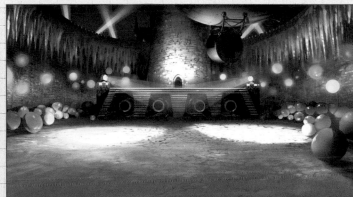

● BALLOON ROOM

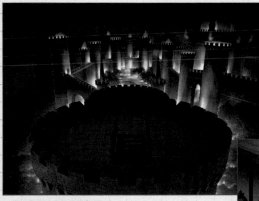

● ROOF

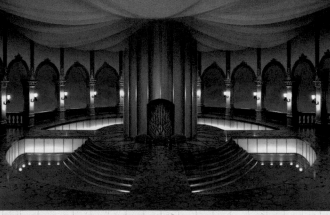

● TOWER WITH VERANDA

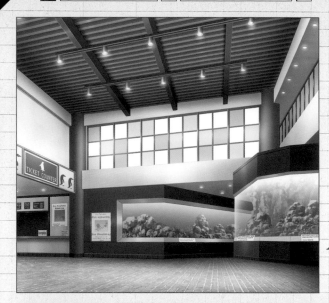

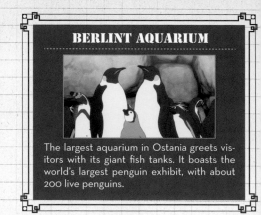

### BERLINT AQUARIUM

The largest aquarium in Ostania greets visitors with its giant fish tanks. It boasts the world's largest penguin exhibit, with about 200 live penguins.

● ENTRANCE

● INTERIOR

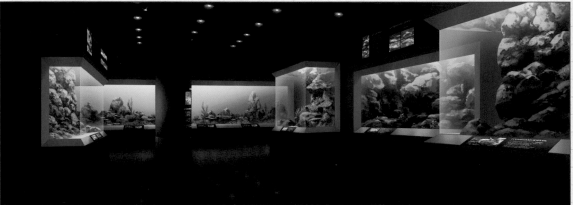

● PENGUIN EXHIBIT

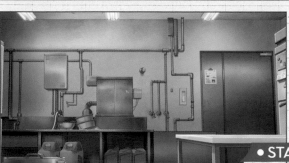

● STAFF ROOM

● BACKYARD

## • BERLINT CITY STREET

## • ROYAL HOTEL

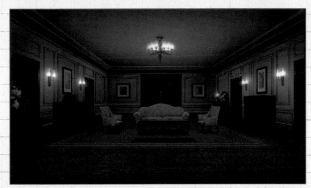

## • SUPERMARKET

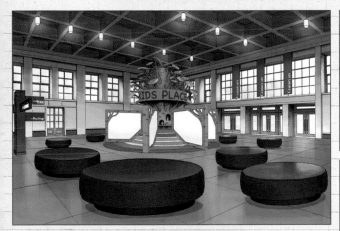

## • MUSEUM KIDS CORNER

## • HOSPITAL (NURSE STATION)

## • BRIAR HOME

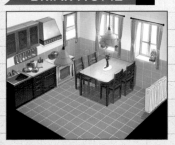

## • YURI'S APARTMENT EXTERIOR

# PROP SKETCHES

Here we show a few memorable items from the series. Many of the sketches were made for props that only appear in Mission 5.

**• LOID'S GUN**

**• DIRECTOR CHIMERA**

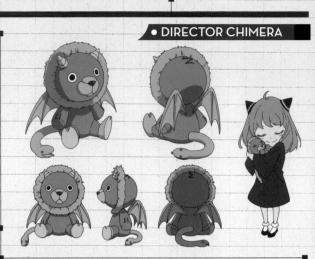

**• EDGAR'S GUN**

**• EDEN STUDENT BAG**

**• FORGER FAMILY PHONE**

INDENTATION USED FOR CARRYING PHONE

PLACE TO INSERT NOTE

**• RUBBER-BALL BAZOOKA**

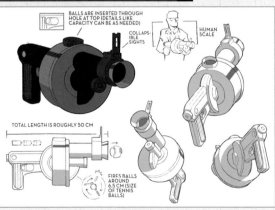

BALLS ARE INSERTED THROUGH HOLE AT TOP (DETAILS LIKE CAPACITY CAN BE AS NEEDED)

COLLAPS-IBLE SIGHTS

HUMAN SCALE

TOTAL LENGTH IS ROUGHLY 50 CM

FIRES BALLS AROUND 6.5 CM (SIZE OF TENNIS BALLS)

**• RUBBER-BALL GUN**

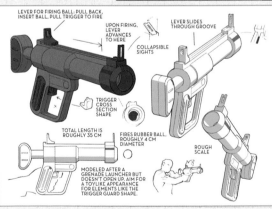

LEVER FOR FIRING BALL: PULL BACK, INSERT BALL, PULL TRIGGER TO FIRE

UPON FIRING, LEVER ADVANCES TO HERE

LEVER SLIDES THROUGH GROOVE

COLLAPSIBLE SIGHTS

TRIGGER CROSS SECTION SHAPE

TOTAL LENGTH IS ROUGHLY 35 CM

FIRES RUBBER BALL, ROUGHLY 4 CM DIAMETER

ROUGH SCALE

MODELED AFTER A GRENADE LAUNCHER BUT DOESN'T OPEN UP. AIM FOR A TOYLIKE APPEARANCE FOR ELEMENTS LIKE THE TRIGGER GUARD SHAPE.

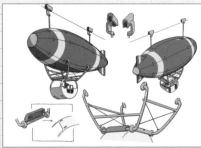

**• NEWSTON CASTLE AIRSHIP GONDOLA**

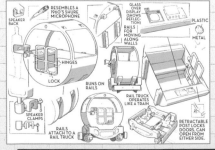

RESEMBLES A 1960'S SHURE MICROPHONE

SPEAKER BACK

GLASS OVER DISPLAY (SHOWS REFLEC-TION)

PLASTIC

RAILS FOR MOVING ALONG WALLS

METAL

HINGES

LOCK

RUNS ON RAILS

RAIL TRUCK OPERATES LIKE A TRAIN

SPEAKER CLAMPS

RAILS ATTACH TO A RAIL TRUCK

RETRACTABLE POST LOCKS DOORS, CAN OPEN FROM EITHER SIDE.

**• NEWSTON CASTLE GONDOLA**

# SPY×FAMILY

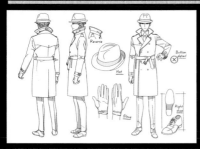
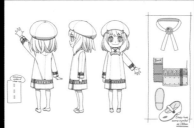
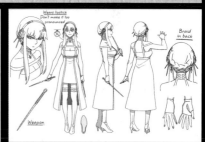

## FILE IV

# CAST & STAFF REPORT

Anticipation has been high for the *Spy x Family* anime since its initial announcement. Despite that intense pressure, the cast and crew made an incredible anime. In this section, they look back on the experience.

Looking back on part 1, family changes, and what's to come...

# SPECIAL FEATURE — FORGER FAMILY ROUNDTABLE

THE CAST WHO PLAY THE THREE MEMBERS OF THE FORGER FAMILY ARE AT THE VERY HEART OF THE *SPY x FAMILY* ANIME. THEY TELL US ALL ABOUT THE SERIES FROM THEIR UNIQUE VANTAGE POINT.

## TAKUYA EGUCHI
(As Loid Forger)

## ATSUMI TANEZAKI
(As Anya Forger)

## SAORI HAYAMI
(As Yor Forger)

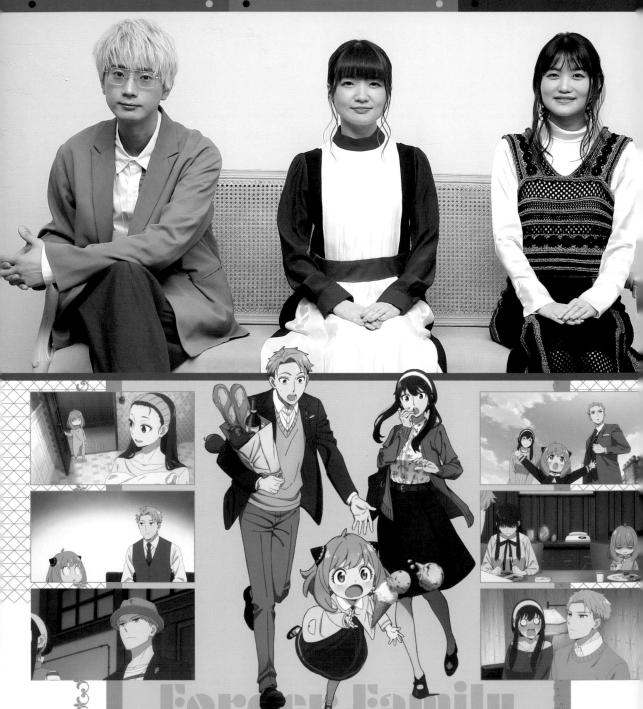

Forger Family

**"I HOPE I DID A GOOD ENOUGH JOB EXPRESSING LOID'S GRADUALLY EVOLVING WARMTH." —EGUCHI**

## ● THE PLOT-DENSE EPISODES OF PART 1

**What were your impressions of the show as you finished recording episode 12?**

**EGUCHI (Loid):** Honestly, at the time my main thought was, "Wow, the session is over already?" Looking back on those episodes now, I hope I did a good enough job expressing Loid's gradually evolving warmth. Initially I hadn't intended to alter my performance all that much, but I was able to convey some change with guidance from the directors.

**TANEZAKI (Anya):** I had been a fan of the manga, but there was so much more depth to the story that I hadn't been aware of until we started recording. Between that and trying to nail the vibe, it wasn't until the final episodes that I finally felt like I was beginning to grasp what I was supposed to be doing. I thought, "I just got into the rhythm! Please don't make us take a long break before episode 13!" [*laughs*]

**HAYAMI (Yor):** I felt like I wanted to roll right into recording episode 13 too! Another thing that struck me when we finished recording that batch of episodes was just how dense they were. Looking back on it now, though, we only covered three volumes of the manga. It's incredible how much happened!

**What were everyone's favorite episodes from the first part?**

**EGUCHI:** That's a hard one because they were all full of scenes I loved. But as this is an interview for the anime guide, the scenes I'd most like to discuss are the ones that are original to the anime. And for that, I'd have to say the scene in episode 5, where Loid becomes Loidman…

**TANEZAKI:** He put it on! That one, right? [*laughs*]

**HAYAMI:** Oh, I know!

**EGUCHI:** Yeah, that's got to be the one. [*laughs*] The timing of having an original episode like that right after completing the first major milestone with the admissions interview really showed the breadth of the series.

**TANEZAKI:** Episode 5 was so cool and fun, and it really had a ton of character movement. I think it had the thickest script, too. [*laughs*] I really love Loid in that episode. The blushing-papa thing is just so irresistible!

**EGUCHI:** As much as I enjoy seeing Loid working hard at his spy duties, I also really like the contrast between that Loid and the deeply embarrassed, stiffer Loid in episode 5.

**TANEZAKI:** The pacing of the comedy in that episode was perfect. Like Yor tripping and immediately falling asleep after her fierce battle with Loid, and Count Scruffy Head making that arrogant speech and then going down in one slap. I think episode 5 is a great example of how they were able to make such a densely packed half season by skillfully expanding on the manga.

**HAYAMI:** The original scenes are wonderful too, but I think looking back on it, I'm just in awe of what they were able to achieve in the first episode. Yor didn't appear in it, so I experienced it for the first time along with the viewers when it aired. I was so impressed with the overall high quality of the episode and how it pulled viewers into the story.

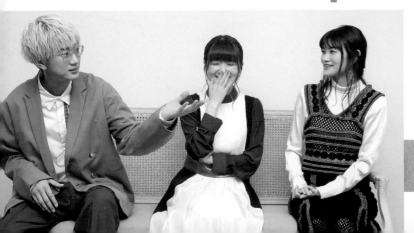

## ● THE MEMBERS OF THE FORGER FAMILY

**The first part was a turbulent time for the Forger family. Were there any family moments that specifically stuck with you?**

TANEZAKI: It was such a gradual process of the three of them spending time together and learning to sympathize with each other that it's hard to point to any one moment as being the pivotal one for the Forger family.

EGUCHI: Since there wouldn't be a story if they'd never met, I'd say the first meetings were the pivotal ones to me. Beyond those, I especially like the scenes, such as the ones in episode 3 and episode 12, in which all three of the Forgers team up to solve some sort of crime.

HAYAMI: If I was forced to choose one, it would have to be the time that Anya earned her stella star. That scene really made me think, "Oh, I'm so happy for her!" I absolutely love that big smile on Anya's face and the way you can tell that Loid and Yor are truly happy from the bottom of their hearts.

TANEZAKI: The kindness on Loid's face and the way Yor looked so happy was wonderful! I cried when I saw that episode on TV for the first time.

EGUCHI: I think Loid was feeling deeply proud at that moment. Since those lines came after that sequence of Anya trying so hard, my performance for that part came as naturally to me as the words did to him. There was such a feeling of gratitude toward Anya.

TANEZAKI: Anya's rescue attempt was so passionate and pure. From the moment she heard the drowning boy's thoughts, she completely stopped thinking about things like stella stars and being praised and was just left with this earnest desire to save him. I think that was why she got the stella. When we were performing that part, I remember having trouble figuring out how to convey things like exhaling underwater.

**At that point, the three of them had really coalesced into a family. I'd love to hear what each of you likes about the other Forgers from the perspective of your characters.**

EGUCHI: To a cool and collected spy like Loid, you can only see the sentimentality he's come to feel toward the other two through his vibe when he's around them. Loid's feelings are clearly being swayed by factors he isn't able to express in words, but I think you can sense that there's something positive there.

TANEZAKI: Everything about Papa is cool. Especially in episode 12, where you can tell he's at his absolute physical limit but still works hard. He's incredible. Mama is strong, but really, that's it. [*laughs*] But even if she's bad at everything else, I think it's great that she continues to challenge herself when it comes to things like cooking and never backs down.

HAYAMI: I love how Loid appears flawlessly coolheaded and rational, but you can still see this incredible warmth inside of him. No matter how professional he looks to the world, his family always sees him as kind. I think that's driven by his convictions. Anya's cute, but beyond that, I think she possesses this innocent but powerful influence that drives all sorts of things around her, even if she isn't aware of it.

TANEZAKI: In episode 6, when Anya got entangled with those street thugs during a shopping trip and was rescued by Yor, she was really taken with Yor's strength.

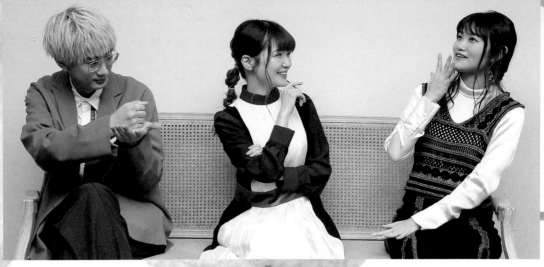

**HAYAMI:** She said she wanted to be just like Mama and trained with her, right? That sort of innocent reaction ends up saving lives sometimes.

**EGUCHI:** I think all three Forgers are burdened by their pasts but are good people. I want them to be able to enjoy their lives. In the opening, you see the Forger family going on vacations. Watching that always makes me tear up a little.

**TANEZAKI:** We haven't even seen it in the manga yet, but it would be so much fun to watch them do things like go on a drive or make something as a family—ceramics, for example. Wouldn't it be great to see what skills each of them brings?

**HAYAMI:** I'd be curious to see what they would make!

**EGUCHI:** Loid would probably make something flawless, but Yor's would show some unique sensibilities. [*laughs*] Maybe it'd be mistaken for the work of a master artisan and command a high price?

**TANEZAKI:** Or she'd just end up using it as some sort of weapon.

**HAYAMI:** That would be fun! Or maybe they could go stargazing as a family. Just imagine the three of them gazing up at the heavens together…

**EGUCHI:** How peaceful! Family excursions really are symbolic of family harmony, so I hope we'll get to see the three of them go to all sorts of places and experience all sorts of things together.

## ● GROWING THROUGH *SPY X FAMILY*

You've all been part of numerous *Spy x Family* marketing events and exhibitions. Did any of those leave a particularly strong impression on you?

**EGUCHI:** For me, it was Jump Festa 2022, where I first appeared as the voice of Loid. I did voice-overs in advance for scenes that hadn't been animated yet. [*laughs*] It was my first time, so I was extremely nervous. That event was the start of everything to come, so it left a big impression on me.

**TANEZAKI:** I'm not sure if this is exactly what you mean by a "strong impression," but apparently it's standard practice at streaming service AbemaTV to have guests do a drawing segment, which is a tradition I wish they'd abandon immediately. [*laughs*] It happened right at the start of promoting the series, and I did so badly. Nothing I did met the judge's artistic standards, and it was brutal. That certainly left a big impression on me. [*laughs*]

**HAYAMI:** But, Ms. Tanezaki, you're far and away the most skilled artist of any of us!

**TANEZAKI:** "Skilled" is massively overstating it!

**HAYAMI:** [*laughs*] For me, it's when we all appeared on Gen Hoshino's *All Night Japan*. It was so valuable to hear how another creator involved with making *Spy x Family* thinks about the series.

> "BEING INVOLVED WITH *SPY x FAMILY* HAS CERTAINLY LED TO ME SPENDING MORE TIME CONSIDERING WHAT 'FAMILY' MEANS TO ME."
> —HAYAMI

**TANEZAKI:** I didn't even think of it as work. [*laughs*] That was a treasure!

**EGUCHI:** Mr. Hoshino is so familiar with multiple aspects of the industry and has such deep knowledge about them that we were able to just relax and have a great conversation.

**Do you feel appearing in *Spy x Family* has led to any personal or career growth?**

**EGUCHI:** Fundamentally, every role I take brings out new feelings that I utilize in that performance, and they stay with me to be used in future roles as well. But *Spy x Family* has demanded far more than usual from me in terms of technical growth. For example, the way that Loid will have to go from a normal conversation directly into performing a monologue requires skillfully switching between performances that have very different levels of intensity. Going forward, *Spy x Family* may prove to be valuable in helping me to consider how to approach whatever new aspects of a performance are demanded of me.

**HAYAMI:** Being involved with *Spy x Family* has led to me spending more time considering what "family" means to me and what forms a family can take. Likewise, seeing the characters performing their assigned roles in the Forger family makes me ponder questions like, "What role am I fulfilling?"

TANEZAKI: I'm not sure if this counts as growth, but I'd never had a role that involved doing so much publicity. Whenever the three of us do interviews together, and I see Mr. Eguchi's and Ms. Hayami's responses, I'm so often blown away by them, as they have so much more experience doing PR than I do. It's been a real privilege to get to learn from them.

EGUCHI: Oh no, that's not true at all.

HAYAMI: Honestly, I've never had a role that involved doing this much PR either! [*laughs*]

TANEZAKI: The conversation style is so difficult for me, and it's hard to tell if I'm promoting things effectively... I sit there thinking, "You two are such grown-ups!"

EGUCHI & HAYAMI: [*laughs*]

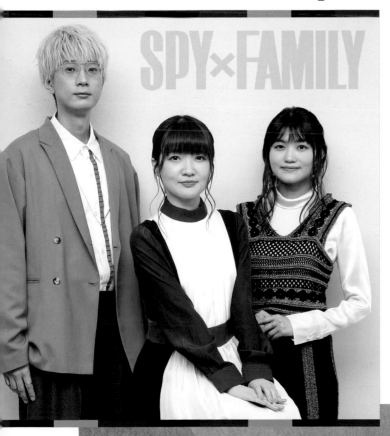

## ● MESSAGES FROM THE CAST TO THE FANS

### Finally, do you have any messages you'd like to share with our readers?

HAYAMI: The second half of the season is coming, and I hope you'll all watch it! Whether you've been with us for the first 12 episodes or have never seen *Spy x Family*, whether you're old or young, male or female, *Spy x Family* would love to have you. I'm sure you'll enjoy it, so I hope you'll make it a part of your routine!

TANEZAKI: In the second part, a certain character we only got a brief glimpse of in episode 11 joins the cast to incredible effect. [*laughs*] They've been adding in the final sound effects to the episodes, and I cannot tell you how much *wakuwaku* ["excitement"] it brings me just to hear that character's voice.

Episode 12 showcased the harmonious "family" aspect of the show, but episode 13 brings the "spy" aspect in with a bang, and I hope you'll enjoy watching it with *wakuwaku* in your hearts.

EGUCHI: The teaser video for the second part features a different vibe from what we've seen before and may have left some viewers wondering where the show is headed, and I promise you, it's going in some very interesting directions!

On a personal level, sometimes the anticipation surrounding the first part felt like it was happening on a different world, but as we near the broadcast of the second part, I've been feeling the enthusiasm of our fans and the excitement of our staff much more keenly. Like the rest of our team, I'll strive to use all that I've learned from the production of part 1 to make the episodes of part 2 even more entertaining.

# HIROYUKI YOSHINO

The actor who plays Franky, the Ostanian intelligence asset who helps Westalis spy Twilight, discusses his character's humanity and the charms of *Spy x Family*.

## ● RESPECTING THE ORIGINAL WORK

**What were your impressions of the show as you finished work on the first half of the season?**

YOSHINO: Franky didn't appear all that often, but he was there during truly important moments, and I was grateful for that. Also, on a personal level, the quality of the episodes in the first part of the season really exceeded my expectations and left me quite excited for the second half.

**What were some of your goals when performing the Franky character?**

YOSHINO: To be honest, before we started recording, I thought Franky was someone who spoke with a lower voice than what the character ended up having. However, after the testing stage, the audio director asked me to make his voice a little more varied and younger sounding, so I tried a new approach, speaking in a fairly high key and with a more enthusiastic, buoyant tone.

My goal with the performance was to respect the original work. When working on an anime based on a manga, even within the wider range of things you're able to express in animation, it's important to try to account for the energy of the manga when deciding how you want to play a scene. You want to ensure that what you're creating will please

fans of the manga as well. An anime is something you make as a team, so I need to make sure I'm holding up my end of that in my role as a voice actor.

**What is your overall impression of Franky?**

YOSHINO: I view him positively, but he's certainly a man of many secrets. All we really know about him is that he's a freelance information broker, so it's possible he's actually an awful person. [*laughs*] But from what we've seen of him so far, I think he's a fun and caring person and a great character who's hard not to like.

**Are there any areas in which you resemble Franky?**

YOSHINO: We have the same voice. [*laughs*] There must be similarities, but the worlds in which we live are very different, and our lives don't really overlap much. And as I said before, not much has been revealed about who Franky really is, even in the manga. Without knowing more about him, it's hard to determine how we are and aren't alike.

**What is your favorite scene from the *Spy x Family* anime?**

YOSHINO: The scene in episode 5 in which they play at the castle. That scene added a lot to what was in the manga, but it felt so natural that it's easy to assume it just happened

PHOTOGRAPHY: HIROKO KIKUCHI
HAIR & MAKEUP: HAPP'S
STYLIST: YUYA MURATA (SMB INTERNATIONAL)

**"I VIEW [FRANKY] POSITIVELY, BUT HE'S CERTAINLY A MAN OF MANY STORIES"**

Profile
### HIROYUKI YOSHINO

Born 2/6, originally from Chiba Prefecture. Previous major roles include Yasutomo Arakita in *Yowamushi Pedal*, Hajime Iwaizumi in *Haikyu!!*, and Yusuke Fujisaki in *Sket Dance*.

off page. And as the actor for Franky, I really felt those additions and liked the episode a lot. I think it's just incredible what the staff has come up with to bring *Spy x Family* to life as an animated series while showing such respect to the original work.

### Franky certainly gets a key role in episode 5.

**YOSHINO:** I certainly did talk a lot. [*laughs*] There was a lot of fun stuff in that scene, and the staff trusted me to do whatever I wanted with it, so I had a lot of freedom to perform it the way I liked. Since it's a story about Franky playing along with Anya's spy fantasy, I imagined interacting with a real child. That's the sort of thinking that led to the "scruffy scruffy scruffy" [*mojajajajajaaaa*] laugh of Count Scruffy Head [*Count Mojamoja*], for example.

### So you yelling "mojajajajajaaaa" was an ad-lib?

**YOSHINO:** It was. The villains in anime for children often have some sort of quirky speech pattern, right? Based on that, I was given permission to use "mojajaaaa" for Count Scruffy Head's laughs. I thought that would help convey how eagerly he was playing along with Anya's game. In fact, when Count Scruffy Head first appears at the beginning of the castle sequence, there wasn't really a line for him in the script. So that's when I tried out the "mojaaaa" thing for the first time.

## ● A PERFECT RECIPE FOR ENTERTAINMENT

### Are there any characters you especially like?

**YOSHINO:** I'm sure everyone feels this way, but I really do like Anya. You can't help but focus on her when she's on-screen. Watching her never gets old. And her awkwardness is so endearing. World peace really does rest on her actions, but she's scatterbrained when it

comes to academics and not very skilled athletically, either, and I thinks those sorts of flaws are really interesting in a child. I think my favorite Anya scene is when she earns a stella, and when asked what she wants as a reward she answers, "Peanuts." Like, that's it? It's such a perfectly childlike answer.

*Spy x Family* has so many vibrant characters and does such a good job of giving them opportunities to shine. Each of them is lacking somehow in ways that only make them more interesting. It also has such an intricate setting that somehow manages to feel natural to viewers… I think it's just an incredibly well-thought-out piece of entertainment.

### What are you looking forward to in the second half of the season?

**YOSHINO:** The first half was able to bring *Spy x Family* to life as an anime in such an entertaining way, and I hope everyone will be able to enjoy more of those sorts of scenes in the second part. *Spy x Family* has lots of humor and fun, but it also has all the core elements of a strong drama. And I hope to continue laboring to bring those great dramatic moments to all of you.

### Finally, do you have any message you'd like to share with the fans?

**YOSHINO:** I think original scenes and things that can only be expressed with animation are part of what make this adaptation of *Spy x Family* so entertaining. I hope you're able to enjoy not just the manga but the rich world of its animated adaption as well.

Franklin

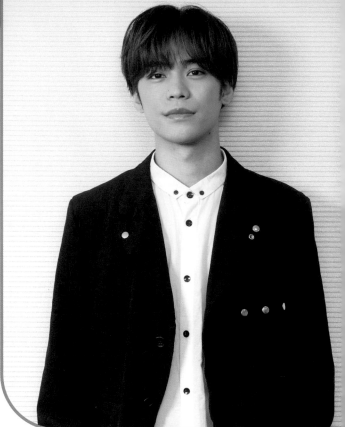

## MAIN CAST INTERVIEW 2
### VOICE OF YURI BRIAR

# KENSHO ONO

Diplomat, secret policeman, younger brother obsessed with his sister—Yuri Briar wears many faces. Voice actor Kensho Ono recounts his impressions from the recording sessions.

### ● EXPRESSING THE DUALITY OF YURI

**What were your impressions of the show as you finished work on the first half of the season?**

**ONO:** I was an avid reader of the manga before the anime adaptation was even announced. I'd read it thinking, "If I were to play a part, maybe it'd be Yuri?" I was so happy when I got the role. Yuri's appearances are mostly in episodes 7 to 9, so it felt like I burst onto the scene and disappeared just as quickly. But Yuri is an interesting character who significantly disrupts things in his brief appearance, so it was a lot of fun recording his part. It really left me wanting more, so I'm eagerly looking forward to his next scenes.

**After performing as Yuri, what was your impression of the character?**

**ONO:** Yuri has an extremely active inner voice. When he visited the Forgers in episodes 8 and 9, he had normal conversations with Yor, while simultaneously developing a deep antagonism toward Loid in his internal monologue. I found that really interesting and very human. I think we can all relate to Yuri's habit of saying one thing while thinking another. I—like most people, I would think—tailor my words to leave a good impression of myself. That doesn't necessarily mean I'm trying to curry favor by concealing my true feelings—it's just the sort of image creation that people engage in when they interact with

each other. I see those sorts of human impulses in Yuri, and that makes him more relatable to me.

**Were there any aspects of the Yuri role that you found especially challenging?**

**ONO:** I was conscious of his two-faced nature. At a glance, he seems like this kind and sociable young man, but his thoughts tend toward the extreme, such as the excessive love he holds for his sister. I was trying to properly convey that duality in my performance.

**Did you have some sort of special approach for those scenes where he expresses his "excessive feelings" for his sister?**

**ONO:** His mindset involves absolute trust in Yor. He believes everything Yor says is 100 percent correct. When she says she never mentioned getting married because she forgot, Yuri responds with, "Well, if you say so, it must be true. Sorry, sis." That cuts right to the heart of his feelings for her. Leaning on that trust, without trying to over-explain it, leads to a very natural performance.

**The visit to the Forger home in episodes 8 and 9 was very impactful. How did you approach those scenes when you recorded them?**

**ONO:** We were allowed to approach it however we felt best in the recording session. For the more comical parts, we

PHOTOGRAPHY: HIDEAKI HASABE
HAIR & MAKEUP: YUTO
STYLIST: DAN

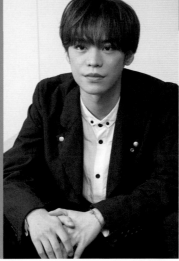

Profile

**KENSHO ONO**

Born 10/5, originally from Fukuoka Prefecture. Previous major roles include Hathaway Noa in *Mobile Suit Gundam: Hathaway's Flash*, Giorno Giovanna in *JoJo's Bizarre Adventure: Golden Wind*, and Tetsuya Kuroko in *Kuroko's Basketball*.

## "YURI IS AN INTERESTING CHARACTER WHO CONSTANTLY DISRUPTS THINGS"

played it a little too over-the-top in a test take, and then pulled back a bit based on the notes we were given afterward. Outside of that, there wasn't much direction, so we relaxed and had fun with it. The pacing of those scenes is very fast, so we let that dictate the tempo of the session and recorded it fairly quickly.

Once the Briars started drinking, things really got intense. In the secret police torture scene in the first half, we showed off Yuri's scary side. As a reaction to that, I wanted to play drunken Yuri as more funny and fun. I suppose it also gave the impression that with the power of booze, anything can happen. Personally, my favorite part was when Yuri ordered them to kiss. He had this pouty expression during the scene, so I did the same thing with my lips while playing it.

### Did director Kazuhiro Furuhashi or sound director Shoji Hata have any specific comments about how they wanted you to play Yuri?

**ONO:** When Yor got a phone call from Yuri in episode 2, I was asked to play him as a typical little brother. At that point, Yuri was just a sweet kid worried about his big sister. I developed the nice-boy facet of the character to make him seem pleasant and youthful. There wasn't really a specific direction for how to play him in episodes 8 and 9, but I do remember having a discussion about how best to convey his extremeness while grounding the performance in the "absolute trust in Yor" that I mentioned earlier.

### How did you approach your performance in terms of Yuri's attitude toward Loid?

**ONO:** He definitely recognizes Loid as an enemy. There were a lot of monologues in which he expressed his loathing, and I approached the recording sessions brimming with belligerence and a mindset of "What do I need to do to make him and my sister break up?"

## ● ANTICIPATING MORE YURI IN THE SECOND HALF

### Are there any Yuri scenes or lines of dialogue that you particularly enjoyed?

**ONO:** The ones in episodes 8 and 9, of course. I love how even as the story is comical and Yuri becomes more and more drunk, he reveals more of his true self. It feels like you're catching a glimpse of what's really in his heart when he eventually says, "Can you even imagine how it feels for me to have the most important person in my life just suddenly taken from me by some guy who appeared out of thin air?" That left a big impression on me. Also, I love the scene where he's sent flying by Yor. The *itpppppbt* noise he makes when he's hit goes on for a really long time. Having to repeatedly do yelling noises like that is difficult, so I psyched myself up to try to get it done in one take.

### Do you have any favorite scenes of the other characters?

**ONO:** The expressions in episode 5 really resonated with me. That's the one where Anya gets accepted into Eden Academy and they rent a castle as a reward. Her smile is so amazing, and when she thought back to her painful past, it really made my eyes well with tears. I thought that episode was special.

### Do you have a message for the show's fans in anticipation of the second half of the season?

**ONO:** I've been watching the show when it airs on TV, and it flew by way too quickly. A new batch of stories is coming, so I hope you'll watch every week and look forward to Yuri's appearances! I know a lot of fans are expecting more over-the-top behavior from Yuri, and I promise to be as wild as I can without breaking the mood of the scenes. I hope you'll enjoy the second part!

# MAIN CAST INTERVIEW 3
## VOICE OF DAMIAN DESMOND

# NATSUMI FUJIWARA

Natsumi Fujiwara portrays Damian Desmond with a subtle and sensitive performance. She discusses his charms and the recording sessions with his Eden classmates.

## ● STRIVING TO NOT MAKE DAMIAN TOO CONTEMPTIBLE

**What were your impressions of the show as you finished work on the first half of the season?**

**FUJIWARA:** I remember how nervous I was for my debut scene! [*laughs*] Damian is initially quite haughty, but after he meets Anya, you do get to see a little bit of his childish innocence, which I was happy about. The first half of the season ends without digging into who he is as a character, so I'm looking forward to that in the second part!

**As you were voicing Damian, what did you find appealing about the character?**

**FUJIWARA:** Damian behaves arrogantly, but you can see the kindness at his core, and even his innocence at times, like the way his heart started fluttering when Anya cried, or the way he accepted it when she said she wanted to be his friend. I think his heart is actually very open to other people.

**What other Damian scenes did you enjoy?**

**FUJIWARA:** In episode 10, even after he declared he would lead the class to victory, he couldn't help but protect Anya from getting hit. I love how gallant that was. Also, when Anya got her first stella star and their classmates were scoffing about it and looking to Damian for approval, he completely shut them down: "If you've got a problem with our school, why don't you take the transfer exam for another one?" That was so cool! His respect for succeeding through fair play and hard work is endearing to me.

**How would you personally characterize the way Damian feels about Anya?**

**FUJIWARA:** He considers her a rival in his quest for stella, but I think we can agree there are more complicated feelings mixed in there. Damian's only in first grade, so he doesn't understand what those feelings mean and can get flustered by that. I think after he saw Anya crying, he became interested in her, but his family circumstances and his desire to be acknowledged by his father still weigh much more heavily upon him.

**How do you approach capturing that mix of arrogance and innocence in your performance of Damian?**

**FUJIWARA:** My initial voice for him was apparently too young, so the sound director and I had several discussions about it. Their note was, "His voice should be on the low side when speaking normally, to give the sense that he's calm and has a bit of an above-it-all attitude. That way, when he's monologuing or the more childish parts of his nature are emerging, you can have some gradations in your pitch." It took a fair amount of time before we finally arrived at the perfect Damian.

PHOTOGRAPHY: HIDEAKI HASABE
HAIR & MAKEUP: ADDMIX B.G.

## Profile

**NATSUMI FUJIWARA**

Born 6/2, originally from Shizuoka Prefecture. Previous major roles include Kabane Kusaka in *Kemono Jihen*, Toru Mutsuki in *Tokyo Ghoul: re*, and Chihiro Komiya in *Shonen Maid*.

**"IT WAS ALWAYS FUN HEARING 'THEIR CHARACTERS'**

**How was it working with Ms. Tanezaki, who voices Anya?**

**FUJIWARA:** Ms. Tanezaki has such phenomenal powers of expression. She can even play the parts of Loid or Damian in her fantasies of Loid praising her and Damian inviting her to his house. There were times during test recordings when she took the character even further than the broadcast versions, and I was blown away by how hard she works to nail down these perfect Anya moments. She's able to express Anya's charm in ways that aren't even in the script, which in turn makes me want to work even harder to express the charming aspects of Damian!

**What is it like recording the scenes with Ms. Sato, who voices Emile, and Ms. Okamura, who voices Ewen?**

**FUJIWARA:** It's very comfortable and collaborative. The way they immediately react whenever Damian says something is very heartening. There's an enjoyable call-and-response there. It was always fun hearing their characters' overblown reactions to things.

**The dodgeball episode had a lot of new moments for Damian and them.**

**FUJIWARA:** I performed as if I was really in that dodgeball game, so it was quite intense. Some of the moments have Damian, Emile, and Ewen saying things like "Shadow Clone Attack" in sequence or unison, but rather than nailing it perfectly, we played it intentionally out of sync because it would be more childlike that way. But Bill just looms so large over all of it… [*laughs*] In the dodgeball scenes, the voice of Bill, performed by Hiroki Yasumoto, grows even more threatening. You can really sense the bloodlust in his roars. Even though he was directing his lines at Anya, I was feeling scared, as if he was directing them at me.

**Do you have any favorite scenes from the animated series?**

**FUJIWARA:** I love the scene in episode 12 when Anya is playing with her penguin and other stuffed animals. She has a ritual where they split a peanut and eat it together, but since the stuffed animal can't eat it, Anya eats both halves herself. It's so cute.

## ● CHARMING MOMENTS OUTSIDE THE SCRIPT

**Can you share with us some of your goals for the second half of the season?**

**FUJIWARA:** I think Damian is a character we'll be delving into more deeply as the series progresses, so I want to push myself to express his internal conflicts in a clear way. Also, recording sessions for *Spy x Family* include a lot of ad-libbing, and I'd like to do more of that in the second part to make the sessions more fun.

**Did Damian have any ad-libs in the first part?**

**FUJIWARA:** It was just one short line, but in episode 10 after the dodgeball game, when Damian is talking to Anya and the other students, he was originally only supposed to say, "What did you say, Stubby Legs?!" But they let me add in "Huh?! Say that again!" a few lines later. In the second part I'd like to be more proactive about trying different ad-libs, which might make me feel a little closer to Damian as a character.

**Can we request a message for the show's fans?**

**FUJIWARA:** The second part will be starting soon, and I promise we'll work hard to reward your patience! I hope you'll be excitedly awaiting each new episode and wondering things like, "I wonder how they'll adapt *this* scene from the manga to the anime?"

Desmond

## MAIN CAST INTERVIEW 4
### VOICE OF BECKY BLACKBELL

# EMIRI KATO

The voice of Anya's best friend at Eden Academy answers our questions about Becky's appeal and her personal favorite moments.

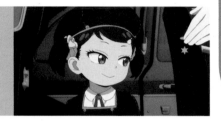

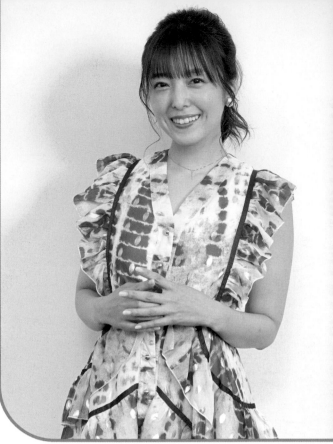

### ● SHOWING THE KINDNESS AT BECKY'S CORE

**What were your impressions of the show as you finished work on the first half of the season?**

KATO: They kept Becky's casting under wraps until the week before episode 6 was first broadcast, so it was agonizing not being able to say anything publicly about the show until then! [*laughs*] When she did appear, I saw a lot of people saying, "That voice is perfect for Becky." That made me extremely happy. Some even said it was the same voice they heard in their heads when reading Becky's lines in the manga. After worrying I wouldn't live up to expectations, I felt that positive response strongly.

**What were some of the challenges or concerns you faced when performing as Becky?**

KATO: While she has very precocious and princess-like sides to her, I was very conscious about conveying that, at her core, Becky is a kind person. Her lines can be rather snooty and I didn't want her to be unlikable, so I tried to balance them out with a sense of childishness so she'd make a more gentle impression. A lot of her scenes are with Anya, so another challenge was how to give her big reactions when Anya's are more subtle, but without overshadowing Anya.

**I imagine Becky, as a character, is expected to have a diverse range of expressions.**

KATO: That's what makes her so much fun to play! I like to think I can make her more appealing with the way she verbally expresses things, as she's exactly the sort of character that feels natural for me to play. I've really enjoyed the breadth of her emotional range.

**In what ways do you think you personally resemble Becky? Are there areas in which you're opposites?**

KATO: I'd like to think Becky's guilelessly authentic personality resembles my own. At least, it would be nice if it did. [*laughs*] I don't possess Becky's strong will at all. When I was a child, I admired friends who were able to stand up to boys and be direct with them the way Becky is.

**What sort of guidance do you remember getting from director Kazuhiro Furuhashi?**

KATO: In episode 11, when Becky has to refer to Anya as "Starlight Anya," Becky responds, "Ugh, what a pain." My instinct was to hit the line lightly, as if she was shrugging it off, but I was asked to make her annoyance more clear. We recorded that line many times and had more back-and-forth about it than any other scene. Outside of that, there weren't many requests for major changes, and they let me perform Becky as I saw fit.

PHOTOGRAPHY: HIDEAKI HASABE
HAIR & MAKEUP: NAO KAWAGUCHI
STYLIST: YUU TAKAHASHI

## Profile

### EMIRI KATO

Born 11/26, originally from Tokyo. Previous major roles include Mayoi Hachikuji in *Monogatari*, Kyubey in *Madoka Magica*, and Mey-rin in *Black Butler*.

**"I WAS VERY CONSCIOUS ABOUT CONVEYING THAT', AT HER CORE, BECKY IS A KIND PERSON."**

**Were there ever times when you had questions about the material for the directors?**

**KATO:** At the first session, I asked what ages Becky and Anya should seem to be, and I was told, "Becky is very mature for her age, so please play the part without any regard for her actual age."

**What are your favorite scenes from the *Spy x Family* animated series?**

**KATO:** I liked the scene in episode 7 where Anya and Becky were having lunch together. Becky casually says things like, "Well, they're nowhere near as talented as *my* chef." I like how we're able to express her wealth through these inadvertent asides. When Damian comes over, she says, "Ew, go eat in your dorm," and you see Becky's childishness emerge. I'm having fun reliving my own childhood through this role.

If I had to pick an overall favorite episode, it would be episode 10, the dodgeball one. It showed off the endearing qualities of Becky and several other characters. There are scenes original to the anime that highlight the friendships within Damian's group, as well as Bill's more childlike side. As for Becky, I love how she immediately comes running over to Anya as soon as the game ends, which shows what a good friend she is. Becky's words of encouragement toward Anya in that part were ad-libs that they kept in!

**Did you have many opportunities to ad-lib?**

**KATO:** Every now and then. There was another ad-lib when Becky tells Damian's group, "You're not supposed to say stuff like that to girls." There are lots of other ad-libs in scenes where they're arguing or reacting to things. Damian's voice actor and I often play off each other in a rapid back-and-forth, and little ad-libs often emerge.

I still remember how Atsumi Tanezaki played Anya in the scene when she punched Damian. It was

so incredible. It left me thinking, "This is going to shape who Anya is as a character."

**So who are your favorite characters in *Spy x Family*?**

**KATO:** They're all so wonderful that it's tough to choose. I really enjoy the brother-sister dynamic between Yor and Yuri. The way Yuri expresses his obsessive love for Yor is so funny, and I love how jealous he gets of Loid. I love that he calls him "Loidy." [*laughs*] They currently don't have anything to do with Becky, but as a fan I look forward to seeing how the siblings' relationship develops.

## ● THE HEALING WARMTH OF *SPY X FAMILY*'S FAMILIAL LOVE

**What are your impressions of the *Spy x Family* manga?**

**KATO:** The stories are so packed with feelings of familial love—I never expected that from the sort of grim spy drama it seemed to be at first glance. I also love the use of color on the covers of the collected volumes. I was a fan of the manga, so I was excited to see how its unique world would be translated into animation.

**Can you share with us some of your goals for the second half of the season?**

**KATO:** Everywhere I go, people tell me, "I'm watching *Spy x Family*." It feels like its growing more popular every day, and it's an honor to be a part of such a wonderful work that so many enjoy. I hope I can help enliven the second part with my performance.

**Do you have a final message for the fans?**

**KATO:** I expect the second part to be full of the incredible stories that resonate in our hearts. I will do everything in my power to make it a show that causes you to feel all warm inside when you watch it.

### VOICE OF SYLVIA SHERWOOD
# YUHKO KAIDA

**1** She's an exceptional handler who keeps an eye on her agents so she can back them up. She's very professional.

**2** "You think we're made of money?!" She's always so cold that I love to see her lose her cool.

**3** I love Anya. It's adorable watching her brain run in circles figuring out how to support her papa's mission or how to keep her family stable without revealing her own secret.

**4** I really enjoyed the stories in episode 9 and the warm feeling they left me with. It shows how you can be a wonderful family even if you're not related by blood just by caring for one another. I wanted to steal so many lines for myself. My favorite was Anya saying, "You seem very green today, Papa."

**5** As a fan of the show, I'm so excited about the second half of the season! I can't wait to see those characters again! Let's all rewatch the first half as we wait!

Profile **Yuhko Kaida**

Born 1/14, originally from Kanagawa Prefecture. Previous major roles include Isabella in *The Promised Neverland*, Shimei Ryomou in *Shin Ikki Tousen*, and Shan in *True Cooking Master Boy*.

### VOICE OF HENRY HENDERSON
# KAZUHIRO YAMAJI

**1** I read the script thinking I was auditioning for some goateed villain, only to discover it was for a very upright, serious, and stylish gentleman!

**2** "Elllleeegggaaaaannnnce!!!"

**3** Yor. The way she looks at you when she's in assassin mode gives me chills. Maybe I'm just a masochist…

**4** Episode 4, "The Prestigious School's Interview." The way Yor landed after stopping that cow made me shiver. Maybe I'm just a Yor fan?

**5** I don't know when Henry will appear again, but in the second part I will aim for ultra-ultimate elegance, an elegance that transcends even "elllleeegggaaaaannnnce," whatever that may be.

Profile **Kazuhiro Yamaji**

Born 6/4, originally from Mie Prefecture. Previous major roles include Kenny Ackerman in *Attack on Titan*, Katsumi Kureko in *Wave, Listen to Me!*, and Gildo Tesoro in *One Piece Film: Gold*.

### VOICE OF EMILE ELMAN
# HANA SATO

**1** Initially, he seems like a suck-up with a foul mouth who's attached himself to a stronger kid, but he did take that dodgeball hit to protect Damian. He has the courage to protect the friends he loves and a kindness that drives him to work hard on their behalf.

**2** I love the scene in episode 10 where Emile says, "You'll always be a true MVP in our hearts." We recorded many variations, and I'm so happy they chose that one.

**3** I've been waiting for someone to ask me. It's Mr. Henderson! He follows the rules and has a keen aesthetic sense, and I consider him to be a very desirable man. The glimpses we see of him outside of school suggest he's a kind man, and I love him!

**4** Episode 10 was so cute! Emile's training session and coordinated dodgeball moves with Lord Damian and Ewen, Anya's "Star Catch Arrow," Bill's fastball, and Becky's banter were all so lively and fun.

**5** To those who can't stand the wait for the second part…I'm in the same boat! Let's all wait like Anya in *wakuwaku* anticipation!

Profile **Hana Sato**

Born 4/26, originally from Tokyo. Previous major roles include USApyon in *Yo-kai Watch!*, Pascal-sensei in *100% Pascal-sensei*, and Nash and Luka in *Black Clover*.

### VOICE OF EWEN EGEBERG
# HARUKA OKAMURA

**1** I think his innocent love of his friends is his most likable quality. How he makes fun of Anya is sort of the flip side of how he idolizes Damian. I tried to focus on his childlike honesty while recording.

**2** I liked the dodgeball episode! I put special effort into Ewen's plaintive wail after Emile blocked the ball with his face. It felt like we were fighting a war together in front of the mic.

**3** As a member of the student body, my heart skips a beat whenever Henry Henderson is on-screen. He's reliable, honest, sincere, and, most of all, elegant with himself and others. I want him to be my life coach!

**4** I love so many scenes in episode 5. There was lots of new-to-the-anime excitement, and the characters and anime production crew were really giving it their all.

**5** Thank you, everyone who watched the first part! The second part will have more *wakuwaku* excitement for you!

Profile **Haruka Okamura**

Born 8/22, originally from Kanagawa Prefecture. Previous major roles include Maid in *Birdie Wing: Golf Girls' Story*, spectator in *Tsukipro: The Animation 2*, and others.

1 What do you find appealing about your character?
2 What do you consider to be your character's best moments and lines?
3 Who are your other favorite characters?
4 Which is your favorite episode and scene?
5 Do you have a message for the fans?

◀◀◀◀◀

VOICE OF CAMILLA

# UMEKA SHOJI

**1** Maybe that she's such a thoroughly awful woman? [*laughs*] I figured there should be no half measures with her, and thankfully they let me throw myself wholly into the role. It was a lot of fun.

**2** When she tries to spill hot gratin on Yor but Yor gracefully catches it, and a little dollop of gratin ends up hitting Camilla's nose. You can see a cute side of her there that I really liked.

**3** Yor. Her thoughts can be violent. [*laughs*] But she's kind and honest and cares deeply about her family. I wish some of her would rub off on Camilla!

**4** Camilla's line in episode 2, "There seem to be a lot of spies around lately, you know?" Also her line about Yor's previous job. Both were excellent. I remember being completely engrossed in the drama of that storyline while recording. It was very clever. [*laughs*]

**5** I think the more you watch *Spy x Family*, the more you fall in love with every character. I hope people will be able to see some of Camilla's finer aspects soon.

**Profile** Umeka Shoji

▌ Born 8/20, originally from Kanagawa Prefecture. Previous major roles include Neko Musume in *GeGeGe no Kitaro*, Amane Sumiragi in *Waccha PriMagi*, and Eri Karen in *Digimon Universe: Appli Monsters*.

VOICE OF MILLIE

# MANAKA IWAMI

**1** Milly uses her femininity to great effect and is so unreservedly honest that she tends to blurt out whatever she's thinking. I really enjoy those two aspects of her personality! [*laughs*]

**2** The scene where she proposed sneaking a booger into the section chief's coffee had a big impact on me. I liked that one a lot.

**3** Anya! Everything about her is just so cute and endearing. Her expressions and unique use of language are so addicting. She has a childlike innocence, but I love that she's concerned about the things happening around her.

**4** I like the scene when Loid puts the ring on Yor's finger. It's so cool and spy-like when he quickly improvises and uses a grenade pin as a ring, and then kneels down and slides it onto her finger even as he's blowing up the incoming attackers. Such a perfect proposal considering what a unique family they are.

**5** I was a big fan of the manga, so as I reflect on my great fortune at being able to be a part of *Spy x Family*, I'll keep working hard to ensure the second part is enjoyable!

**Profile** Manaka Iwami

▌ Born 4/30, originally from Saitama Prefecture. Previous major roles include Rakira in *RPG Real Estate*, Shigutaro in *Phantom of the Idol*, and Rice Shower in *Uma Musume: Pretty Derby*.

VOICE OF SHARON

# MIREI KUMAGAI

**1** I find Sharon's groundedness and rationality interesting. She's also mean, but not thoughtlessly so. I think she and I have a lot in common, so I try to do right by her in the performance.

**2** I like the scene where Yor confides in Sharon about her marital worries, and Sharon shows an unexpected caring side. It didn't end up being voiced, but I did prepare three pieces of ad-libbed advice for her. I'll leave that to your imagination. [*laughs*]

**3** I like the obsessive love Yuri has for his sister, and how he goes all out in the ways he expresses it. I'm the voice of young Yuri as well, so I strongly sympathize with adult Yuri when he appears.

**4** I love the scene in episode 9 when young Yuri gets the top score on a test at school and Yor gives him a kiss as a reward. It's so sweet, and I love everything that happens after as well!

**5** Thank you so much for watching the first part! I've had so much fun watching it along with you every Saturday. I hope you can be patient just a little bit longer for the second part to start airing.

**Profile** Mirei Kumagai

▌ Born 9/30, originally from Shizuoka Prefecture. Previous major roles include Seras Keren in *So I'm a Spider, So What?*, Misato Takachi in *Tsukipro: The Animation*, and Mimori Futaba in *Backflip!!*

VOICE OF DOMINIC

# SHOHEI KAJIKAWA

**1** He's good-natured and takes care of those around him. He speaks his mind, even if he's drowned out. Camilla loves him, so I think he has charming qualities that haven't made it into the manga yet.

**2** I like when he bumps into Yuri in front of his apartment. He's frank with him but keeps a respectful distance.

**3** Definitely Anya! She's so cute and funny. I laughed especially hard at the whole "eat the foulest meal" thing in episode 3. I haven't been able to take my eyes off her since episode 2 when she pretended to be a heartbroken girl with a sob story background.

**4** I'd have to go with episode 1. It had a very different vibe than the "pop music" impression I got when I read the story. The anime preserved all the cool things about the manga!

**5** I'd been eagerly anticipating the anime adaptation of this one for a long time, and I couldn't be more grateful to be able to be a part of it. I want to experience the *wakuwaku* excitement of the second part right along with you.

**Profile** Shohei Kajikawa

▌ Born 6/20, originally from Osaka Prefecture. Previous major roles include Magnus in *Bakugan: Battle Planet*, Namari in *Shaman King*, and various characters in *Moriarty the Patriot*.

SPY×FAMILY

MAIN CAST COMMENTS

# PRODUCTION STAFF
## COMMENTARY & INTERVIEWS

The team behind *Spy x Family* has completed the first half of its debut season and is still hard at work. Nevertheless, Director Kazuhiro Furuhashi was kind enough to answer whether he feels he's succeeded in his prebroadcast goal of creating an "Anya boom."

Despite our late time slot, I'm hearing that Anya's popularity is growing, even within elementary schools. Therefore, I feel we've attained the first stage of our goal. Now, amidst the unimaginable state of the world we find ourselves in, we will continue to animate *Spy x Family* with the belief that if our upcoming episodes introduce even one more person to Anya Forger, we'll have done our part to bring about world peace. Highlights of the second part include dogs and tennis.

### DIRECTOR
# KAZUHIRO FURUHASHI

Profile

Director of *Dororo*, *Mobile Suit Gundam Unicorn*, *Rurouni Kenshin*, and other animated films and series.

**Profile**

**KAZUAKI SHIMADA (CLOVERWORKS)**
Served as character designer and general animation direction for *The Promised Neverland* and *Mahou Shoujo Nante Mouiidesukara* and as animation director for *Encouragement of Climb*, among others.

**KYOJI ASANO (WIT STUDIO)**
Served as character designer and general animation direction for *Attack on Titan* (seasons 1-3) and *Psycho-Pass*, and main animator for *Bubble*, among others. WIT Studio executive.

# PRODUCTION STAFF COMMENTARY

## GENERAL ANIMATION DIRECTOR DOUBLE INTERVIEW

● KAZUAKI SHIMADA  ● KYOJI ASANO

## ● A HUGE REACTION! LOOKING BACK AT THE FIRST PART

**What were your impressions of the show as you finished work on the first half of the season?**

SHIMADA: It was a mixture of relief that we'd made it through safely and questioning whether we could have done just a little bit more… Now that we're in the middle of producing the second part, we occasionally look back at past revisions, but the next job is always hot on our heels.

ASANO: We truly did enjoy the work we did in part 1. It got a huge reaction from people around me, and I was able to enjoy watching it as it aired with my kid. Mr. Shimada's designs had lines that were easy for animators to put into motion, and I think that was the main reason this project was so enjoyable.

SHIMADA: Ultimately, it varies based on what we're adapting, but I always like to simplify the lines on the reference designs as much as I possibly can.

ASANO: A lot of animators want to work on character movement, so everyone fusses over how to minimize the number of lines in each character. When adapting manga, I draw while looking at both our character reference designs and the original manga designs, so I'm always comparing the two and thinking things like, "The way Shimada draws Anya's hair, by grouping the strands together, that is so smart."

SHIMADA: The original *Spy x Family* manga has very well-balanced lines, so I figured the designs would mostly work as is for the anime. I always try to preserve as much of the nuance of the original work as possible. But when it's time to make the characters move, maintaining the consistency of their 3D shapes was challenging. The hair on Anya's head, for example.

ASANO: If you try too hard to make that sort of thing realistic, you'll end up falling down a deep rabbit hole. The manga is drawn in a way where you can perceive her hairstyle from either side view, but in reality…

SHIMADA: In anime, when characters turn around, it often looks like their hairstyle has suddenly changed completely. If you're replicating an existing scene, you can draw it to match that, but working that out when doing your initial reference drawings is difficult. Loid gave us a lot of trouble with that.

ASANO: That's because Loid projects such a wide variety of different impressions. In manga that have run for several volumes, animators must decide which version of the character to model the animated version after. Loid is an *ikemen* type—a conventionally handsome man—but in many of the more recent chapters, he hasn't really been drawn like that. Then it becomes a question of "Is Mr. Endo not drawing him solely as an *ikemen*? And if that's the case, I want to incorporate those design goals into our version."

SHIMADA: Since they have such a wide range of expressions, we had to figure out how many expressions we should include in the reference designs.

ASANO: Anya also has both her normal cute eyes and dot-style eyes for gag faces. I asked our director, "How closely should we try to match the manga's use of gag faces?" I was told, "The manga's art is the correct art." Essentially, while expressing that sort of thing in the anime may be difficult, the more closely we can hew to the manga, the happier fans will be.

**This anime is being produced by two different studios. As the general animation directors for each studio, how has that process been?**

SHIMADA: Even in normal circumstances, I often alternate with other people in the role of general animation director, so it doesn't really change anything.

ASANO: Yeah. It's just too much to ask one person to handle the general animation director's duties for an entire season. The production facilities alternate from episode to episode, so instead of one studio frantically trying to get everything done, sometimes the thought is, "Let's leave this to CloverWorks so WIT Studio can get its own work done."

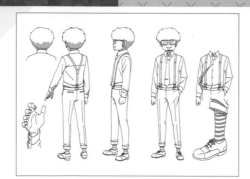

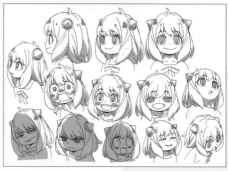

**SHIMADA:** In the end, our job is to draw, so it doesn't matter much whether it's one studio doing it or two.

**ASANO:** Also, [Director Kazuhiro] Furuhashi is aware of everything that's going on, is in contact with all the production teams, and is checking over everything, so he's able to keep everything unified and in balanced.

## ● THE GENERAL ANIMATION DIRECTOR'S JOB IS TO SPEAK WITH PICTURES!

**With you both working as general animation directors for the same project, did you have a lot of preliminary discussion first?**

**SHIMADA:** There was a little bit of back-and-forth on the first episode, but that was about it.

**ASANO:** I was an animation director on episode 1 on a part-time basis, and Mr. Shimada was the general animation director, so I was able to sort of learn on the job. It was mostly me confirming small details like, "The shadows under their chins in the reference documents—should that be a solid fill?" [*laughs*]

**SHIMADA:** For my part, I like to draw things out, then use that picture as the basis for discussions.

**ASANO:** That's the sort of thing you can do when you're dealing with art. Early on, I took my drawings to Mr. Shimada for him to correct, and that's how Mr. Shimada was able to convey his feedback to me. Then, when I was the general animation director on episode 3, I checked other people's work while using Mr. Shimada's corrections as a reference. At first I was doing it sort of nervously, but over time I was able to intuitively grasp the underlying basis for each correction.

**SHIMADA:** I had an earlier project, so I joined *Spy x Family* a little late and had to kind of rush through the reference art. As a result, when we entered production, the corrections were often, "I know it's different from the reference art, but actually this way is better."

**May I ask each of you what you think about the other's working style?**

**SHIMADA:** Mr. Asano is just a ridiculously good artist. When I had him as an animation director on episode 1, he drew the pictures of Edgar, Nguyen, and others from the part when Anya was kidnapped, and they were perfect from the very first draft. They ended up being such cool-looking villains!

**ASANO:** Edgar needed to appear in the promotional video, so that was the first thing I worked on. In the manga, the gun and background looked very real, so the characters were drawn very realistically, and I tried to replicate that realism. But I feel a lot of my own little quirks ended up in his design.

**SHIMADA:** No, not at all! When I checked it, there wasn't a single problem. Incredible work, as usual.

**ASANO:** As someone who isn't responsible for any character design or artwork for publication, I enjoy a lot more flexibility. [*laughs*] I'm always staggered by the size of Mr. Shimada's workload. I've seen this on other projects as well, but having a single designer be responsible for character designs, general animation direction, and key visuals must be brutally exhausting! In effect, that gives him responsibility for the whole project's direction. It's a ton of work and responsibility, and it must be terrible to endure. I can't believe how flawlessly he pulls off all his roles! If I were in his shoes, I'd be living at the office full-time. [*laughs*]

**SHIMADA:** *Spy x Family* did require an unusually large amount of reference work. There are frequent guest characters, and the main characters have a lot of costume changes. But I was able to hand off half the general animation director duties to Mr. Asano here and get help with the remaining half, and somehow managed to get everything done in the end…

**ASANO:** The first teaser artwork made for the anime had two versions, one with their cover identities and one with their secret identities. Once they were fully

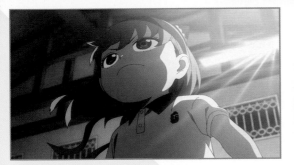

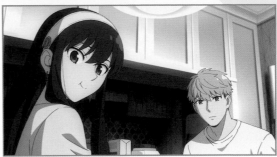

colored and released, it gave us a clear goal for the character designs and facial expressions. As the dual nature of the characters is a key part of *Spy x Family*, having that artwork early in the process was really valuable.

**SHIMADA:** Ah, that teaser artwork… That brings back memories. [*laughs*] I felt like our standards for design and coloring started to come together after the artwork was released.

### Did *Spy x Family* lead to any changes in your working process?

**ASANO:** This is a purely personal thing, but halfway through episode 3 we went completely digital. We'd been following our workflow from previous projects, so we had been doing our checking on hand-drawn art on the basis that "drawing on paper is faster." But due to COVID, we had to work from home, and I couldn't expect people to hand deliver their pages to me. I set up a big digital tablet and started using that and realized, "Oh, digital is fast too!" [*laughs*] After that, the company switched to all digital as well.

**SHIMADA:** It definitely got busy, but it never felt like the old days where we were pulling all-nighters. On *Spy x Family*, we were able to live normal schedules, going to work in the morning and coming home at night. Not that that's anything all *that* remarkable… [*laughs*]

## ● NOTABLE CHARACTERS AND SCENES

### May I ask who your favorite characters were in the first part?

**SHIMADA:** I always enjoy drawing Franky. Handsome characters [like Loid] are tough to draw, but it's relaxing to draw someone like Franky. And since he has a rectangular face with round eyes, it's very easy to keep him in balance.

**ASANO:** I like Franky too. And also Anya.

**SHIMADA:** Don't you find Anya difficult to draw?

**ASANO:** All of the characters are difficult to draw! [*laughs*] Lately I've liked Becky. Once I saw the finished anime with all the voices in place, I thought, "Wait, Becky's cute too?!" Stuff like her little grunts in the dodgeball episode are so funny. I hope she appears more often going forward.

### Do you have any favorite moments from your time working on the first half of the season?

**SHIMADA:** If you mean moments we were individually responsible for, then it would be the car chase in the second half of episode 2. CloverWorks had some of their best people on that one, and I love how it turned out. And the penguin part in episode 12. Animals are always super hard to animate, and I was shocked at how well the art turned out. Of the WIT Studio episodes, I liked the dodgeball game in episode 10. It was comical and interesting, and the effort that went into the animation, like Anya's super move, was incredible! Also, the second part of episode 9, which begins in the morning at the Forgers' home, is very deftly executed, in my opinion. The Yor in that scene is, in my heart, the best Yor of all. [*laughs*]

**ASANO:** I remember how talented the animation directors of episode 9 were. The will-they-or-won't-they kiss scene in the opening part was really well done too. It really captured the tension of the original manga scene well. When my kid saw episode 8, where Yor pulled Loid in for the kiss, they were so upset. "It just ends here?!" [*laughs*]

### There was certainly a lot of action in episode 5.

**ASANO:** We asked Keisuke Ookura, who excels at action scenes, to handle Loidman. I was oohing and aahing as I checked his work. Mr. Furuhashi and his old friend Satoshi Iwataki also did great work on the Yor scene toward the end of the episode. Ookura also handled the dodgeball super-move shot in episode 10, but on action scenes especially, it's always a matter of *how* you respond to the storyboards, and it takes the

talents of a great many animators to make these scenes happen. Fortunately, a lot of those talented animators were eager to participate because they already knew and loved *Spy x Family*.

## ● ENTHUSIASM FOR THE SECOND PART

**What is it that animators like so much about *Spy x Family*?**

**SHIMADA:** Anya has such cute expressions and interesting movements, and there are a lot of animators who would like to animate those. Also, it's a little more approachable because it's a comedy.

**ASANO:** Also, there's the juxtaposition. It has comedy and drama, and there's a solid backbone for both. Whether you want to draw cute characters, action, or Loid and Yor getting kissy-kissy, *Spy x Family* has something for you, and I know a lot of animators like having a variety of challenges. [*laughs*]

**As general animation directors, your role is to standardize the look of the art. What are the challenges and benefits of doing that?**

**SHIMADA:** At its core, what we do is check the individual drawings and unify them into a single consistent work. Naturally, each artist has their own little quirks and variations, so we try to eliminate those and ensure that the quality of the artwork reaches a certain standard.

**ASANO:** As animators ourselves, we too would prefer to be able to draw however we like within the time allowed. [*laughs*] That sort of work is fun, and it's what we used to do. But as general animation directors, we have to look out for things like whether or not the art matches the reference art and whether or not some movement is typical of a character to ensure that the episodes reach the level of quality our viewers expect. So our focus has to be on prioritizing things being done properly.

**SHIMADA:** It's tough work. It can really be quite painful at times. [*laughs*]

**ASANO:** It is! [*laughs*] Getting to draw the art is just so much more fun.

**But it was because of your hard work that the first part was so widely praised for its visual quality.**

**ASANO:** Thank you for saying so. I'm always checking social media to see what people think of the projects I work on. The overall nature of the comments gives me a sense of "Okay, this is the benchmark we need to hit going forward." It's always a challenge to figure out

how much revision you need to do to hit that target in a limited time frame. And then on top of that, we get the producers of *Spy x Family* calling us up to say, "Fix this Anya here!" [*laughs*]

**SHIMADA:** I too am always concerned about fan reactions, but I'm too scared of what the viewers will say, so I almost never look at them. [*laughs*]

**Finally, what can you tell us about the second half of the season?**

**SHIMADA:** Ah, the second part at last. Now that we've all gotten good at drawing the characters, I believe we can further improve the quality and deliver something that transcends the fans' expectations. We promise to work hard to make that happen!

**ASANO:** The incredible response to *Spy x Family* throughout the world has been very energizing for us. We feel a great deal of both pressure and determination to deliver a product that won't embarrass fans of the show or the manga—and that includes ourselves, as many of us are huge fans as well. We're working hard to make that happen as we speak!

## SOUND DIRECTOR INTERVIEW

### SHOJI HATA

**Profile**

**SHOJI HATA**

Worked as a sound director on *Aoashi*, *Edens Zero*, *One-Punch Man*, and *Moriarty the Patriot*, among others.

### ● THE AUDIO TWEAKS THAT MAKE *SPY X FAMILY* WHAT IT IS

**Looking back on the first half of the season, what are your impressions?**

HATA: I knew expectations were high for this project, so even before we recorded, I spent a lot of time making sure everything was on the right track. There was lots of trial and error involved in creating every aspect of the show's aural branding, from the audition and casting to the music composition. Everyone involved had strong opinions about everything, so I compiled and addressed notes from the director, the studio, and the manga team. It took a great deal of time, but everything went quite smoothly when we finally began recording as a result.

**What were your guiding principles when approaching the sound direction?**

HATA: In the manga, there were a lot of unique elements, like mind reading and the heavy use of monologue, and I wanted to make sure I came up with good ways to handle those things. Also, after discussing it with [Director Kazuhiro] Furuhashi, we agreed that making the anime appealing to people who don't usually watch anime should be one of our goals. We wanted to use a lot of traditional and easily understood elements so casual viewers could watch it and think, "You know, anime is pretty cool!"

**The monologues you mentioned are a major characteristic of *Spy x Family*. How exactly did you choose to handle that?**

HATA: In *Spy x Family*, the story unfolds at a fast pace, and the dialogue is often interspersed with narrative monologues. If you don't carefully differentiate between the two, it will appear that the characters are continuing to talk to themselves and the distinction won't register with the viewers. In order to focus their attention on the parts we want them to hear, we vary the volume and ask the actors to be aware of which words they need to draw special attention to. For example, when there's a lot of dialogue or multiple characters are speaking, we want the performers going into the recording sessions knowing which words from which characters need to come to the forefront.

**What other sorts of discussions did you have with Mr. Furuhashi and the producers or the rest of the production staff?**

HATA: It was often stressed that this was a major work that was intended to be enjoyed by a large audience, but at the same time, we were condensing the manga and presenting it in a densely plotted and fast-paced way. If we just strung scenes together, the pacing we wanted would get muddled. Each scene had to have a clear focus that everyone needed to be conscious of. Also, Director Furuhashi places a lot of importance on the audio, so even the tiniest of jokes had to be experimented with repeatedly in the recording sessions until they landed right.

**It sounds like there were lots of things you had to experiment with before you understood what would and wouldn't work.**

HATA: That's true. Casting [Takuya] Eguchi as Loid and [Saori] Hayami as Yor may have been considered very conventional choices, but it took a great deal of trial and error on their parts before they really nailed their roles. It was those performances that established the brand image of the first 12 episodes.

### ● THE WAY THE CAST WORKED

**The cast all spoke of a work environment in which they were allowed to experiment with various ideas. I guess that was part of your plan?**

HATA: Both Mr. Furuhashi and I have the same philosophy of waiting to see what emerges from the actors rather than forcing certain performance styles.

"[WE WAIT] TO SEE WHAT EMERGES FROM THE ACTORS RATHER THAN FORCING CERTAIN PERFORMANCE STYLES."

Sometimes the performances end up being even better than whatever we had in mind going into the session. That's the ultimate reward of trusting your cast. We all have the manga, so we know where the story is going, which means in our sessions we wait and see what the cast will do with that. In particular, [Atsumi] Tanezaki, who plays Anya, has managed to bring out some brilliant and unexpected readings, despite not always having much confidence in them herself. And the performances that emerge from those have really had a big influence on Anya's characterization.

### What sort of direction is given to the cast at these recording sessions?

**HATA:** *Spy x Family* has a lot of humorous dialogue, and we fine-tune those lines very carefully. We want them to be funny, but you can't hit them too hard or it kills the moment, so we need to figure out exactly how serious each line read should be. That's especially true of Loid's dialogue, which requires very careful adjustments to land just right. That said, everyone has such a strong grasp of their character that at this point they do the work without us having to request it.

### What are your impressions of the three members of the Forger family?

**HATA:** Well, I'll start by saying that the one thing they have in common is that they're well acted. When Mr. Eguchi is performing as Loid, he can modulate his voice to an incredibly minute degree. For example, if we ask him "Can you say that a little more strongly?" he can adjust the pitch so subtly that an untrained person wouldn't even notice the difference. He's a fairly quiet guy at work, but he has a real actor's vibe to him.

Ms. Tanezaki is the type of actor who is always agonizing over her performances, trying to get them just right. Many of us on the production staff believe that Anya is the crux of the story, and the Anya that's emerged from Ms. Tanezaki isn't just cute, but some sort of entirely new flavor of cute that could only have come from her.

Ms. Hayami is very good at playing both stillness and motion, and just as we expected, she used that talent to make Yor into the interesting character she is. Even before the show aired, a lot of fans thought, "Yor *is* Saori Hayami," and I think that worked out for the best. Even in our recording sessions, Ms. Hayami deftly strikes the perfect balance between Loid and Anya, and her presence is always strongly felt.

Now that our cast has really come into their own as Loid, Anya, and Yor, I would say that they always all make strong impressions on me.

### Outside of the main characters, are there any cast members who have made an especially strong impression in your recording sessions?

**HATA:** An especially strong impression… I supposed I'd have to say Hiroki Yasumoto's Bill from episode 10. [*laughs*] When I read the manga, I thought, "Kids like this don't actually exist," so after Mr. Yasumoto was cast for the part, I had a lot of trepidation in advance of the recording session. But the instant I heard his very first line, I was like, "Oh, we *did* get this right!" We were all smiles at that recording session.

I'd also say Franky and Mr. Henderson each have charming idiosyncrasies that demand a high level of acting talent. Mr. Yamaji had that voice down from the start. When he screamed out that "elegant" in episode 4, even he questioned, "Are you sure that was what you wanted…?" [*laughs*] I was extremely happy with it.

### What was the concept behind the show's music?

**HATA:** Normally we'd start by hiring a composer, and then I would discuss the setting with them in regard to music and they'd put together a menu of music for the show. But this time it was decided that we wanted music that matched up with the visuals in cool ways and would therefore need to be scored like it would be for a film (where the music is created after the visuals) whenever possible. For example, we scored the

orchestral music toward the end of the first episode, and parts of the vocals in episode 5 were also scored. We devoted a lot of time to figuring out which parts we wanted scored.

Overall, the music is split between two poles, one being the stylish sound that's traditional for spy movies, and the other being the heartfelt music used in domestic dramas.

## Was there anything you were especially particular about regarding the sound effects?

**HATA:** The biggest sticking point was the sound effect for Anya's telepathy. A huge group of people got involved in that decision, even manga creator [Tatsuya] Endo. We considered something like 20 to 30 different variations. It's rare that you see that much work go into a single sound effect!

## What was the basis for your decision?

**HATA:** One basis was matching the impression of the sound conveyed in the manga, and another was the context of what other sounds might be heard in the background as it played. It had to be a good sound on its own, but it was also important that it be clearly distinguishable when there's other background noise or music playing.

## For my final question, can I ask for your thoughts about the second part?

**HATA:** The first half of the season was a process of the show gelling into its ideal form based on a gradual process of trial and error. For the second half, we'd like to show the characters' growth over time—this is where our performances really start to bear fruit. There are new characters who have made strong impressions in their very first sessions. The music also builds our brand image of being both comical and serious, so I hope we can produce a more evolved and interesting show for our viewers.

We in the production team are very much enjoying it, so I hope that our viewers will feel the same sense of *wakuwaku* excitement that we all do. And I hope that they'll continue supporting us so the show can continue for many years to come!

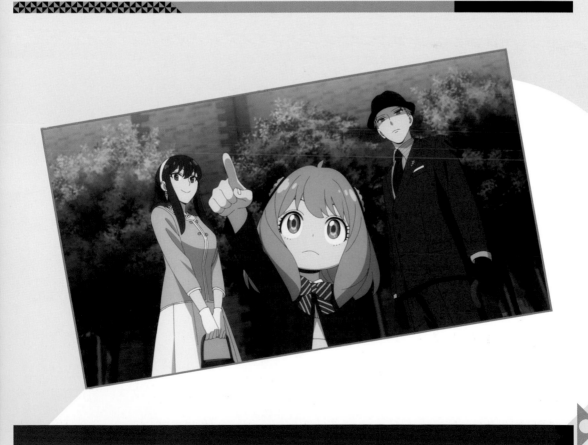

# KEY FRAME GALLERY

# SPY×FAMILY

Key frames are the backbone of beautiful animation. In this section we present an assortment of key frames from memorable moments in the first part of season 1.

## MISSION 1: Operation Strix

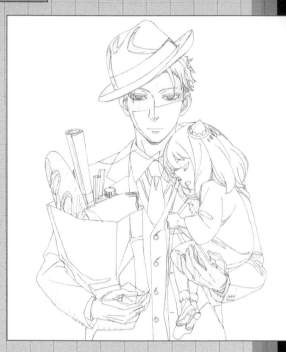

Skin Nguyen wig

## MISSION 2: Secure a Wife

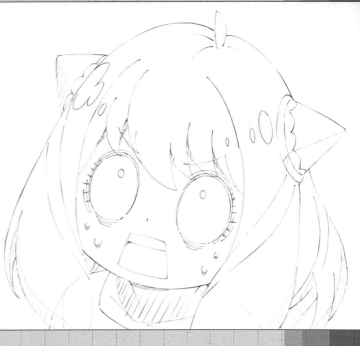

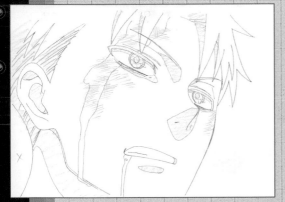

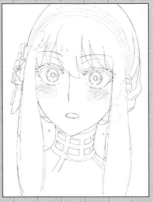

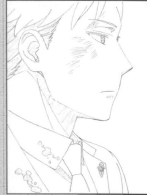

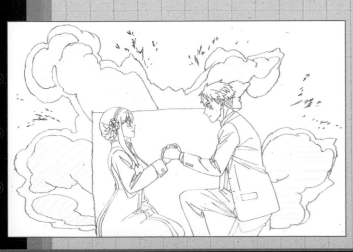

## MISSION 4: The Prestigious School's Interview

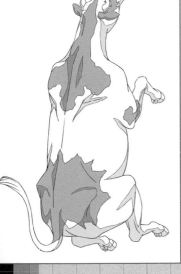

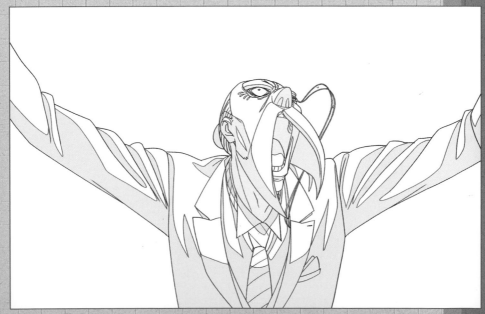

# MISSION 5: Will They Pass or Fail?

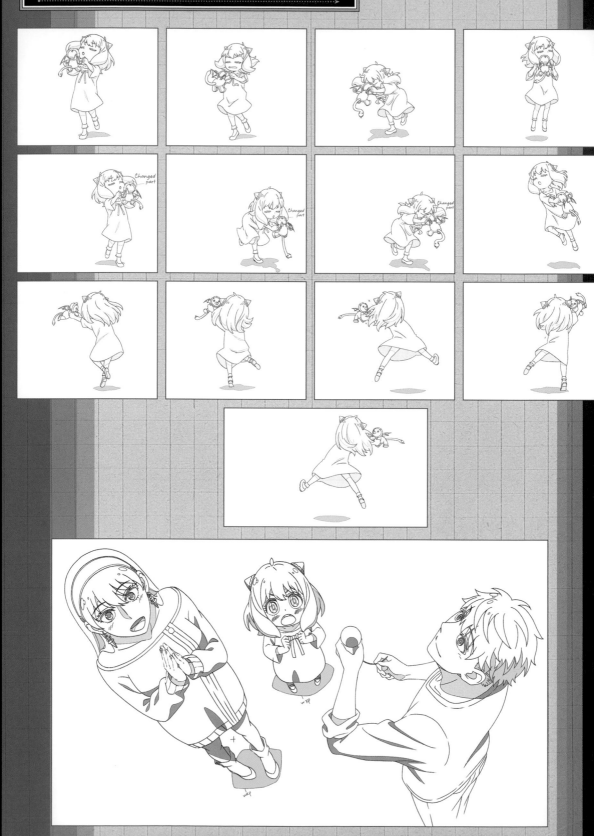

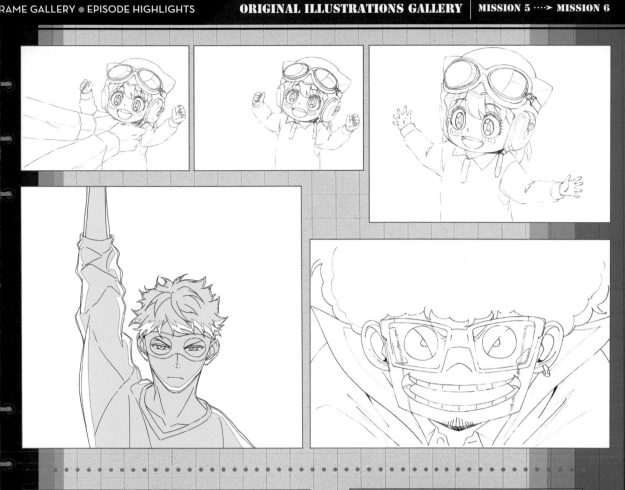

## MISSION 6:
### The Friendship Scheme

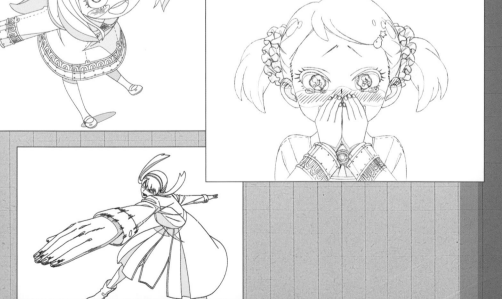

Notebook

Text-
book

Pencil
box

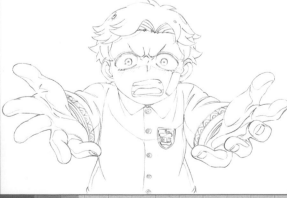

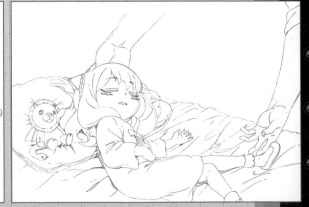

## MISSION 8:
### The Counter-Secret Police Cover Operation

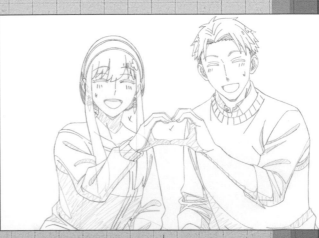

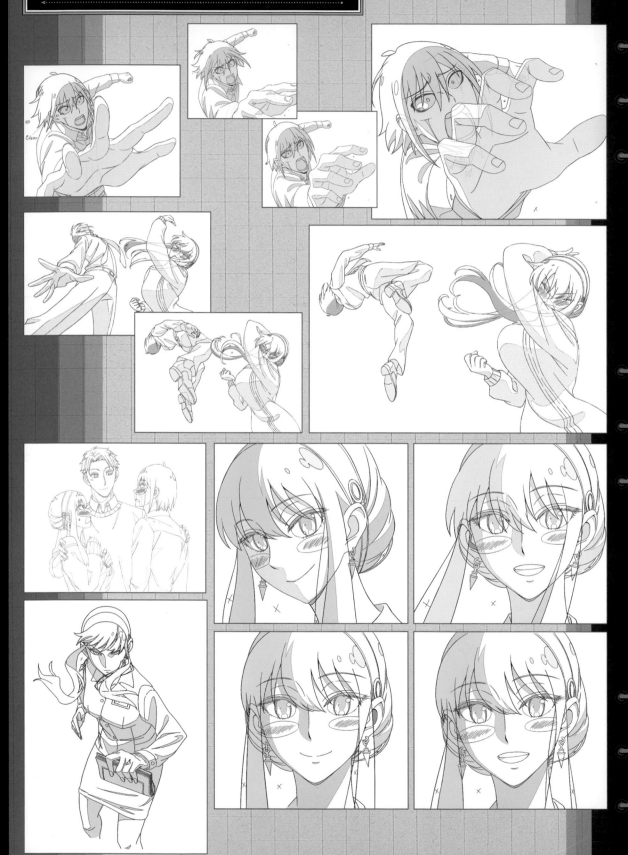

## MISSION 10: The Great Dodgeball Plan

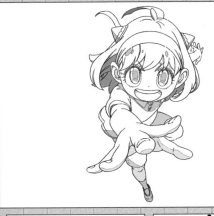

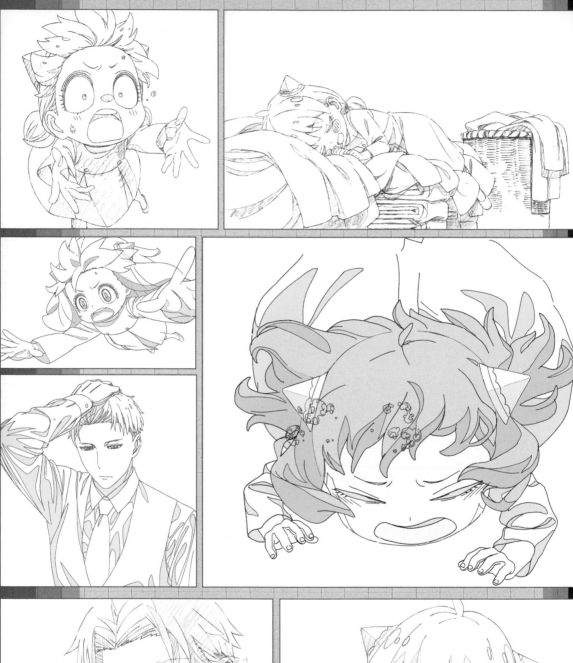

## MISSION 12: Penguin Park

# Opening Animation

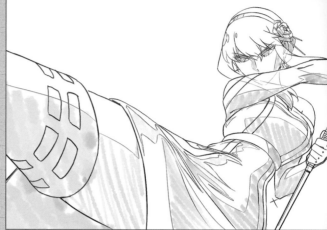

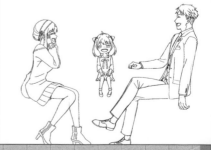

## Ending Animation

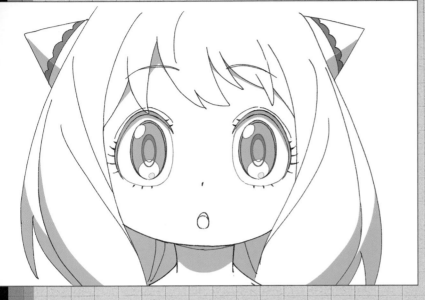

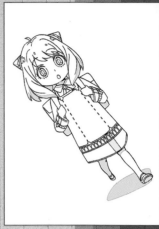

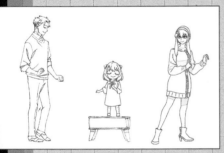

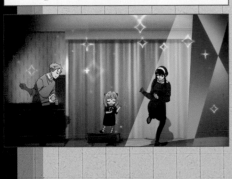

SEE HOW SOME OF THE SHOW'S NOTEWORTHY SCENES WERE CRAFTED AT THE STORYBOARD STAGE. THE SUBTLE CHARACTER MOVEMENTS AND EXPRESSIONS ARE A LARGE PART OF THE ANIME'S CHARM.

## Papa's a Cool Liar

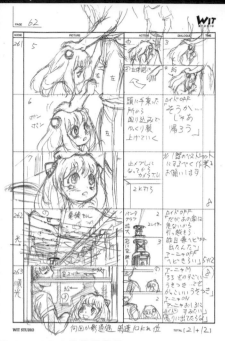

Having driven away the gangsters, Loid and Anya return home. After Anya runs up to Loid, you can tell from his hand movements as he comforts her that the nature of their relationship has changed.

## Anya Passes the Admissions Test

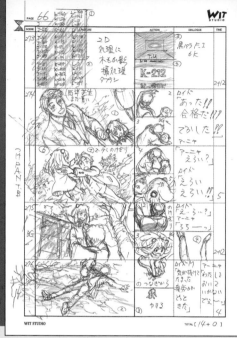

Loid and Anya rejoice after seeing her number on the board. Even calm and collected agent Twilight forgets himself for a moment in celebration. His collapse from exhaustion is carefully detailed.

## Battling the Smuggling Ring

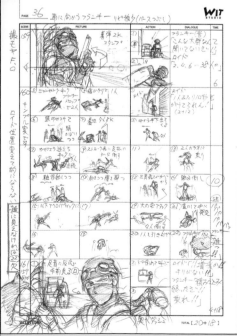

In the battle scene against the smugglers, Loid's takedown of 38 enemies is tightly packed onto one storyboard page. Notice how energetically Loid bounces from shot to shot.

## Yor's Concussive Recovery Method

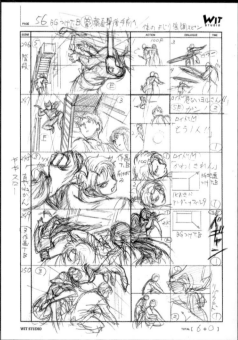

In this scene, Loid and Yor escape together. Note the knife-wielding foe striking from above and Yor's kick coming in from off-screen. The smooth movement and camera angles give the scene visual depth.

## MISSION 1

**OPERATION STRIX**

## MISSION 2

**SECURE A WIFE**

## MISSION 3 — PREPARE FOR THE INTERVIEW

### Anya Helped Clean?

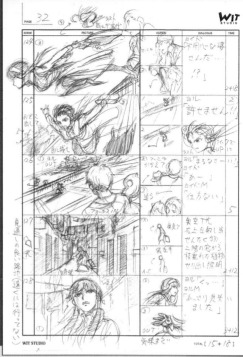

Part of a scene original to the anime that takes place after Yor moves in. Yor seems charmed by Anya and Loid's sharp repartee and is eager to join their lives.

### Yor Takes a Dive

In the anime version of this scene, Yor abruptly leaps into pursuit of the purse snatcher. A mix of close-ups and distant shots centered on Yor deepen the depth of the action.

## MISSION 4 — THE PRESTIGIOUS SCHOOL'S INTERVIEW

### Shocked by Elegance 1

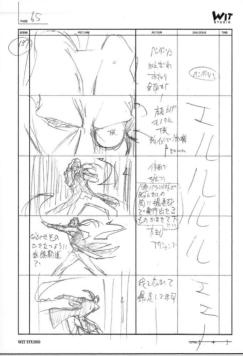

Henderson's scream is one of the highlights of episode 4. The camera zooms out from a tight close-up to a full-body shot showing the action. The comments note that he's "gotten carried away in his excitement."

### Shocked by Elegance 2

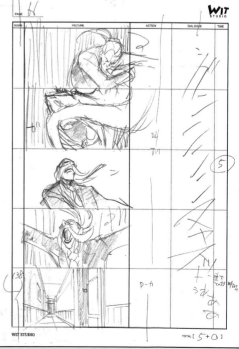

In the second part of this elegant scene, Henderson spins, his hair disheveled, and spreads his arms as he finishes shouting the "nnnnce" of elegance. Such a magnificent spasm of passion!

## Loidman vs. Yorticia 1

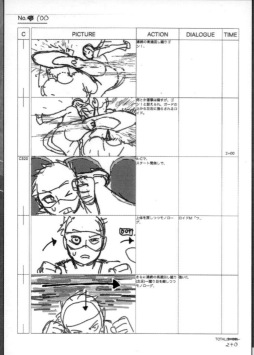

## Loidman vs. Yorticia 2

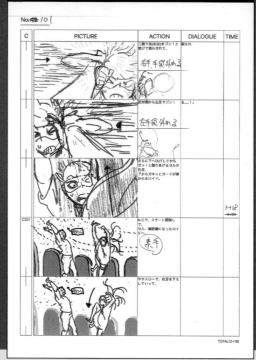

★MISSION★
# 5

## WILL THEY PASS OR FAIL?

The climactic moment of Anya's save-the-princess game, in which a monstrous Yor dishes out a series of rapid spin kicks as effortlessly as if it were a light volley of jabs.

Loid is focused solely on defending himself. The storyboards even detail the shredding of his gloves! Yor breaks through his guard and begins sliding into her next attack in slow motion...

## Anya's Killer Punch 1

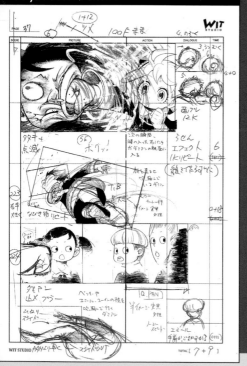

## Anya's Killer Punch 2

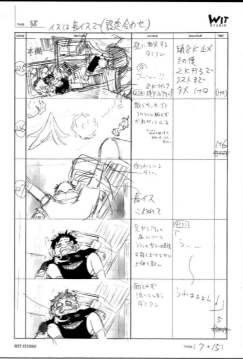

★MISSION★
# 6

## THE FRIENDSHIP SCHEME

Anya unleashes the killer punch Yor taught her. Just like in the manga, the anime emphasizes the sense of movement in the buildup to the punch. The storyboard details the twisting of Anya's fist and the aftereffects.

This storyboard shows Damian after he's sent flying. In contrast with the punch, this moment unfolds more slowly. After a proper amount of buildup, Damian bursts into tears.

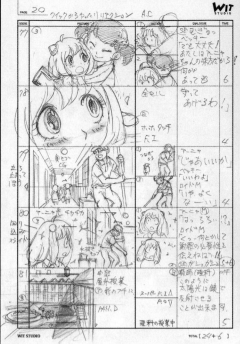

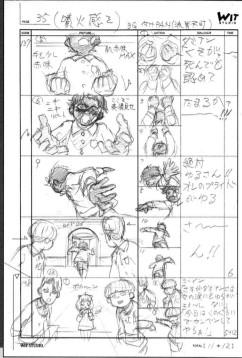

## MISSION 7 — THE TARGET'S SECOND SON

### Becky's Friendship

Becky shows her deep affection for Anya. The storyboard details Becky's hug and Anya's response in this precious moment. It also notes every subtle movement of Loid, who has infiltrated the school.

### Damian's Pride

Sent reeling by Anya's tears, Damian loses his cool and runs away. To best express his emotional state, the storyboard artist shows his face as little as possible, focusing instead on his hand gestures and reddening skin.

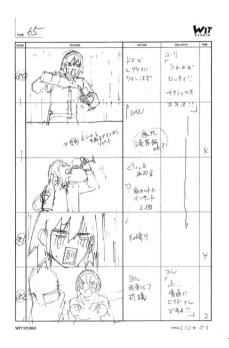

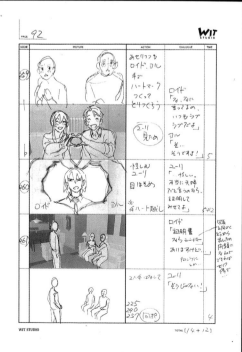

## MISSION 8 — THE COUNTER-SECRET POLICE COVER OPERATION

### Drunken Yuri's Wail

To illustrate Yuri's drunkenness, the screen is blurred between two close-ups, followed by [voice actor Kensho] Ono's memorably plaintive wail.

### Proof of Their Love

Loid and Yor's perfectly "in sync" lovey-dovey scene. In the manga they show pictures, but in the anime they make a heart with their hands. The shot of a doubtful Yuri through their hand heart is inspired.

## The Bashful Slap 1

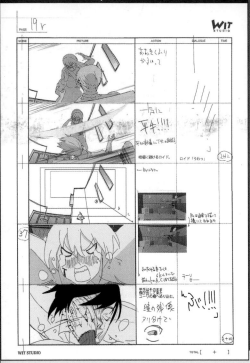

Just as Loid and Yor are about to kiss, Yor is unable to contain her embarrassment and lashes out with a slap. Loid narrowly dodges, but his windswept hair testifies to the power of the slap...which then connects with Yuri.

## The Bashful Slap 2

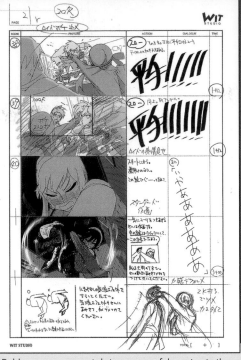

Bold camera movements bring a sense of dynamism to the action, and the bold lettering of the word *SLAP* speaks to the storyboard producer's intentions. They also provide specific instructions for how Yuri is sent flying afterward.

## Bazooka Bill's Power Shot

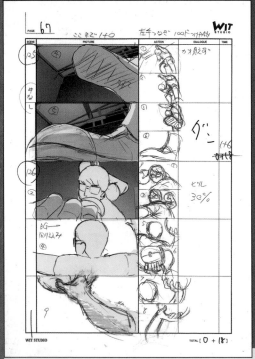

Bazooka Bill's memorable first throw! We see his heavy footfall and his arm slowly lifting the ball. The camera's movements almost seem farcical, but they build anticipation for the powerful shot to come.

## Star Catch Arrow

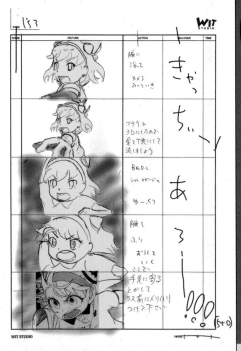

The game is settled by Anya's killer shot! The camera lingers on her dramatic throwing motion for longer than it did for Bill. Stars erupt from behind her as the voltage rises.

**MISSION 9 — SHOW OFF HOW IN LOVE YOU ARE**

**MISSION 10 — THE GREAT DODGEBALL PLAN**

## MISSION 11 — STELLA

### Anya's Athletic Prowess

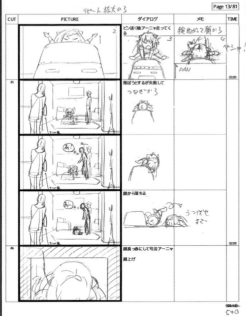

To earn a stella star, Anya demonstrates her athletic prowess by battling a vaulting box at home. Her ensuing tumble and fall are depicted in great detail in a cute and humorous fashion.

### Anya Struggles in the Pool

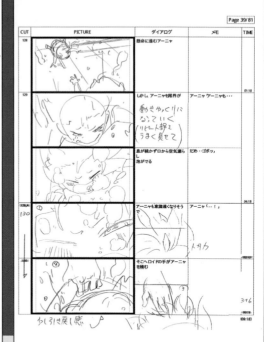

Anya leaps into the pool to save a drowning child! She finds herself in increasing danger underwater, and her distress is clearly expressed through her facial expressions and dialogue.

## MISSION 12 — PENGUIN PARK

### Moved by All the Fishies!

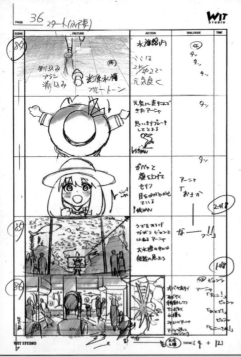

The Forger family arrives at the aquarium. Anya is delighted by the giant tanks that surround her. The storyboard artist mandates brisk, lively movements to match the tempo of the dialogue.

### There's No Time for Crying

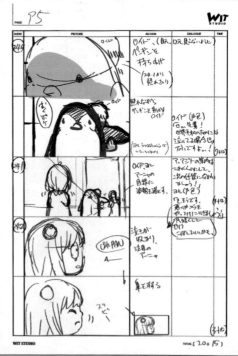

To cheer Anya up, Loid endures a humiliating game of make-believe. His and Yor's embarrassment is depicted in great detail. The stages of Anya's sniffle are adorable too.

# SOCIAL MEDIA ILLUSTRATIONS
## FROM THE PRODUCTION STAFF

THE PRODUCTION STAFF FREQUENTLY POSTS ORIGINAL ART ON THE ANIMATED SERIES'
OFFICIAL SOCIAL MEDIA ACCOUNT. WE'VE COMPILED SOME OF OUR FAVORITES HERE!

## THE COUNTDOWN TO THE PREMIERE OF PART 1

**8** EIGHT DAYS TO GO! SHUNSUKE AOKI

**7** SEVEN DAYS TO GO! SAORI YONEZAWA

**6** SIX DAYS TO GO! YUU MATSUO

**5** FIVE DAYS TO GO! RYOUSUKE NISHII

**4** FOUR DAYS TO GO! KEISUKE OOKURA

**3** THREE DAYS TO GO! RYUU MIURA

**②**
**TWO DAYS TO GO**
**TATSUYA MURAKAMI**

**①**
**ONE DAY TO GO**
**KAZUAKI SHIMADA**

COMMEMORATING HITTING 500,000
FOLLOWERS ON THE OFFICIAL
SOCIAL MEDIA ACCOUNT

KYOJI ASANO

COMMEMORATING HITTING
ONE MILLION FOLLOWERS

KAZUAKI SHIMADA

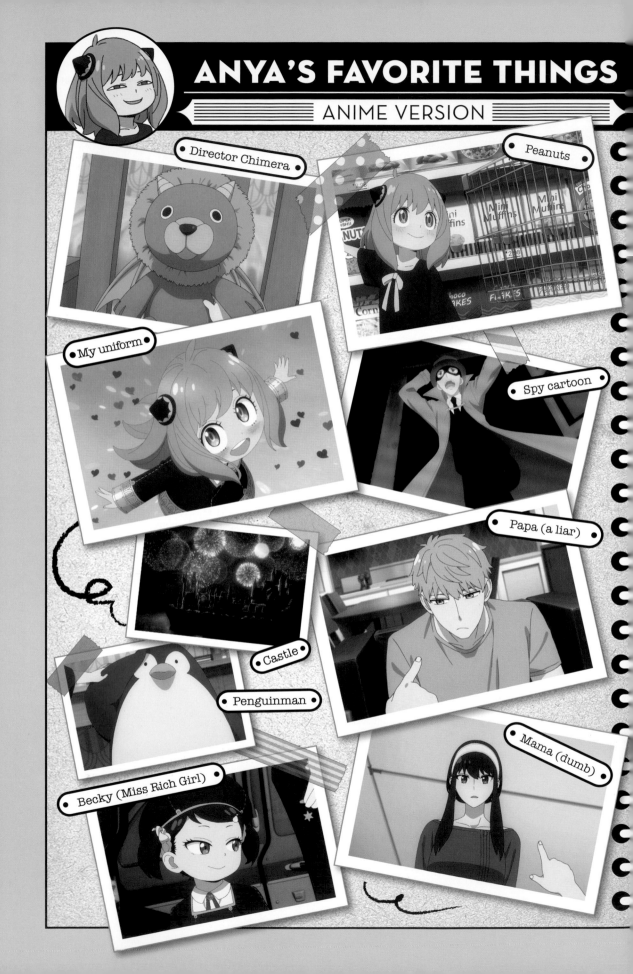

# SPY×FAMILY

## → THE OFFICIAL ANIME GUIDE ←

## MISSION REPORT: 220409-0625

## FILE V

# ORIGINAL MANGA REPORT

The creator of the original Spy x Family manga has been involved with every aspect of the anime adaptation. Let's find out what the father of *Spy x Family* thinks of the results!

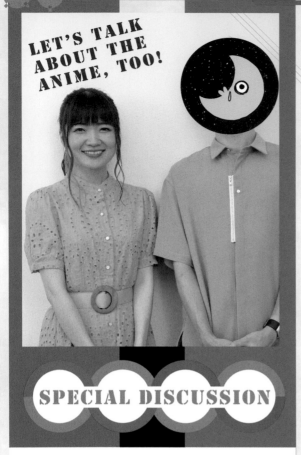

LET'S TALK ABOUT THE ANIME, TOO!

## SPECIAL DISCUSSION

## TATSUYA ENDO
✕
## ATSUMI TANEZAKI

After talking on a radio program, these two reunite for an extended conversation. Are they more alike than you might think?!

● PHOTOGRAPHY: HIROKO KIKUCHI
● HAIR & MAKEUP: LISA SUGAHARA
● STYLIST: YUU TAKAHASHI

### WHEN MR. ENDO WAS ON MS. TANEZAKI'S RADIO SHOW

**Mr. Endo, in June you appeared on the radio progra* *Atsumi Tanezaki Wants Sushi!* What were your though* about it at the time?**

**ENDO:** Looking back on it now… I was so nervous that I do remember much of anything. [*laughs*]

**TANEZAKI:** I have nothing but regrets about that! I wish I had go ten into a better rhythm and asked you more questions… Howev* our listeners seem to have enjoyed it regardless. For example, t* part about how you and Mr. Lin [the editor of *Spy x Family*] wou* discuss a single line of dialogue over the phone from the mome* he got onto the train to the moment he got off was very well * ceived! It was a relief to me to be able to introduce our listeners * some things that weren't widely known.

**ENDO:** These "regrets" you mentioned—I think the casual enviro* ment of your show and your nervousness were why I was able to ta* to you despite my own anxieties. It was a lifesaver.

**TANEZAKI:** Like being in a haunted house, where standing ne* to someone who's more scared than you paradoxically calms y* down—is that the logic? If so, I'm glad it worked out that w* [*laughs*]

**Were there other specific questions you had wanted * ask on that program?**

**TANEZAKI:** Personally, I wanted to ask Mr. Endo about the peri* of "therapeutic rehabilitation" he was in before *Spy x Family* we* into serialization, but we had limited time available on the progra* so I restrained myself. I would have asked why you entered rehab* itation, what was involved, etc.

**ENDO:** If I were to answer that honestly, it would turn into a ve* long and dark conversation. [*laughs*]

**TANEZAKI:** Oh, I would imagine… It's just that my own life is * full of anxiety that I couldn't help but wonder! [*laughs*]

**ENDO:** And yet you seem to be having so much fun while you* working. I suppose there's another side to that, right?

**TANEZAKI:** It's because we enjoy things that they end up hurtin* so much, right? I still think this is the only possible job I could d* I devote my full energies to it, but as soon as the recording sessi* ends, I immediately start thinking things like, "Was there a bett* way to express that?" There are so many talented voice actors that* makes me think, "It's a miracle I've survived at this job for as lo* as I have" and "What do I need to do to keep being able to wo* alongside these talented people?"

**ENDO:** I think that goes to show how seriously you approach yo* work. At the time, I couldn't deal with my work at all. Or may* it was more that it got so painful that I ran away from it. [*laughs*]

**TANEZAKI:** But if all you did was run away from it, this in* credible work of yours would never have been created.

**ENDO:** I guess the reason for my rehabilitation period was s* I could return from my abandonment of my work. For abo* ten years, making manga hadn't been very enjoyable for m* It had nothing to do with my level of success or the nature * what I was making. It was a purely psychological issue. B* after struggling through various things, I think I'm now ab* to approach making manga in a slightly more optimistic wa* I even wrote "Manga is fun!" on a piece of paper and tape* it to my bedroom wall, as if to try to persuade myself in* believing it. [*laughs*]

**TANEZAKI:** When I go to work, I too am always tellin* myself, "Let's have fun!" [*laughs*] But, Mr. Endo, even durin*

our rehabilitation period, you were still drawing as an assistant for other manga creators, right? Why was that?

**ENDO:** Because just like you [with voice acting], I think manga is all I can do. No matter how painful it gets, I cling to it because I don't feel I have any other options.

## MS. TANEZAKI'S ACTING RANGE

**Mr. Endo, you've been effusive in your praise of Anya's voice.**

**ENDO:** I had the privilege of participating in the audition phase. Whenever Director Furuhashi and his team asked Ms. Tanezaki to change some aspect of her performance, it would change completely, and she blew everyone else out of the water. I wanted to shout, "This is it!" Getting her to play the part was such a relief to me.

**TANEZAKI:** I've mentioned before that in the first stage of auditions, when we were submitting tapes, the right performance hadn't really come to me yet.

**ENDO:** At the tape stage everyone submitted "cute little girl character" voices. But the Anya in my head was never like that. She had more of a *Chibi Maruko-chan* voice. We asked all the actors to do different voices, and I had Mr. Lin talk to them about letting me sit in on the auditions. When I saw Ms. Tanezaki audition, I was amazed at her range. Later, when I went to the acoustic room for a meet and greet with the cast and I got to hear Ms. Tanezaki's normal speaking voice, I was kind of relieved? I thought, "Oh, she actually created a character for the performance!"

**TANEZAKI:** This isn't limited to Anya, but I almost never consciously create a voice for a part. It's interesting that you see that as creating a character... You could say the voices usually come naturally to me as I think about the character? I guess that's why Anya, who is so expressive, is expanding my range in so many ways.

**What are some of the Anya moments you enjoyed in the first part?**

**ENDO:** In episode 11, when Anya fantasized about being invited to Damian's house and Ms. Tanezaki mimicked Loid's, Damian's, and Donovan's voices, I thought that was hilarious.

**TANEZAKI:** At the recording session, I asked if we could do it that way. The original plan was to have each actor perform their own role, but since it was in Anya's head, they agreed to let me try. I was so happy they used that version, and I'm relieved that you found it so funny! [*laughs*]

**ENDO:** That shows your great work ethic. When I sat in on recording sessions, you were always asking if you could do retakes of your lines. I could sense your passion for the role.

**TANEZAKI:** But in my head, I'm always thinking, "What if I propose we do it this way, and then the joke bombs?!"

**ENDO:** That you're knowingly taking that risk and doing it anyway is what makes your attitude so great.

**TANEZAKI:** Well, I'm able to do that because there are people who will make the final judgment for me.

## "IN MY HEAD, I'M ALWAYS THINKING, 'WHAT IF I PROPOSE WE DO IT THIS WAY, AND THEN THE JOKE BOMBS?!'" —TANEZAKI

They're able to look at it from an objective standpoint and say what will or won't work. I'm such a big fan of the manga that I have lots of ideas, but in animation there are issues of flow, tempo, and length. If I get frustrated that there are things I can't do, I try to get away with as much as I can and be flexible when I can't.

**ENDO:** Honestly, maybe it would be better to just have the entire show be in your voice. Like the entire narrative was a fantasy of Anya's. In the end credits it would list every character's name with "Atsumi Tanezaki" by them. [*laughs*] Although your workload might end up being a little much...

**TANEZAKI:** That would certainly be a once-in-a-lifetime opportunity, so I'd be down for it! [*laughs*] Even if it isn't a full episode, maybe just half of one.

**ENDO:** Another moment I liked was when Anya was dancing and singing while watching TV in episode 2. You can't hear it very well in the episode, but I had a good laugh at that in the recording session.

**TANEZAKI:** Before we recorded that, they played the music for me from the show Anya was watching. My hope had been to have Anya humming along to it, but a little off sync. However, when they played it for me the composition was pretty complex, and instead of being just slightly off, I wasn't able to remember the tune at all! But the whole thing had been my idea, so I had to frantically try to figure out a way to do it!

**It sounds like a lot of ideas are proposed during the recording sessions.**

**TANEZAKI:** It helps that at the time we do the recording, the visuals are mostly finished. I can see how Anya is moving in the scene, which inspires new ideas. Though I don't decide what ideas get used, I try to suggest them as frequently as possible.

**ENDO:** Manga is pretty similar in that respect. Once you start doing the art from your script or storyboards, new dialogue often comes to you. That's especially true of humor. I almost never start with a plan to have a character say some funny thing—those lines come to me once I can see the situation and flow of the scene.

I also want to call out the moment in episode 6 when Anya goes to the park and is showing people her uniform. The "This is my uniform. Ta-da!" part. You used this very flat intonation that still sounded cute. You do that in other scenes sometimes, and I love when you choose to perform it that way.

TATSUYA ENDO

SPECIAL DISCUSSION

ATSUMI TANEZAKI

EN DO

TA NE ZA KI

MISSION REPORT: 220409-0625 ● 151

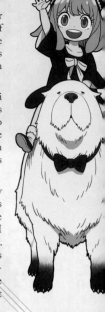

**TANEZAKI:** When I read that scene in the manga, I thought, "I want to actually say the *baan* sound effect ["ta-da" in the English version] that's on the page." I really love the sound effects you use in the manga, especially the *dotanko dotanko* ["trot trot"] when Bond is running. [*laughs*] And the *sowawa sowawa* ["fidget fidget"] when Anya is waiting for Bond, and so on. I thought it would be fun to get a bit of the flavor of the manga pages into the dialogue.

**ENDO:** Thank you for paying such close attention to these tiny details!

**TANEZAKI:** I'm still pretty inexperienced as a voice actor, and I question myself after takes, but once the director gives me the thumbs-up, I never ask for another take unless something has gone horribly wrong. Still, sometimes I leave feeling "I wish I could do that one again…"

**ENDO:** I'm the same way when a manga chapter doesn't come together the way I want it to. I trust my editor, Mr. Lin, and if he says it's good, then I'll think, "Yeah…all right, then I guess it's good enough." Previously I've pushed too hard to make it something that *I* am satisfied with, and then I fall into a rabbit hole of revisions, and it just ends up getting even worse.

Separately, I like doing little side things I can sneak into the corner of panels that have nothing to do with the main story, like when Bond ate Yor's cookies and died. Those sorts of things I frequently end up being happy with.

**TANEZAKI:** I can be like that during recording sessions. Making anime requires lots of people to row in the same direction, but sometimes there's some aspect that's insignificant enough that you can use it to express yourself a bit.

**ENDO:** I assume that's when the directors don't have anything specific in mind, and the cast is free to have some fun with it. I imagine you must look forward to that moment when you hear, "Ms. Tanezaki, that's perfect!"

**TANEZAKI:** You've come to a fair amount of our sessions, and when we're in that situation and a performance gets the thumbs-up, there is such a feeling of relief that not only did we get something approved, but it happened with *the writer of the manga sitting there watching.* I know you're a busy man, but I would love it if you could keep coming to see us record! [*laughs*]

### In those sessions, has Ms. Tanezaki ever had any questions for you, Mr. Endo?

**ENDO:** I believe you asked me some questions when you were recording the admissions interview part of episode 4?

**TANEZAKI:** It was about the scene were Anya cries, "Ma…ma…" I wanted to know how clearly Anya remembered her mother at that point in the story.

**ENDO:** I don't confirm most things one way or the other and leave it to the cast's imaginations. If there's something that doesn't feel right to me, I convey that to the sound director.

### CHARACTERS, LINES, AND…SOUNDS?

### Ms. Tanezaki, what are some of your favorite things about Anya from the manga?

**TANEZAKI:** I love it when Anya messes up the pronunciation of words, but I also love it in episode 4 when they're heading to the interview and she says, "I have a booger I gotta pick!" [*laughs*]

**ENDO:** What a completely ridiculous line. [*laughs*]

**TANEZAKI:** But being able to say that line made me so happy, along with Loid's response of "Absolutely not!" Also, I love stuff like that

haughty little expression she had after she won her stella star. In terms of chapters, I liked when they made the griffins in art class (Mission 25). That has the same place in my heart as the Eden Academy admission chapters.

**ENDO:** [Loid voice actor Takuya] Eguchi cited that same chapter as one of his favorites, and for my part, I just have to say… why? That's certainly not one of the ones that I was satisfied with. (Although admittedly, there are very few chapters that meet that standard.)

**TANEZAKI:** There are lots of reasons! My favorite character, Mr. Henderson, has lots of funny monologues. Then there was their appraisal of the griffin child—I laughed so hard I thought I might die. There were some good sound effects too, like Anya imagining the griffin flying with a *shugoo* sound ["pshoo" in the English version]. You have such a great ear for onomatopoeia.

**ENDO:** I see sound effects as another opportunity for humor an choose them accordingly. Hiroyuki Nishimori, a manga creator deeply respect, always used onomatopoeia to such cute and funn effect that I use his work as a reference. The *dokinko dokinko* soun effect comes straight from his work, I believe.

Changing the subject a little here, when I wrote a recen chapter about Anya and Henderson in the manga (Mission 64), i my own head I heard Ms. Tanezaki and [Henry Henderson voic actor Kazuhiro] Yamaji doing the voices for the characters. Tha was quite the new experience for me.

**TANEZAKI:** When I read that chapter, I immediately though "I'll get to work with Mr. Yamaji again!" [*laughs*] But nothin makes me happier than hearing that my voice plays in the head c the creator of the original manga. Thank you!

### What other impressions has the manga left on you recently?

**TANEZAKI:** I always love the Bond-centric chapters, but I especiall liked the chapter that featured Franky and Bond (Short Mission 8)

**ENDO:** I made that Short Mission after the arc about Loid's pas left me an emotional wreck. I just wanted to do something tha wouldn't cause me a lot of mental or physical strain.

**TANEZAKI:** I did wonder if writing and drawing that sort of thing would be hard on the person writing it…

**ENDO:** It was. Having to think about serious issues for a long tim always has considerable repercussions for me. And then there wa the timing of that arc, considering what was going on in the worl And finally, there was simply the physical toll that my schedule ha been taking on me.

**TANEZAKI:** And just as you were becoming exhausted, your reader were also thinking, "Boy, am I ready for some comedy again." An that's when the Fluff-and-Scruff type of stories tend to hit, isn't it

**ENDO:** On a production level, I do consider those opinions a much as I can. When I see comments saying, "We haven't see much of Anya lately," I factor that into my thinking. I also try t have a good balance of stories in the collected volumes.

**TANEZAKI:** So you consciously create the great balance found i *Spy x Family*!

## GREAT TALENTS CLASH!

**TANEZAKI:** During a *Spy x Family* promotional TV appearance, the cast members portraying the three Forgers all drew pictures, but I couldn't draw a bold piece of artwork like Mr. Eguchi and [Yor actress Saori] Hayami could, so I drew a bunch of extra lines to make it look like I knew what I was doing. When you sketch, do you have a clear idea of what lines you need to draw from the start?

**ENDO:** By manga artist standards, I am not too confident in my art and draw a bunch of lines to compensate. I just draw a lot and then trace the right lines with a pen.

**TANEZAKI:** I'm afraid to commit to any lines. But as an amateur who doesn't understand the fundamentals of art, I guess I'm free to do whatever I want but afraid to at the same time. [*laughs*]

**ENDO:** The image people have of talented artists is that they use fewer lines. Animators truly do know how to make clear figures with a minimal number of lines. Mr. Eguchi's and Ms. Hayami's lines may be bold, but I believe that's because they're bold at heart. [*laughs*]

**TANEZAKI:** That's so true! I'll never beat them! I'm embarrassed to be so timid in comparison. That's why I want that drawing segment abolished immediately.

**ENDO:** No, that part's always so entertaining. I want them to keep doing it!

**TANEZAKI:** Harsh… [*laughs*] Fine, do you have any advice so I can at least look a little more competent? Like, "If you just draw this, you'll be fine."

**ENDO:** If there really was a trick like that, every manga artist would use it! [*laughs*] Those two are just in a different league from you, so you have no choice but to go in a different direction.

**TANEZAKI:** So stop trying to win on impact and win on composition instead…

## GREAT EXPECTATIONS

**ENDO:** By the way, were the questions you asked on your radio show solicited from the listeners?

**TANEZAKI:** No, I guess I figured it was too important to hand off like that. A broadcast writer wrote me an interviewer's guide that was the most polite document I'd ever read in my life. But I was so phenomenally bad at keeping the program moving forward that I wasted all our time, and I deeply regret it.

**ENDO:** I know I said this before, but I still maintain that that's one of the charms of your program. I like the informal vibe.

**TANEZAKI:** When I was interviewing you, I felt so many things I couldn't put into words. It was so frustrating.

## What did your listeners think of the interview?

**TANEZAKI:** I did get a lot of emails from listeners who were trying to cheer me up. [*laughs*] Things like "You don't need to feel so bad

> ## "NOTHING MAKES ME HAPPIER THAN HEARING THAT MY VOICE PLAYS IN THE HEAD OF THE CREATOR OF THE ORIGINAL MANGA." —TANEZAKI

about how that went!" and "I enjoyed learning things I didn't know about Mr. Endo!"

**ENDO:** At the end of your radio programs, you always say you have regrets. Is that because you *want* to have regrets? [*laughs*]

**TANEZAKI:** I think it's more that when I'm left to my own devices, I automatically start regretting things. So I figured I might as well make that a show segment.

**ENDO:** And the way you let us hear it is so funny. It's like you're fading out on a high note. [*laughs*]

## Do you think that Anya is the sort of character who regrets things the way Ms. Tanezaki does?

**ENDO:** No, absolutely not. [*laughs*] Every now and then she apologizes to Loid about something, but that's probably just her way of getting out of the situation. Even after she gets a tonitrus bolt, she immediately forgets all about it. I guess kids are like that.

**TANEZAKI:** Did you do any research about how to write child characters?

**ENDO:** Not especially, no. You know how you build a vague impression of children from watching TV? I just draw from that. I wonder if you do the same thing when you're portraying children.

**TANEZAKI:** Yeah… When there's children on the train or something, I certainly try to pay close attention to how they talk.

## May I ask you each for one final message for our readers?

**ENDO:** Ms. Tanezaki's portrayal has been fantastic from the start. She had so many hilarious unused takes that I hope they compile them all for a special feature someday. I hope you'll all continue watching! I'm certainly looking forward to hearing them record it.

**TANEZAKI:** I enjoy everything about the *Spy x Family* manga, right down to the sound effects! Please continue to entertain us as you always have, Mr. Endo. I promise we'll continue doing our best to express it in animation. Thank you very much!

TA·NE·ZA·KI

# SPY×FAMILY

The original *Spy x Family* manga continues with serialized releases and collected volumes and is only getting better with the addition of new characters and storylines. If you haven't read it, it's time to catch up!

## THE FIRST MAJOR JUMP+ HIT! A WORLD-SPANNING SMASH!

IN THE THREE AND A HALF YEARS SINCE ITS LAUNCH, *SPY X FAMILY* HAS BECOME A MAJOR HIT FOR THE SHONEN JUMP PLUS+ MANGA SERVICE. NOW ITS ANIME ADAPTATION IS INSPIRING FURTHER GROWTH AND EXPANSION INTO NEW MEDIUMS LIKE MUSICAL THEATER!

## A SPY COMEDY ABOUT A FAMILY AND ITS SECRETS!

### LOID FORGER

Superspy Twilight is the father of the fake family he assembled. His deep hatred of war is rooted in his tragic past...

### ANYA FORGER

Anya continues using her telepathy to secretly help Loid and Yor. Despite past hardships, she loves her new life, which is rich with family and friends.

### YOR FORGER

The assassin known as Thorn Princess pursues the roles of wife and mother but continues killing for her assassin-syndicate employer. But has her attitude toward her work begun to change...?

### BOND FORGER

Bond is a large dog who has been welcomed into the family. He possesses a special power, which he uses to protect the Forgers. He loves Anya!

## A FAMILY CONFRONTS THEIR MISSIONS AND EVERYDAY LIFE

AS THEY STRIVE TO COMPLETE OPERATION STRIX, THE FORGER FAMILY FACES NUMEROUS TRAVAILS. HERE ARE A FEW OF THE CHALLENGES EACH FORGER IS FACING!

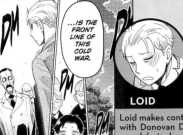

### LOID

Loid makes contact with Donovan Desmond, but when he tries to read Donovan's true intentions, he finds him inscrutable.

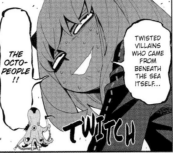

### ANYA

Despite her poor academic performance, Anya loves attending Eden Academy. On this day, she does some ill-conceived boasting...

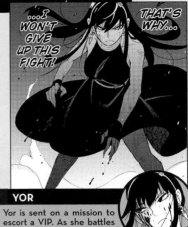

### YOR

Yor is sent on a mission to escort a VIP. As she battles enemy assassins, she begins questioning her life choices.

### BOND

During a walk with Loid, Bond foresees a fire and charges to the rescue! Afterward, the bond between dog and owner seems to deepen...?

## AND ALL THE VARIED CHARACTERS WHO SURROUND THEM!

# TATSUYA ENDO'S PUBLISHED WORKS  *As of 9/2022

## SPY×FAMILY

### Volumes 1 – 9
### (Ongoing)

VOLUME 1

VOLUME 2

VOLUME 3

VOLUME 4

VOLUME 5

VOLUME 6

VOLUME 7

VOLUME 8

VOLUME 9

*Spy x Family: The Official Guide—Eyes Only*

*Spy x Family: Family Portrait*
Original concept by Tatsuya Endo
Novel by Aya Yajima

### Tista
TWO VOLUMES TOTAL

An assassin hunting evildoers in New York is actually a young girl burdened with a tragic destiny. She seeks atonement in this intense crime action manga series.

### Blade of the Moon Princess
FIVE VOLUMES TOTAL

Kaguya, the crown princess of the moon, is exiled to Earth after a coup. She must gather friends and elude assassins as she strives to reclaim her throne in this epic, Japanese-flavored sci-fi tale.

### Seibu Yugi: Tatsuya Endo's Collected Short Works

This book compiles Endo's first four manga one-shots from *Weekly Shonen Jump*, including his debut work, "Seibu Yugi." They share the theme of defying fate.

「SPY×FAMILY」 ORIGINAL COMMENTARY

# TATSUYA ENDO'S

# ANIME

## COMMENTARY
### & Mini Interview

Like any other viewer, Mr. Endo enjoyed each episode as it was broadcast on TV. In this section, he recounts his impressions and some behind-the-scenes memories.

**MISSION 1**

**1ST EPISODE**

I remember being so nervous the first time I came to a recording session. I didn't have a particularly strong sense of how I wanted the characters to be performed, so I was just flailing around. Luckily, the talented voice actors, directors, and sound team were there to bail me out. I also remember that we couldn't figure out what Anya's telepathy should sound like, which became a huge problem. [laughs]

**MISSION 2**

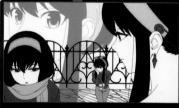

**2ND EPISODE**

The action scenes at the warehouse in the second half are just incredible. Also, this is the first episode with the opening animation. I love how flashy and cool the visuals and music are.

This isn't really about the anime, but before "Mixed Nuts" came together, Official Hige Dandism invited me to one of their concerts. It was such an incredibly cool show.

**MISSION 3**

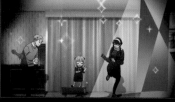

**3RD EPISODE**

This episode has a lot of little anime-original additions here and there, and I remember what a pain it was having to check over the script and all the storyboards. This is the first episode with the ending theme, right? The animation is great, and I was really moved by how well it matched up with the music. The lyrics for "Kigeki" are fantastic. I was so happy to receive a message from Gen Hoshino when he was composing the song, and I treasure that message still.

**MISSION 4**

**4TH EPISODE**

Kazuhiro Yamaji's performance of Mr. Henderson is fantastic. It kept me laughing during the recording session. I got to hear him do lots of different versions of "Elegaaaance!" They were all so hilarious it was impossible to choose just one.

**MISSION 5**

**5TH EPISODE**

I remember the script checks for this episode were utterly excruciating. On the other hand, the ad-libs from Hiroyuki Yoshino, who plays Franky, are quite funny. They made me think, "Now this guy's an entertainer." [laughs] Also, the cool action scenes that take place in the castle turned out fantastic.

**MISSION 6**

**6TH EPISODE**

I mentioned this in my discussion with Ms. Tanezaki, but Anya saying "baan" ["ta-da"] at the park is so cute. It was exciting to get to hear so many new characters' voices for the first time in this episode. Also, when I watched this episode on TV, I often thought, "Wait, is this the way this location is supposed to look? I guess it is..." The show often makes me see parts of Spy x Family's world in a new light.

## MISSION 7

**7TH EPISODE**

The first classroom scene! In the manga, I just wrote whatever came to mind on the blackboard without giving it much thought. Seeing that replicated in the anime made me realize "Wow, this isn't appropriate for a first grade curriculum at all." [*laughs*]

## MISSION 8

**8TH EPISODE**

I like the addition of the ashtray they grind the cigarettes into in the interrogation scene. It gives the scene a very grim feel. Kensho Ono's upbeat performance here is incredible.

## MISSION 9

**9TH EPISODE**

I like how wobbly and messed up Yor's mouth looks when she's shaken up in anticipation of the kiss. [*laughs*] Maybe it's because Yor's in full color, but she comes off as more sexy than she does in the manga.

## MISSION 10

**10TH EPISODE**

Mr. Henderson's shower scene is reduced to just his legs. I guess we hit the limit of what standards and practices will allow? Bill completely steals the show in this episode. Hiroki Yasumoto is not doing an elementary schooler's voice at all. [*laughs*] Bill is so physically impressive, it had me wondering if he was actually a member of Yor's syndicate of assassins. Also, his dad was M. Bison.

## MISSION 11

**11TH EPISODE**

I love how Anya is animated when she's running away from Loid in one of the early scenes. The animation in this episode is just excellent all around. I know I said this earlier too, but Ms. Tanezaki doing the voices of Damian and the others is hilarious.

**12TH EPISODE**

Loid's shuddering gait in this one is surreal and well-done. When he's learning the details of the penguin mission in the subway, the old woman speaks in a loud voice even though there are random people beside them. I thought, "Wow, WISE is a sloppy organization."

Also, the penguins are adorable. The way they pecked at Loid's food bucket when he was undercover is such a great detail and very cute. The animation of this episode is all-around great too. The scene where Yor kicked the bad guy into the ceiling was cool. I ended up rewatching it frame by frame.

The second part of the episode features a home scene that is of no real importance but that is still moving to see animated. I enjoyed the humorous inclusion of the "Mazekoze [Mixed] Nuts" label. This is a Short Mission that I desperately banged out when I was way behind schedule, and to see it highlighted as the ending of the first part like this...

---

**Your impressions as you look back on the first half of the season?**

I was both surprised and grateful for the high standards of animation and audio the series maintains from start to finish. The animation was incredible and looked extremely cool. The cast's performance was excellent, and every actor was a great fit for their character. Each episode generated huge amounts of discussion on social media and left me staggered by the anime's reach. There were so many licensed items and promotional crossovers that I can't follow what's going on anymore.

**Any new discoveries from watching the anime?**

Maybe it's because the anime has both voices and music, but certain scenes from the anime—even ones that are straight from the manga—get me a little emotional. I remember Mr. Eguchi, who plays Loid, told me, "Even though I'm listening to my own voice, when I watch the

episodes as a viewer, I still tear up." I sort of feel the same way.

Also, there are a lot of parts in the manga where I had to cut corners because I was on a tight deadline or something. Then when I watch them in the anime, where they did a proper job creating the detailed backgrounds and animating the full action scenes, I often found myself saying, "Huh, so that's how that would have gone."

**Ways in which the anime has been helpful to you?**

When I write manga dialogue, I don't typically hear character voices in my head, but lately sometimes I hear the lines being spoken in the voices of the cast. Maybe that just shows how close their voices are to my mental images of the characters.

On the other hand, lately I've come to see the anime as a sort of rival of mine—in a good

way. When people tell me they prefer the anime, it bothers me. [*laughs*] I know I'll never be able to beat the anime, with its voices and animation and music, but it makes me want to work hard and exploit the unique pacing and visual aspects of manga to make people prefer the manga instead.

**Any final comment for your fans?**

Next month, the second part is scheduled to begin. It has longer arcs and more stories that are centered around individual characters, so I think you might be able to enjoy it in a slightly different manner from the first part. Also, the fluffy guy you saw a glimpse of in episode 11 is very cute, so I hope you'll enjoy that too.

**MINI INTERVIEW**

*More Thoughts About the Anime*

# ANIME-RELATED

## SOCIAL MEDIA POSTS

Mr. Endo often posts original artwork on his personal social media account in advance of new episodes and other special occasions. Here are some of the illustrations that he's created in excited anticipation!

**Anya Before a New Broadcast**

**Anya and Nanana (TV Tokyo's mascot)**

**Opening Theme Song Release!**

**Ending Theme Song Release!**

**The Kigeki Family?**